The Political Economy of Gender

The Political Economy of Gender

Women and the Sexual Division of Labour in the Philippines

Elizabeth Uy Eviota

Zed Books Ltd
London and New Jersey

The Political Economy of Gender: Women and the Sexual Division of Labour in the Philippines
was first published by Zed Books Ltd,
57 Caledonian Road, London N1 9BU, United Kingdom
and 165 First Avenue, Atlantic Highlands, New Jersey 07716, USA, in 1992

Cover designed by Sophie Buchet
Typeset by EMS Photosetters, Thorpe Bay, Essex
Printed and bound in the United Kingdom
by Biddles Ltd, Guildford and King's Lynn

ISBN 1 85649 109 9 Hb
ISBN 1 85649 110 2 Pb

A catalogue record of this book is available from the British Library
US CIP is available from the Library of Congress

Contents

Preface

Sex and political economy are implicated with each other. The scope of political economy is the process by which human beings, as they daily renew themselves, transform nature into objects for their own consumption. Sex is the process by which human beings reproduce themselves from generation to generation. Sex and political economy then is the relationship of processes which satisfy three fundamental needs: hunger, sex and procreation. But sex is also the category which differentiates human beings engaged in the process of transforming material life daily and of reproducing themselves generationally. Sex and political economy then, is also the relationship between women and men, which sex works at what, and who does what to whom.

The focus of this book is on one specific connection between sex and political economy, the sexual division of labour; that is, the allocation of tasks throughout society on the basis of sex. The sexual division of labour is not only a differentiation of tasks, it is also a differentiation of worth, status, and power. It is a division which is as much political as it is economic.

The book takes a look at the sexual division of labour across diverse aspects of social life and within town and country, family and state, forms of property exchange, trade and technology. Special attention is paid to the experience of Filipino women. This experience has involved changes in colonial powers, systems of economic relations, prescribed sexual behaviour and cultural practices. These changes have not been uniformly experienced by women; this experience has varied among them depending on the places they occupied in the social economy, but always and fundamentally, women's experience has been defined by their relation to men.

The theoretical object of the discussion, therefore, is not women in isolation, but women in relation to men, that is, gender relations. Gender relations are socially constructed and have a political character; they interact with processes in society and are informed by and respond to these processes. In the Philippines, the relations between women and men are intertwined with a colonial past and a present that is characterized by the country's subordinate position in the international political economy.

One might well ask, what can a discussion on the sexual division of labour accomplish? And why bring in history? The answer is the link between theory

and practice: only in examining a social group's experience through historical, social, economic and political change is it possible to understand the mechanisms by which change acts upon that group's position in a society. Only if we understand the mechanisms by which a group's position is secured in a specific context can we confront the problem of how to change it.

The book covers roughly four and a half centuries (from 1521 to 1989) of social and economic transformation in the Philippines. The foundations for the basic alterations in social, economic and political life were laid down by Spain, however slowly paced, during the first two centuries of colonial rule. By the late eighteenth century political and economic events in Europe had begun to affect the Philippines.

In the next two hundred or so years the Philippines was to experience great material and ideological changes as the country was integrated into the global economic system, waged wars against colonial powers, and came to be one arena of a world war. Since the end of World War Two the country has undergone an accelerated pace of economic change along capitalist lines, with an ever-deepening subordination within the international economy, political upheavals and economic crises, and profound polarizations within society.

Many countries (often referred to collectively as the 'Third World') share roughly similar social and economic legacies and characteristics. Most of these characteristics are traceable to social, economic and political conditions laid down during the colonial period but which have been (and continue to be) exacerbated by unequal relations between countries and between classes within countries.

Evidence has accumulated that, apart from their polarizing effects, these unequal relations both historical and contemporary, have also created or aggravated gender divisions. Social, economic and political relations converged with tradition to affect relations between and among women and men. As this book looks into historical and contemporary processes it provides both a comparison and a contrast to other countries. The exploration of conceptual, economic, political and gender issues have resonance for the position and condition of women in many countries of the Third World.

The discussion draws largely from historical accounts, government reports, censuses and similar enumerations, sectoral studies and surveys. These sources were read critically and some observations and reservations about these documents are expressed here briefly.

First, historical and contemporary accounts are expectedly coloured by a writer's perspective. In the colonial period especially, most writers, whether foreign or Filipino, were male. A male perspective characteristically gave male activities prominence and often took the male view as the sole or principal one; where women or women's activities were mentioned, these were either of an incidental nature or within a gender-specific context. Accounts written by foreign white men were also about women of colour, a group differentiated not only by subordinate gender but also by subservient race. In this book these historical and contemporary accounts and events are placed within the perspective of gender and class relations, relations embedded in power and

conflict, of one group's dominance over another.

Second, enumerations, such as censuses and survey instruments and methods of analysis, no matter how 'gender-neutral' they claim to be, embody specific gender-based arrangements. These instruments and methods were fashioned by Western colonial powers (primarily, male) and vestiges of standardized data techniques remain because there has been little incentive to change assumptions and adjust categories. As Western-style creations these instruments embody both an 'industrial' or urban bias and a gender bias.

One of the more pervasive of these biases is the way work is defined. Work productive of value is paid and this is what figures in national accounts (for example, the GNP); household work is not productive work and is not paid. The categorization for gender is that productive work is men's work and household work is women's work. In fact, however, especially in countries such as the Philippines, work – particularly women's work – is a mixture of paid and unpaid services across a variety of life's functions. Instruments which do not take these services into account, therefore, obscure the heterogeneity of labour and the complexity of labour use.

Historical and contemporary documents and past and present-day enumerations are used with these reservations. They are data widely available; they also provide useful comparisons with recent trends and do present some broad patterns of change.

My concern for broad structural shifts puts this discussion, for the most part, on the level of a general secondary analysis. Rather than concentrating on exact historical detail, more attention has been paid to overall patterns of change. Because of the prominence given to objective forces too, subjectivity or personal experience is not given the importance it deserves. As a result of the neglect of this perspective, the initiatives of subordinate groups – the manner by which women and men act to maintain, rearrange or resist change – are not adequately discussed.

The discussion is also largely limited to the experience of what has been called the 'Hispanicized' or 'Christianized' lowland majority in the Philippines. Little has been written on the experiences of minority cultural communities. The experience of change among these minorities needs to be examined and integrated into the broader picture of national change. Women and men in these communities are going through the political and economic changes which have been, or are being, experienced by the majority group more rapidly, often more violently, and in different ways.

This book, like any other, was written within an intellectual and political climate. The discussion draws on conceptual insights of individual women and men all over the world and from an international and national women's movement of the past 25 years or so. The arguments presented here revolve around a specific intellectual position and are anchored in a specific view of economic and political realities. A book on the sexual division of labour written 25 years ago, if the issue were to be raised at all, would have been phrased differently.

A good part of the material in this book was written in 1983–84 for a doctoral

dissertation. Revisions were made on the manuscript and several sections were added in 1988–90.

The discussion begins with a perspective on the intersection of political economy, ideology, and culture as this is expressed in the sexual division of labour and in sexual practice. This perspective then frames the narrative through four periods of Philippine history: pre-Hispanic Philippines, Spanish colonization (1521–1896), a brief interlude of self-rule, a half-century of American occupation (1898–1942, 1945–6) and the contemporary period (1946–89). Each of these sections gives a brief overview of the direction of broad social and economic changes and elaborates on the manner in which these changes have articulated with gender relations and sexual divisions in the labour process. The contemporary period includes an overview of cultural communities, an examination of state behaviour towards women and men and an analysis of gender and systemic crisis. The book ends with a brief discussion of an alternative social and economic order that would be organized on the basis of each individual's fulfilment of her and his human potential and creativity.

Acknowledgements

I acknowledge, with gratitude, the intellectual debt owed to numerous women and men all over the world who have shared, in conversations and writings, their ideas on gender relations and class. Many of the insights in this paper were drawn from the analytical and conceptual tools developed by them.

I wish especially to thank certain individuals who played important roles in the writing of this book. Dale Johnson gave initial encouragement and abiding support throughout the course of study and work that led to the writing and completion of the dissertation on which a large part of this book is based. Members of the doctoral committee, Lourdes Beneria. Rhoda Blumberg and Judy Gerson and outside readers, Ricky Abad, the late John Doherty and Naila Kabeer read through the draft and made useful comments. The Wenner Gren Foundation and Rutgers University extended timely and generous financial support which allowed me to devote full attention to the dissertation. I also recall friends and colleagues with fondness, especially Liz Mitchell, Minoo Saba. Mary Racelis, the late Eleanor Leacock and the late Carlos Eliazo who made graduate work and life away from home as pleasant as possible.

The Canadian International Development Agency extended a generous grant to the Department of Sociology and Anthropology at the Ateneo de Manila University, which enabled me to take the time to make a book out of the dissertation. I wish to thank Sarada LeClerc of CIDA for her personal support of my project. I am specially grateful to Ricky Abad and Delia Aguilar for taking the time to read the entire manuscript and to make concrete suggestions; to Germelino Bautista and John Humphrey for reading sections and pointing out issues which needed to be made clear; to Anna Gourlay and Robert Molteno for their help in the publication of the book; and to assorted kin, Rey, Octavius and Vladimir for their help in the research and the typing. I appreciate the courtesy extended to me by the staff of the libraries of Rutgers University, the University of Hawaii, Institute of Development Studies at Sussex University and the Ateneo de Manila University.

Finally I wish to express my deepest appreciation and gratitude to my parents, Maria Uy and Colman Eviota, to whom this work is dedicated, for providing the supportive and rewarding relationship that enabled me to do what I wanted to do.

Part I:
Contours of the Discussion

1. Sex, Gender and Society

In every culture, in every age, women and men relate to each other in culturally specified ways. This manner of interaction has been called a 'sex–gender system';[1] it defines how males and females become men and women; it allocates specific tasks and roles to women and men on the basis of their gender; it fixes the parameters of approved sexual and procreative behaviour; and it sets the tone of gender-based social relations and social worlds. A sex–gender system is composed of many related parts with a fundamental coherence; but, as with other social and cultural systems, contains within it dissidence and contradiction.[2] As with other social systems, it is neither static nor unchanging; rather it is engaged in an ongoing interaction with other systems.

The broad interest of this book is the interaction between the sex–gender system and the economy in Philippine life. This interaction is a historically rooted, complex process encompassing a diversity of ideological, cultural and material life. The sex–gender system and the economy are concrete structures within society and women and men are formed together in social groups within these structures. Structures shape people's existence as members of institutions, as articulators of culture, as groups differentiated by sex, age, colour and ethnicity and as active participants of social collectives and nations. Structures shape people's lives, but people in their everyday lives activate the structures; they act to maintain, rearrange or change them. The place of individuals within social structures, their social positioning, presents people with their respective 'life chances'.

This chapter looks at what constitutes a sex–gender system, how a particular system has developed through time and what the consequences have been for the life chances of women and men in general, and Filipino women and men in particular. It then presents a trans-historical view of the intersection of a sex–gender system and the economy by means of the concept, the 'sexual division of labour', and proceeds to describe how this division has been worked out in Philippine political economy. The section ends with a discussion of specific elements within the sex–gender system, that of sexuality and ideology, and their connections to the labour process.

But first we need to disentangle the notions of 'sex' and 'gender'.

Sex and gender

Females and males – women and men – have always been different. They differ in biology, in psychological disposition, in social behaviour. These differences have an aura of inevitability and naturalness which time seemingly has made intractable. Yet, except for the biological differences in procreative functions and secondary sex characteristics, behavioural differences between women and men are social constructs – created by women and men themselves; they are a matter of culture.[3] It is this social–cultural construction that we call gender.

The social construction of gender is an interplay of biology, the body – itself historically constituted[4] – and culture; biological sex differences form part of the raw material with which social relations are constructed. In this construction, biological females and males become gendered individuals, women and men, feminine and masculine, through culture. Females and males actively acquire a gender identity which corresponds, more or less, to socially and normatively defined notions of femininity or masculinity.[5] Each sex behaves, again more or less, according to this identity and is expected to perform social roles and tasks assigned to it.[6] But as there is, generally speaking, universality in biological sex differences, there is variability in socially constructed gender differences. There is diversity in what constitutes feminine behaviour and masculine behaviour – as in which sex works at what – across various cultures and within cultures, across time-periods and within single generations.[7]

People as members of social groups create gender-based behaviour according to what they believe to be differences and transmit these beliefs to future generations. The most influential and tenacious of these beliefs is that gender differences are natural and inherent. Women and men do not behave similarly, it is argued, primarily because their reproductive systems are not alike and also because they differ in the structure and secretion of their hormones, the sensitivity of their physiological systems, and the size of their organs.[8] To change behaviour based on these biological arrangements, the argument continues, is unnatural, undesirable and well-nigh impossible.

Evidence from the social sciences tells us, however, that women and men behave differently because, more than biology, social and cultural processes make them different. In fact apart from their reproductive systems and other secondary sex characteristics, there seem to be as many biological and social-psychological differences among females and among males as there are between females and males.[9] Cross-cultural evidence on male–female variability in sexual propensity, sexual arousal, performance of tasks, and nurturance roles also shows that no one characteristic is natural to males or females, but that culture and society see an interest in differentiating women and men.

The corollary of the belief in biological sex as the necessary and sole cause of behavioural variations between women and men is the belief in natural differences in social roles and social efficiency. Women and men are believed to perform roles and carry out tasks according to their biologically specified destinies. Again, as we shall see in the discussion of origins, gender roles and

activities change in different historical periods and cultures. In the historical development of social institutions and systems, biologically based differences became the basis of prestige and privilege which were then attached to one social category of individuals. This group has sought to maintain its privilege in a variety of ways. The reduction to biology of gender differentiation perpetuates this position of privilege and it is the basis of many forms of social differentiation – the differentiation in work, social roles, sexual behaviour and social power.

A search for origins

History shows the variability of sex–gender systems in time and space. Yet despite this historical specificity, sex–gender systems have exhibited many common elements. Within differing socio-economic formations – whether feudal, pre-capitalist, capitalist or socialist – social relations between women and men have not been equal. Men as a group have had greater and more direct access to social resources, whether they be food, land, money, or political power; they are able to move more freely; their sexuality is less restricted; they have minimal responsibility for self-maintenance and the care of the young and the elderly; and they occupy a privileged position in terms of their command of labour, especially women's labour. How did these asymmetrical social relations come about? The search for the origins of asymmetry involves unravelling the threads of gender hierarchy through various historical and social trans-formations. The path is one of ethnographic reconstruction bringing together several lines of inquiry; the task, a continuing and collective process posed more as probabilities and connections than as certainties and determinations.

Social transformations are always situated in a specified time and space, yet without necessarily universalizing all human experience, some historical conjunctures can be seen as critical moments in the reorganization and restructuring of the sex–gender system. Three are prominent: the characteristics of gender organization in early human society, the formation of the state, and the origins and effects of modern capitalism.[10] These last two conjunctures were mediated for many countries by a fourth conjuncture: colonization.

The experience of industrialized countries provides examples of these historical transformations as they initially occurred as a drawn-out process, but it is countries of the underdeveloped, largely colonized world that are rapidly undergoing these changes, mediated by a set of factors. These factors – first, direct colonization and, later, subordination to an international system – have precipitated a substantially different expression of some of these conjunctures.

Early human society
The social organization of foraging societies – small-scale, migratory and kin-based groups of female gatherers and male hunters – indicates a flexibility of gender roles. Women's work processes and the social relations attached to

these processes may have been different from those of men, but not necessarily inferior to them. Although this flexibility does not indicate the absence of male dominance in early human societies, it does suggest a sphere of autonomy for women, or at least, some parallel spheres for women and men.

Male social dominance may have emerged from the first social division of labour. The roles of women as gatherers and men as hunters are most probably based on the fact that women's reproductive role led to them also being responsible for the daily subsistence of both women and men, young and old. Women in these groups gathered root crops and fruit plants for the immediate survival of the members. The provision of food eventually made necessary the regular cultivation of grains and tubers and the invention of the first tools to carry out agriculture with regularity. Women as gatherers and then as cultivators not only collected from nature and consumed what nature grew, but also replaced what they got and made things grow.[11] Female productivity, then, was the precondition for male productivity.

Men's appropriation of nature was qualitatively different and, it has been argued, was more closely linked to the invention and control of certain technology. While women provided the daily staple food through agriculture and agricultural tools, men provided another kind of food, meat, through hunting and the use of hunting technology.

According to the ecological–technological explanation, a gender hierarchy appears to have developed from the division between gathering and hunting.[12] It may have originated from the nature of hunting itself: hunting was an aggressive act. Hunting also entailed more risk and the meat obtained from it was a scarce and therefore prized commodity. Or hunting technology was put to other use: tools became, in time, instruments of coercion which men used to control and dominate women and other men.

The productionist argument on the other hand traces the origins of the subjection of women to the transition to sedentary agriculture and the production of surplus, made possible by regular cultivation, which led to the formation of social classes. Women as food gatherers moved into their new roles as primitive agriculturalists becoming, in the process, the main source of kin-based or tribal–clan wealth in two ways: they were the bearers of the next generation and they were the principal producers of food. One elaboration on this connection postulates the simultaneous origins of class oppression and gender oppression.[13] The growth of private productive property was linked to the dismantling of a communal, pre-state society that was kinship based. As property now held individually needed to be maintained and correctly transmitted, women as wives became means of production for their husbands; marriage grew more restricted and the legitimacy of heirs more crucial. Reciprocity among kin was curtailed, unequal access to productive resources gradually developed, and estates, castes and classes arose out of a kin-based social organization. The creation of a class hierarchy was intimately connected to the creation of a male-dominated family. Women's autonomy in the sexual and social spheres was circumscribed as classes developed.

More recent studies on economic and political systems of earlier societies,

however, indicate that it was political reorganization that precipitated the subordination of women. These studies suggest the formation of a state as a crucial historical conjuncture in the development of a systematic male-dominated social order.

State societies and colonization
The formation of the state meant the crystallization of class and gender differentiation. The state classified categories of people as dominant and subordinate and sustained this hierarchy at both ideological and material levels. Gender was an important category of differentiation. Women as a social category were increasingly subjugated to men, who became heads of households; women's right to property was circumscribed as was their access to productive resources. When state formation was defined by a colonizing power, the state also became constitutive of specific gender, racial and ethnic arrangement.

The convergence of state formation, colonization and gender differentiation involved several key factors: the relative power of kinship and clan, the flexibility of cosmological–religious systems, the emergence of intensive warfare, the connection between the domestic and extra-domestic economy in trading systems, and the autonomy of women.

Politics and gender in kin-based groups: The political structures of primitive societies both derived from, and encountered resistance within, the kinship systems that had organized pre-state societies. It was within kinship-based groups that women's subordination already seemed to occur.

When state structures first began to appear, kin-based forms of organization became restricted and their legitimacy and autonomy was replaced by an evolving sphere of territorial and class-based politics. Established, highly ranked groups and emergent élites acquired both material and symbolic resources which were controlled and reproduced through kinship structures. The kinship system of organization was modified to meet increased demands for the production and distribution of goods extracted by these privileged groups. As states were formed, these kinship organizations and structures were transformed and became the basis of more powerful, politicized domains; social relations in all their aspects (economic, political, religious, ritual and gender) were no longer experienced through kin-based organizations. Colonial powers used these privileged groups and kinship structures to construct their political rule. It seems that women as a social category were subjugated along with and in relation to kinship.

Kin-based organizations characterized by some form of hierarchy became fraught with increasing tension over alliances, descent and transmission. Women were crucial figures in these kinship-based political transactions. Women of high rank were important as biological transmitters of status so that some control was exercised over their social as well as sexual relationships, although ordinary women also experienced a loss of autonomy in political exchanges at their own levels.

Cosmological organizations: Kin-based political organizations were legiti-
mated by religious and cosmological systems; thus, changes in these systems
were the ideological outcome of structural and material tensions in political
organizations. In non-hierarchical systems, women participated in both
teaching and preaching in the ritual domain. As hierarchies developed, so it
seems did sexual antagonism. Female or androgynous gods were replaced by
ascendant male figures. Some of these replacements were indigenous in nature;
in other cases, they became the tasks of foreign missionaries.

Intensive warfare: Wars soon became a feature of early states. Kinship
structures were deeply affected as men were conscripted under conditions of
intensive and continued warfare. Warfare had two broad effects on women:
élite males gained more power in the social order with gains in political
dominance, and more power over women, who as wives, were needed to form
alliances; at the same time, however, élite women seemed to have experienced
more autonomy in sexual, political and economic affairs when men were absent
from the scene. But warfare had adverse effects on ordinary women, especially
when they became spoils of war and subjected to rape and sexual abuse. The
relationship between intensified warfare and women's subjugation is much
more complex than a straightforward deterioration of women's status.

Trading systems: Changes in trading systems and in the social relations of
production and distribution which underwrite trade show evidence of changes
in access by social groups. The important elements in these trading systems are
who produces goods, who appropriates them and who distributes them.

As demand for a traded commodity increases, labour needs to be intensified
and trading alliances are formed. Women are affected in different ways.
Marriage systems are rearranged in order to reproduce trading and political
alliances. The practice of polygamy increases access to resources that wives
control or can produce. Women are exchanged in kinship alliances or
reciprocity systems to expand trade networks. But women themselves also
traded; thus, appropriation and distribution were not exclusively male
functions. In so far as trade is linked to the intensification of production and
exchange, women as wives, producers and traders are linked to it too.

The Effects of Capitalism

The large-scale and profound social transformations which attended the
development of capitalism were built upon the diverse roots of sexual
hierarchy. But while capitalism may have derived such social inequalities as
inheritance and differences in property ownership, gender-biased judicial
systems, a male-dominated household, and an ideology of male sexual needs
from the past, it transformed these structures and ideologies for more elaborate
purposes: a specific family household system that further glorified male
prestige; the radical separation of home and workplace and the consequent
domestication of women; and gender divisions in the workplace such as sex
segregation in occupations, women's marginalization from waged work, and

wage differentiation.

The capitalist process in underdeveloped countries, however, has been fundamentally shaped by colonization and imperialism, exacerbating or modifying many of these transformations. Foreign powers imposed their own complex forms of social and gender hierarchies, radically reordering indigenous societies. The confrontation between colonizer and colonized took diverse forms. Conquered peoples resisted, accepted or modified these imposed hierarchies according to their own forms of polity, economy, religious and sex–gender organizations. The result of these encounters was not, in the majority of cases, the replication of the state and capitalist development found in imperialist countries; what occurred was an uneven type of development of both polity and economy. The effect of foreign rule on gender roles was generally deleterious and the colonizing powers, invariably male-dominated, dismantled or belittled women's social, political, economic and religious roles. Men became heads of households and families; leadership roles and the activities of men were reinforced while those of women were devalued or obliterated. Cultures where the sexes had parallel roles in the social relations of production were reorganized, granting privileged status to men and male activities. Foreign penetration either created or paved the way for a system of assigning greater worth and status to social groups or individuals.

The effects of modern capitalism together with work divisions in early human society, the formation of states and the effects of colonization were all historical conjunctures crucial in the reorganization of sex–gender systems. These conjunctures reveal a complex process involving a multiplicity of variables and interlocking structures. These variables and interlocking structures inform the perspective on the relationship between sex and political economy.

Perspective

The position of women in political economy is structured by a double set of relations, arising from their relations to men on the one hand, and deriving from their position in the economic organization of society on the other. These are relationships of interaction and opposition which are worked out within a specific configuration of social, economic, political and ideological forces. As societies change, existing forms of relationships between women and men absorb, transform, and mediate the forces of emergent social, economic and political change and are in turn, affected by these forces. In these relationships women and men engage in human praxis, as agents with needs and intentions, actively maintaining, negotiating or resisting, collectively or individually, institutional and cultural forces that bear on their everyday lives.

The form and content, scope and intensities of these relationships broadly delineate the contours of the discussion of gender and the labour process. The intersection between economy, politics and gender is embodied in the sexual division of labour: the demarcations of those tasks which are paid and those not paid, differentials in pay, concentrations in occupations and job-levels

within these occupations, and sexual servicing as the paid work of women.[14] Gender-shifts in the allocation of work responsibilities are connected to changes in property relations and women and men's position in the economy. Whether one is a woman or a man is a major criterion in determining access to most positions. Historically, access to positions of privilege has favoured men much more than women so that sexual divisions fundamentally embody power relations between women and men. Thus, the sexual division of labour belongs in a broader social context of a gender hierarchy which has specific effects on the position of women. This context includes, among others, ideologies which define 'woman's place' and 'women's work' and the control of women's sexuality. Gender, as it constitutes a major division of labour, as it defines an ideology, and as it determines the exercise of power, has over-arching consequences for women and men's lives.

I will be looking at three domains of social and economic life: ideology, sexuality and the material world. The domain of ideology is conscious ideas and unconscious beliefs; the material world, that of work, power and structures; and the sexual, that of ideology, and social and psychological behaviour. These domains are intertwined: the material may shape consciousness but it is consciousness that keeps together economic, political, and sexual life.

2. Gender and Political Economy

The sexual division of labour and capitalism

Society is fundamentally constituted by the relations people form as they do and make things needed for their survival. This is work, the social process of shaping and transforming the material and social worlds; the process by which people become who they are. In Philippine society, as in all other societies, some of this work is performed by women, some by men, while still other work is done by both women and men.

Work is generally of two types: that which is productive, or work for exchange, and that which is reproductive, or work for use and the satisfaction of immediate needs. Productive and reproductive work are both part of a process of survival and renewal: productive work satisfies such basic human needs as food, shelter and clothing; reproductive work is the production of people, not only the bearing of children but also the caring – the daily physical and ideological maintenance of human beings – which enables individuals to fit into the social structure of society.[1] As societies undergo change, the nature of productive and reproductive work also changes and so does the distribution of work between women and men: tasks are reallocated between them and other tasks are added on.

In agricultural production systems in the past, work was not clearly distinguished; production and reproduction were carried out within the household and productive labour was a common enterprise among household members.[2] In large part, the family-household system was the extended form consisting of a variety of kin and non-kin in one unit.[3] There was the customary division of labour in productive activities, of what was women's work and what was men's work, but this was not sharply drawn. But reproductive work, then including processing and preparing food, house cleaning, gathering firewood, fetching water – was almost always women's work. Much of what is known as household work was also productive work because most of what was produced was used or consumed directly by the household members. Common productive labour generally facilitated a 'unity of production and consumption'.[4]

Within the unity of family-household and economic organization, the labour of women and men was geared to the interests of the group rather than of any

one individual. Child-rearing belonged in the larger configuration of reproductive tasks and the mothering role did not have as prominent a position as it does today, the wide variety of tasks precluding inordinate emphasis on this role. In addition, a network of support kin meant that productive and reproductive tasks were shared by both sexes so that the burden of survival did not rest with the individual.

Work arrangements of this type existed in a society where production was essentially based on the satisfaction of the immediate needs of producers. The means of subsistence were derived primarily from the land which was held in common by the collective. Where exchange took place between households, it was one of complementary resources. Women and men went to the market with the products of their labour to exchange products they needed for immediate consumption but which they did not themselves produce.

As a certain stable surplus became available within the community, there arose a social division of labour. Men and women developed specialized skills, production increased, the economic base expanded and social classes of producers and non-producers began to emerge. Social production no longer totally served to fulfil the needs of the producers. Along with surplus and its differential allocation, control or ownership of the means of production, that is, land, became important. Thus, where previously, land was owned on the basis of the right to use the land (or use-right), now ownership of the land itself was pre-eminent; and further, this ownership no longer resided with the collective but with individuals or family households. An emergent state also began to designate males as heads of family households, endorsing the private authority of men over women.

At this stage, a social class appears which intervenes in the economy: the merchant capitalists. The role of this class is to enter the market not to buy in order to satisfy its immediate needs, but to buy in order to sell, to acquire wealth. Merchant capital introduces money into the economy, brings in foreign and luxury products, and intensifies the labour process. In so doing, it cuts deeper and deeper into the productive process. As a result there is a reallocation of work effort between women and men and among family members in household production and reproduction. More time is devoted to productive work and there now arises a need for additional hands to contribute to production.

As merchant capital is obliged to increase production to acquire more wealth, it becomes transformed into commercial capital, or productive capital itself, that is capitalism. Productive capital directly intervenes in the sphere of production and in the process restructures local economies away from self-provisioning by undermining domestic manufactures and encouraging the production of certain commodities. The work of women and men is reallocated from the needs of the household to production for the market; women are drawn into production of certain commodities, men into others.

With productive capital the extraction of profit is no longer derived from exchange of goods but from the labour of the producer or the labourer.[5] The appearance of capitalism as a mode of production is generally based on three

socioeconomic transformations:

1. the separation of the producers from their means of production and subsistence,
2. the formation of a social class which has a monopoly of the means of production – the capitalist class or *bourgeoisie* – and
3. the transformation of human labour-power into a commodity.

This last condition is a result of the appearance of a class, the working class (or proletariat), which has been dispossessed of every means of subsistence and therefore, in order to survive, is obliged to sell its labour-power to the owners of the means of production.

In capitalism, then, labour-power has itself become a commodity and therefore has its own value like any other commodity. The value of this labour-power on the market, or its market price, is the wage. The value of labour-power is determined by the quantity of labour necessary to reproduce it, that is, necessary for the subsistence (the day-to-day physical maintenance) of the worker and the worker's household. The value above this necessary labour is surplus value and it originates from the fact that a difference appears between the value produced by the worker and the value of the commodities needed to ensure that worker's reproduction. This surplus value, when realized in commodities exchanged in the market, is the capitalist's profit. It is, then, in the interest of capital to increase its proportion of the value produced by labour while it is in the interest of labour to increase its proportion of the value it produces.

The accumulation of capital therefore rests on the increase in the rate of surplus-value extraction. This can be broadly achieved in two ways: absolutely, by increasing the time worked without a corresponding increase in wages (but this strategy is constrained by the physical limitations of workers) or relatively, by intensifying labour and making it more productive. In either case, it is in capital's interest to keep the cost of wages down. The drive to accumulate by means of increasing relative surplus value has involved the introduction of machinery and the division of the work-force into differentiated groups to whom more or less wages may be paid. The intensification of labour has entailed the fragmentation of the labour process into small component parts, enabling labour to become more efficient and allowing capital to divide the work according to skills and to pay wages corresponding to the skills needed for the job. Gender was to play a major role in the reorganization of the production process and the division of labour.

The development of a system based on wage relations had profound effects on the household as a unit of production and consumption. The household no longer had access to the means of production; its subsistence relied on the exchange of labour-power for wages rather than on its own internal production. Work for wages became increasingly distinct from work in the household. Wages allowed the household members to buy on the market goods and services that they had once produced. Units of production largely became

separated from the units of consumption.

In this separation men as heads of households were deemed the primary wage workers, although in reality more than one member had to do paid work because wages were inadequate for the survival of the household. Women became these secondary productive workers and were seen as such.

But apart from the specific consequences of a wage-labour system, capitalism also tended to separate the home and workplace.[6] The expansion of capitalism entailed the development of productive forces and with it mechanization, mass production and technological advances. Production was more and more likely to take place in areas outside the home, and later moved outside the community and into towns and cities. This separation and its attendant increase in geographic mobility caused strains in extended family and kin networks; for women, especially, it eroded the network of support for household tasks.

The main questions in these separations were: who was to care for the children, and who was to care for the home? The problem was resolved by a configuration of factors: the demands of childbirth and infant care, an ideological and social order which privileged the interests of men and a specific division of labour which pre-dated capitalist relations. Some women became full-time 'housewives' and were ascribed the responsibilities of child-care and housework; others became both housewives and productive workers. But all women became primarily 'housekeepers', thus cutting them off, or at least keeping them, from a similar participation to men in economic production, especially wage labour.

The gradual establishment of the wage-labour system and the separation of home and workplace involved the restructuring of the household and the emergence of an ideology of familialism. The ideology centred on the extension of women's procreative functions to women's responsibility for the home: women were not only child-bearers, they were also child-rearers, husband-carers, housekeepers, and overall system-maintainers. This social definition of women was encapsulated in the phrase 'woman's place is in the home'. The newly defined tasks of women involved assigning the domestic sphere – the home – as the private sphere of women and of feminine activities. In this ideological construction were included such notions as feminine nurturance, masculine protection, maternalism, self-sacrifice, and emotional and financial security. Women's dependence on men and men's wages became couched in terms of emotional and psychical dependence as well.[7]

However, the articulation of the ideology of woman's place within the relations of production meant that the character of women's subordination and household structures would differ between the classes of capitalism. Among the capitalist and propertied classes, the norm was a family household organized around a male wage-earner with wife and children for dependants. Among the more numerous working and poor peasant classes, however, the norm was a family household organized primarily around dependence on the productive work of more than one member. In these households, women were never full-time housewives and were never fully dependent on men; rather they

were engaged in both productive and reproductive work in order to ensure the survival of the family. For these women there was a disjuncture between the economic organization of the household and the ideology of woman's place. For women of the non-owning classes, in fact, the conjunction of ideology, class and the separation of spheres meant a double shift and a double burden of reproductive and productive work. When they entered paid work, the type of work they performed, the value of this work, and their position in the work-force was defined by their subordinate position in social relations and by their responsibilities for the home.

Women's position in the economy continues to be defined by relations of capitalist production developing in and through contradictions between capitalists and workers and between women and men. Women's position in modern capitalist society has taken on several distinct but interrelated features. These features are:

1. women's relegation to household work and the fact that this work is not valued;
2. their perceived and actual secondary-worker position in the productive sphere;
3. their intermittent participation in social production;
4. their concentration in particular sectors of the economy and in particular levels of the work-force (that is, a sexual division of labour within the production process itself);
5. their uniformly low wages; and
6. their mediated position in the capitalist class structure.

First, women are relegated to reproductive work and this work has no exchange value.[8] Work is necessary to transform commodities bought by the wage into items that can be used or consumed; work is also necessary to maintain husbands, children, and other household members from day to day. This work of buying and cleaning, washing and fetching, making and mending, cooking and caring, watching and minding is done primarily by women and goes unpaid. Reproductive work in the capitalist economy also entails much more than what is subsumed in the terms 'housekeeping' or 'housewives'. It is work that takes place outside the market sphere but is integrated into it: no worker, male or female, would be able to sell labour-power to a capitalist unless basic needs were first met. In reality, then, the household and maintenance work of women is the material base for the reproduction of living labour without which capital cannot appropriate surplus.[9] Women's reproductive work serves both the interests of men and of capital. It is, of course, of major consequence that the range of activities called reproductive work becomes paid work when it is performed by someone other than the wife or a family member when it enters the sphere of exchange.

Second, women are seen and often perceive themselves as secondary (auxiliary, supplementary) productive workers because of their primary responsibility in the home. Women's ties to the home define their role in the

labour-force while men's productive work is not constrained by a similar ideology of domestic work. One of the major implications of this role is women's position in the labour-market: while at specific levels women may be a preferred labour-force or retained because of the nature of their tasks, at the general level, women as a group are less likely to be absorbed into waged work and as a group they are more likely to be released during economic recessions. Women's secondary position also means that especially in situations of a large labour surplus, women must seek their own survival outside the formal wage economy.

Third, married women's patterns of employment are rarely continuous throughout their adult life. As women go through the life-cycle stages of adulthood, marriage, child-bearing and child-rearing, their productive work is interrupted, although a husband's permission also figures prominently in women's decision to enter the labour force.[10] Since women's participation in the work-force is intermittent, they come to be seen as a temporary, uncommitted work-force; their secondary status is reinforced. In contrast, men are the primary income earners, the stable work-force. Men's participation in social production shows a steady increase throughout their working life, unencumbered by child-bearing, children and domestic work and unshackled by the demands of a dominant spouse.

Fourth, women productive workers are concentrated in occupations consistent with perceptions of the proper tasks of women and men and with sexual stereotypes of female and male attributes. Women are disproportionately represented in servicing and family-oriented nurturing occupations (for example, nursing, teaching and secretarial work) which are also relatively low-paid, and they are in low-skilled, low-productivity, casual and highly fluid work with few promotional possibilities (such as domestic service and subsistence trading in the informal sector). Increasing fragmentation of the labour process has meant the recruitment of women to work deemed suitable to their sex (such as labour-intensive work in the industrial sector). The sexual division of labour within the work-force was not created by capitalism but capitalism did create a system in which pre-existing gender distinctions were reproduced in the wage-labour system.

Nonetheless, while the concentration of women in particular occupations may reflect the separation of spheres, the concentration of women in the lower skilled, lower levels of occupation has more to do with male strategies either to place women in these positions or to redefine work as lower skilled because it is women who do it.[11] Men's dominance in the home is extended to the area of wage-labour relations as their superiority is reproduced within the sphere of production. In the hierarchy of home as in the hierarchy of work men are people to be obeyed and served.

Fifth, women are paid lower wages than men because their paid labour is considered a supplementary activity. Again, however, while women's responsibility for the home limits their options for better-paid work, it is also the case that women are paid less because they are relegated to positions which are defined as low skilled; women are seen as bearers of inferior status and men

(as managers, supervisors, and employers) see to it – through a variety of exclusionary strategies – that women remain in these positions.[12] In some countries women receive less wages because they are seen to, and do, consume less food. Women in poor households, in fact, eat less, or even go without food, to feed their husbands and children.[13]

Finally, women's position in a capitalist class structure is a mediated one. As full-time housewives, women are dependent on a male wage (or capital) and thus have only an indirect relation to it; as productive workers, they have a direct relation to the wage or capital; in either case, however, they are directly responsible for the daily reproduction of their own and male labour-power. The work women do and the reduced wages they receive embody this mediated relation. Women's relationship to the class structure then is mediated, to a large extent, by the family-household system and the ideology of the family, male dominance, dependence on men and reproductive work. Women's position in the economy therefore is socially defined by their relationship to men. Men have a primary right to paid work and to better-paid work than women in general, and married women in particular. Women's subordinate position in capitalist society makes sense only in relation to men's dominant position; and this position is secured in large measure by the separation of the private reproductive sphere of women and the public productive sphere of men.

The intersection of sex and political economy in the development of capitalism has led not merely to a differentiation of tasks but also to the systematic differentiation in status and power between women and men.

Women's position in capitalist society therefore derives from the intersection of gender relations, class and the capitalist accumulation process. As well, it derives from economic strategies of the state, the stage of capitalist development and the country's position in the international economy. The manner in which women are drawn to and withdraw from productive work, the nature and degree of the separation of productive and reproductive spheres, and for the most part, the manner in which women's unpaid and paid labour is appropriated are defined by these variables in combination.

Philippine political economy and the labour process

The transition to capitalism has varied from country to country; the transformation of non-capitalist relations has taken very divergent historical forms and has been a very uneven and protracted development. The basic process, as it evolved in the now industrialized (developed) countries, entailed the dispossession of direct producers from their means of production and the increasing conversion of these direct producers into wage workers, that is, proletarianization. But while this has been the case for the developed countries it has been an altogether different experience for underdeveloped countries. In these countries, the process of proletarianization has yet to occur in any profound way and where it has occurred, it has taken on very different forms. Why has this been the case?

The explanation lies in the process of capitalist expansion and accumulation as it unfolded in these economies. In the drive to accumulate, capital is forced to continually revolutionize the process of production and in so doing releases labour in one sector and absorbs it in another. But capital does not grow at an assured and steady pace so that it is unable totally to absorb the labour it releases. This released labour of women and men comprises a surplus population, the 'industrial reserve army of labour'. This reserve consists of a population of potential, marginal and transitory employment and increasingly also of a disposable or redundant working population. Apart from its function as a labour pool, the surplus population also serves to depress wages.[14] As capital expands it then creates in its uneven path a surplus population which is both a condition and a consequence of the development of capitalist production.[15] In industrial economies, historical and technological developments in the process of capitalist expansion meant that this population was gradually and adequately, although not totally, absorbed. But in underdeveloped economies, capitalist expansion has been much more limited so that the dispossession of direct producers from their means of production has not necessarily been followed by their employment as waged workers. As a result their numbers have come to be over and above that necessary for a reserve pool of labour for capital.

What is unique to underdeveloped economies then is the magnitude of that population and how it is generated by capital expansion and accumulation. In underdeveloped countries, the working class, or the class of labourers totally dependent on wages, is a relatively small proportion of the population; the more substantial grouping is a mass of impoverished people consisting of peasant smallholders in agriculture, landless agricultural workers, and of workers engaged in pre-capitalist production relations in both urban and rural economies. The class relation of capital to labour is played out within relations of profit extraction that do not involve wages, relations that reproduce cheap or unpaid labour-power and a marked sexual division of labour. The social structure of these countries has been characterized by the marginalization of the peasantry, the widespread displacement of rural populations to cities, and the large-scale international migration of labour.

The specificity of capitalist expansion in underdeveloped countries is traceable to factors both within and outside the nation state and both historical and contemporary. My understanding of the capitalist process in the Philippines is that it is a specific, qualitatively distinct form of capitalist development, a legacy of colonialism that continued to be reproduced first by import-substitution and then by export-directed industrialization, and, in recent years, by the accelerated pace of international capitalist expansion. The working of political and eocnomic forces on international and national levels has resulted in the uneven development of the country and divisions among its peoples. This development, encapsulated in the concept 'underdevelopment', is shared by a number of countries which have experienced roughly similar relations and conditions.

During an earlier expansive era of capitalism, surplus capital in the now

industrial/dominant countries (most of Western Europe, the USA and later Japan), was invested in the Philippines and other countries (in Asia, Africa, and Latin America) where it could obtain higher than average profits. As it intervened in these countries, surplus transnational capital restructured the production process and redirected it to serve its interests: it revolutionized some phases of production and tapped only those resources which were to its advantage, resulting in the uneven development of these economies. An international division of labour based on unequal exchange was established as a consequence of this intervention: goods requiring smaller quantities of labour from the dominant countries were exchanged for goods requiring greater quantities of labour from the colonies. By means of these operations, transnational capital laid the foundations for the specific incorporation of colonies into the global market and for its own dominance within it. And as transnational capital incorporated an ideology of gender, it also laid the foundations for a specific sexual division of labour.

Transnational capital penetration into the colonial economy was carried out by means of alliances with members of the local ruling class. These alliances were at once functional and contradictory for the class for, although broad class interests were served, as transnational capital continued to intervene, a large part of the surplus was not captured by the local economy but instead was redirected to foreign economies. Capital which was crucial to the industrialization process was not reinvested into the local economy.

The colonial legacy left the country largely dependent on cash crops and unprocessed raw materials for a substantial part of its revenues and a low-productivity agricultural sector and small-scale traditional manufacturing sector with little scope for expanding national income. The local landscape was characterized by a diversity of capitalist and non-capitalist relations of production and forms of labour subjugation.

In the (neo)-colonial period, dominant forces at the global level continue to structure the economic development of the nation state. The political economy at the world level, actualized by class practices of dominant bourgeoisies, the political and economic policies of dominant states, and the activities of international entities – multinational corporations, international banks and multilateral institutions – are now locked in an ongoing asymmetrical relationship with the political economy at the level of the nation state, actualized by local class relations and the policies of political regimes.

The appropriation of surplus value has intensified as the pace of transnational capitalist expansion and accumulation accelerates. The recent agents of expansion, the multinational corporations, are not integrated into the local economy and have a preference for expatriating profits rather than for reinvesting for local capital formation. The latest forms of capitalist expansion have created a new international division of labour in order to maximize profit; with fragmentation of the production process, labour-intensive operations have now been carried out in economies with an abundance of low-paid labour. This new division of labour is novel in its preferential recruitment of specific groups of women.

As transnational capital, in alliance with a collaborative faction of the local ruling class, maintains its dominant presence in the local economy, it reproduces the social and economic conditions for the creation of a large surplus population. The surplus population continues to expand, wages remain at subsistence or barely subsistence levels, and the majority population is impoverished.

Many of the members of this pool of labour work in the most dehumanizing conditions in a variety of poorly paid and unpaid tasks which serve capital accumulation both in the reproduction of labour-power, and in the production, realization, and consumption of commodities.[16] Surplus value is appropriated through mechanisms other than the direct exploitation of wage labour: directly, by way of the underpricing of marketed goods or services produced by small-scale producers, whether in rural or urban areas; and indirectly by way of channelling the household work of the surplus population into the reproduction of cheap labour-power.[17] Women engaged in the reproduction of the labour force, in subsistence production in agriculture, in semi-proletarianized petty commodity production and in casual–seasonal waged work in the industrial sector have come to constitute the larger numbers in the surplus population.

In summary, capitalism develops within a specific constellation of class and gender relations at local and global levels, it absorbs and releases women's labour differently from men's labour and women's productive work increases and decreases as it reacts to the demands made by the household. The differential absorption of women and men's labour is rooted in the merging of an ideology of gender, a male dominant sex–gender system, a pre-existing sexual division of labour and factors particular to capitalism – a wage-labour system and the separation of home and workplace. In the resulting sexual division of labour and separation of spheres, women become defined in relation to their responsibility for the home and economic dependence on a male wage; men, in relation to their responsibility for the public sphere, their role as household head and their primary right to work. When women enter the economy, their work is valued in relation to their subordinate position within the gender hierarchy.[18]

Since the sexual division of labour has not been spontaneously generated by capitalism, therefore, a proper study of gender and political economy must consider the place of this division within the broader context of hierarchical gender relations.

The sexual division of labour involves not only the satisfaction of material needs but also the satisfaction of non-material needs – the psychical and the sexual. In the satisfaction of these non-material needs, men as a group also exercise prerogative. Men have command over women's labour as well as control over their sexuality and this dominance is expressed in an ideology of sex and gender embodied in the marriage contract and the family-household system. The control of women's sexuality and the sexual division of labour, then, are mutually reinforcing elements. Their most graphic alliance is in the trade in female sexuality.

3. Sexuality, Ideology and Cultural Practice

Sexuality, like gender, is based on biological sex; and like gender, it is socially and culturally constructed. Biological females and males acquire sexual identities which correspond, more or less, to socially and normatively defined notions of female and male sexuality.[1] Sexuality is, as with all other social behaviour, learned, acquired, and formed within human relationships and derives from concrete personal and social situations.[2]

Sexuality therefore is not a thing-in-itself, a category detached from the social matrix. It is embedded in a network of social relationships; it affects and is affected by social, political, economic and religious factors. As social construction, then, sexuality is not simply a question of who wants sex and of what sort but also about what one is made to want and allowed to do. The sexual is as much political as it is physical.

The meaning of sexual relations varies in time and context but no matter what the variations in meaning, a sexual relation, as a social relation, is a power relation. It is within this relationship of power that women and men live out their sexuality and that men control women's sexuality.

The social construction of sexuality

Sex between a woman and a man is seen as a natural thing. After all, in order to survive, a culture must reproduce and sexual intercourse is the (usual) way. And if sex is going to happen, both women and men must have some propensity for sexual behaviour.

Now it is taken for granted in our culture and in most other cultures that this propensity is different in women and men. It is held to be in the nature of men to have sexual urges and of women to have sexual attractiveness; that is, for men to 'demand' sex and women to 'supply' it.[3]

In fact, however, sexual propensity has little to do with nature. The evidence across the social, behavioural and physical sciences tells us that sexual propensity and sexual practice have more to do with ideological atmosphere than with genetic differences. The observable differences between women and men in sexual–genital excitability, thresholds of arousal, and the types of sexual stimuli or erotic imagery to which women and men respond are more directly

related to differences in socio-cultural and sexual experience than to hormones.[4]

The reason for the different expressions of sexuality in women and men, therefore, lies in cultures; since the social context has come to support the dominance of men, sexual practice has come to centre around the gratification of male sexual needs. The sexual dominance of men is expressed in the ideology of male sexual needs: men as socially and sexually dominant people have the right to demand sexual satisfaction from women. The moral rule associated with the relational aspect of the ideology is the double standard: for a man, having sex with someone other than one's spouse is giving in to his sexual urge; for a woman, it is a betrayal of husband, family, home life and ideals of motherhood. The root of the double standard, then, is the male claim to female sexuality in the institutions of marriage and the family.

Marriage and the social relations between women and men which flow from this contract give men a privileged command over women's labour as well as the exclusive right to women's sexuality. But while wives may expect and require reciprocal payment for their labour with a share in their husband's wages, wives cannot expect, much less require, reciprocal sexual exclusivity over their husband's sexuality. The institution of marriage and the family rests on a monogamous, subordinate female and the naturally promiscuous and dominant male.

It is often argued that the essence of the double standard, and therefore the need to see women's adultery as a crime, is the potential confusion over progeny. The correct transmission of property is contingent on the woman's chastity, while a man cannot impose illegitimate children upon his wife. This is a compelling explanation but has application only to the propertied classes. Yet the standard applies as well to non-propertied classes. The double standard therefore derives from something more than the fear of illegitimate children, since if there are no children, there is no confusion.[5]

Fundamentally, female chastity has been a question of the property of men in women. Virginity is seen as a valued commodity in a commercial market; girls who lose their virginity are no longer valuable or saleable in the marriage market. The double standard views women as the property of men; that the value of this property is immeasurably diminished if women have premarital affairs, or prospectively, extramarital affairs; hence, the high value set on premarital virginity and on marital chastity.

Yet if society sets a premium on women's chastity, how are male urges to be satisfied? Some women had to be set apart and made available; these women were the prostitutes. The double standard, like prostitution, then, is a reflection of the place of women in society in relation to men. The value of women varies according to the extent of women's function as sexual beings and this function is to cater to the sexual needs of men. With the double standard, chastity is the essence of female virtue, with prostitution, promiscuity; one is a virtue for marriage, the other, for outside it. The important ingredients in the sexual relations between women and men, therefore, are the property relation and the right of men to demand sexual satisfaction from women.

The property relation and the satisfaction of male sexual needs embodied in the ideology of differential sexuality have had varying elaborations in specific periods in Philippine history, which shows that the sexual autonomy of women and men was gradually transformed into a situation where female chastity was inordinately emphasized and male proclivities openly tolerated. But in recent years there has been a simultaneous relaxation of sexual norms and an increase in female prostitution. These broad shifts in sexual meanings and expressions derive from a multiplicity of factors: colonization, religious impositions, the emergence of wage-labour relations, specific economic and political projects of the state, and particular social movements.

Sexuality and social change

In precolonial Philippines, a subsistence economy with a relatively fluid social structure and division of labour, sexuality was relatively freely expressed. In many communities, chastity was not considered important either for women or men. It was also unlikely, given the kin-based organization of these communities, that women or men had sexual relations with people they did not know. Extramarital relations, however, were a subject of concern and were considered improper only for women, indicating an emerging male control of female sexuality within marriage. Among ranked communities, male sexual prerogative coincided with the formation of hierarchies of economic and political power: privileged groups practised polygyny and concubinage.

Colonization both reinforced and revised sexual practices and meanings. As the economy was reorganized, poverty was created. Women who were dispossessed of their means of livelihood were forced to sell their labour and if unable to sell their labour, sold their bodies to strangers. But in so far as most women were still able to farm, to work as independent artisans, or to offer their labour for adequate pay, prostitution was not widespread. Moreover, as a service it was dependent on structural and demographic conditions. It was usually confined to areas where there was a demand for it, such as military camps or frontier areas which had large numbers of unaccompanied men.

But the labelling of non-marital sexual relations and prostitution as deviant behaviour had largely to do with the intersection of gender relations, religion and ideology. Colonization of the Islands was accompanied by a strong religious element which redefined the sexual life of the Filipinos. Colonization contained a Western sexual ideology, a Judaeo–Christian view of sexuality, which was imposed in a variety of ways. Prominent in this view were the connections it made: procreation was the primary purpose of sexuality and sexuality was tied to morality so that sexual relations outside of marriage became 'sinful'. Sexuality had become tied to morality and chastity became very important.

Male-dominated culture and religion, however, emphasize the purity and chastity of women while acknowledging the baser drives and desires of men. Society was faced with a problem: it was bound to uphold marriage and family

but at the same time it acknowledged the sexual urges of men; it had to find a way to gratify the latter without sacrificing the former. The solution that emerged was to divide the women: the 'good' women, the wives and mothers, and 'bad' women, prostitutes and mistresses. Bad women were to satisfy the sexual and other needs that men were unable to satisfy in a legitimate or 'sacramental' marital relationship with good women. In a word, married procreative sex was virtuous sex; while sex for pure pleasure was illicit sex.

A whole code of sexual behaviour arose alongside these shifts in sexual meanings. From the prime insistence on women's chastity, there emerged a host of social restrictions on the conduct of women: sobriety was expected, and so were modesty, bashfulness, submissiveness and all other 'feminine' virtues. Ultimately such conduct was regarded as springing not merely from the usages and conventions of society, but from the fundamental attributes of female nature itself.

The double standard resulted in a highly exaggerated view of the 'natural' differences between the sexes. Women and men began to be defined differently as sexual beings; men's bodies were defined differently from women's bodies; men were subjects, women objects; men were driven by lust, women by love; sex was a privilege which gave men self-esteem, but a duty for women and a denial of self. The sense of duty in women and the attitude of privilege in men, who regarded sex in marriage as primarily for their benefit and satisfaction, led women to take on an attitude of passivity. A cult of motherhood grew, idealizing women's sexlessness and their passion for 'mothering'. And these differences were experienced by women and men in their everyday lives: women of every age got along well enough having only a fraction of the sexual experience of men, and when women and men did engage in non-marital sex, it was a matter of degradation for women but of conquest for men. Sex had become the area in which the systematic inequality of power between women and men was played out.[6]

The male sexual urge became an expression of male privilege and rounded out the Filipino 'machismo' complex of expectations: extensive pre-marital and extra-marital sexual involvement, demonstrations of male fertility through the early and rapid production of children, negative attitudes toward male contraceptives, a dominant manner toward women, disdain and disregard for domestic responsibilities, disapproval of their wives engaging in paid work outside the home, and emphasis on physical strength (and often, violence) as a means of settling disagreements.[7]

The sexual dominance of men found support in the economy and polity. The simultaneous restriction of female sexuality and tolerance of male sexual activity were supported by changes in economic organization. Along with economic differentiation of the population, there arose among those who owned the means of production the need to correctly identify their heirs. Maternity is almost never in question in this transmission but paternity is often difficult to trace. Hence, there was a need to ensure that offspring were the legitimate heirs and this led to an inordinate concern for female chastity especially among the propertied classes. As a more extensive control of

women's sexuality was deemed necessary, the sexual ownership of women by men became locked into the state's inheritance and property laws.

The regulation of female sexuality by religious and political forces continued to be expressed in different ways through the years and it waxed and waned, and varied in intensity according to social class. The practice of the double standard and the ideology of male sexual needs were weakened by some political and economic forces and strengthened by others. Although intensified by the growth of capitalism and the influence of the middle classes, it was not entirely derived from these phenomena.

Ideological definitions of sexuality found reinforcement in the ideology of familialism and of notions of gender attributes for certain types of work. These meanings figured prominently and continue to do so in sexual relations, the sexual division of labour and everyday life.

The realm of meanings

Ideology is the realm of meanings. Ideologies are meanings which enable individuals to make sense of the world around them. Patterns of these meanings, as they are lived by social individuals, constitute a 'way of life', a culture.[8]

Ideology is socially determined yet remains unconscious in its determinations. It is a taken-for-granted sphere of social life but an ideology of sex and gender, as any other, is an integral part of a gender-organized social world. It gives meaning to roles women and men play within the social totality. Ideology is lived experience: women and men as individual subjects are produced and reproduced within this experience. An ideology of gender is lived through consciousness, motive and emotionality in a continuing process of producing, challenging, reproducing and transforming meanings in a gender-based social order.[9] Ideology then is not static nor unchanging; it shapes people's lives but people in their day-to-day existence live the ideology: they act to maintain, modify or change it. It takes many forms and varies in intensity among different classes and social groups.

But ideology does not simply happen; a dominant ideology of what is normal, natural and desirable is intertwined with dominant interests within the social system. Ideology as process, therefore, is a dynamic representation of social, political and economic conditions and the place of gender within these conditions. Ideology, like its material connection, is characterized more by unevenness and contradictory unities than by constancy and homogeneity; but it is these very contradictions which provide the basis for cultural and ideological resistance and transformation. It is within this view of ideology that we begin to understand the ongoing interaction between ideology and material life.

An ideology of gender was built into the historical construction of the division of labour and the reproduction of labour-power in capitalism. The ideology of gender, manifested as an ideology of familialism, involved the

assignment of appropriate roles for women and men within the household and outside of it.

A gender hierarchy informed the production process itself. The ideology of gender decided the type of jobs, the grade of work, and the wages workers received. Work and who did it was based on perceptions of the different abilities of women and men; one group became suitable for certain trades but not for others; men got the better jobs because they were men, and the jobs that men did were in any case considered better than those done by women. Women entered servicing and caring work and such other work which was deemed low skilled and was low paid.

The ideology of gender and its many expressions are reproduced by means of a number of processes and a variety of structures, institutions and agencies. Ideology is reproduced by means of stereotypes, compensation, collusion and recuperation[10] and through such agencies as the family, the state, the educational system, the church, mass media, and through arts and literature.

The process of stereotyping involves the rigid formulation of femininity and masculinity which is daily reproduced in child-rearing practices, textbooks and religion, and at community water pumps, the work-place, the school. But it is the mass media which is extensively and vividly engaged in the reproduction of extremely limited roles for both women and men, but especially women, roles which are often far removed from reality. For the media, women are no more than dutiful housewives or the sexual objects of men.

The process of compensation elevates the 'moral value' of femininity and feminine nature. The role of wife–mother is seen and experienced by women as a glorious and noble calling; the home of which she is 'queen' as an inviolable haven. Women are compensated by being held up as moral exemplars and rulers of the home because women have been eased out of the sphere that really creates value and gives power, the world of work.

The process of collusion is the process through which women internalize their subordination. Women not only accept their role in life, they actively prepare for it by affirming their femininity through behaviour considered appropriate to their sex.

The process of recuperation is the process by which agencies in society negate and define challenges to dominant meanings of gender. Different institutions and agencies have accommodated changes in women's position and the demands of women by redefining meanings, neutralizing challenges and co-opting women themselves.

The processes involved in the ideological reproduction of gender indicate that the relations between the ideology of gender and specific structures, institutions and agencies are often a reciprocal and reinforcing cycle. Formal education and informal training systems channel women and men into courses deemed appropriate to their prescribed social roles. The church defines women's roles and the boundaries of female sexuality: it juxtaposes ideal madonnas and undesirable whores. And the state sees to the modelling of a particular relationship between domestic life and the work-force.

But of all these agencies, the state more than any other occupies a distinctive

role in the reproduction of ideology: because it is not only reflexive, it is regulative, and often repressive as well.

State and ideology

The state is commonly viewed as a neutral arbiter among conflicting interests, relatively autonomous from the interest of social groupings. With respect to gender, the state, it is argued, is 'gender-neutral' or 'gender-blind' in its behaviour. In this view, women implicitly become an interest group within a pluralist setting. As social relations between the genders are challenged, so is state behaviour towards gender. Therefore, if sufficient representation is made to the system by a women's movement, the state can become a tool to transform or improve women's status.

In fact, however, the state is the structural expression of the totality of social relations. Far from being a disembodied structure, the state is both a determined and a determining part of this totality. It both emanates and expresses power, but this power is constituted elsewhere, primarily in patterned relations between social groupings.[11] These relations are fundamentally relations of inequality, of dominance and subordination by one group over another and consist principally of relations of production (or class), gender, race and ethnicity. The sources of these inequalities, at any given historical moment, are multiple. Class, gender and race-ethnic relations therefore are patterned, historically constituted relations of inequality which are played out in the state.

The state as an expression of the totality of dominant and subordinate relations is therefore driven by particular interests. In gender relations, that interest is fundamentally male.[12] The state creates the social order in the interest of men as a gender, through its legitimizing norms, substantive policies and as it relates to civil society. The way state behaviour and policy is framed, then, is the way the masculine point of view frames an experience. In brief, the state embodies the social dominance of men, and this dominance defines the state's behaviour towards women. It views women as members of households headed by men; as half of a conjugal pair where their labour is commanded and their sexuality controlled by men; as part of a productive team where their work is as unpaid family worker or subsumed under the male; as a member of a primary group, the family, where their main task is to take care of husband and children, while husbands go out to earn wages; and as part of a work-force where their work is seen as supplementary to survival and therefore justifiably paid at a lower rate than men. The state support for a specific family-household system and of women and men's role within it cannot be understood apart from the ideology of gender.

But the state does not merely reflect and articulate with gender relations; it also actively constructs gender divisions and monitors, enforces, regulates and sanctions the relations between women and men. The state reproduces gender divisions in a form that has the force of legitimacy behind it. The state enforces women's subordination through the workings of the law, and the

dispensing of justice. The state sees specific people as possessing the right qualifictions for access to political power and economic resources (the right to vote, the right to work); it defines what is illegal (harassment of female prostitutes) and what is 'tolerable' (reluctance to pursue their 'customers'); it decides what is the scope of state intervention (public violence) and what is not (domestic violence). And the state regulates sexuality by encoding the double standard of what women and men are allowed to do.

State and ideology are two of the variables and interlocking structures that figure in the relations between women and men. As they converge with the sphere of production and the realm of the sexual they then become a more systematic network of relations that impinge on the work that women and men do. The material, the sexual and the ideological come together in the sexual division of labour.

The sexual division of labour, sexuality and ideology

The discussion of the multiplicity of variables and interlocking structures that bear on gender relations, sexuality and work brings out important connections and implications in the relationship of the sex–gender system to the broader social system.

First, a specific sex–gender system and the social organization of sexuality are not reducible to any one determinant, political or economic; nor can it be said the particular gender and sexual relations are simply there because a certain economic organization of society demands it. The manner in which gender and sexuality come to be organized transcends economic and political relations: it is shaped by these relations but is not defined by them.

But certainly the sexual and the material spheres are connected. From women's relegation to the household with wage-labour relations emerged the notion of women's proper role: women were naturally suited to housework and childcare and were naturally equipped with the attendant virtues of passivity and receptivity and a passion for mothering. This role is the context of the dominant features of female sexuality–passivity, subservience and maternalism.[13] The dominant features of female sexuality are also the dominant features of women's recruitment to the work force: the concentration of women in feminine servicing work, such as nursing, teaching, domestic services and prostitution.

Second, gender pervades all aspects of work, extending way beyond the allocation of tasks. The creation of opposing categories of female and male work, within the production process itself, and the establishment of a hierarchy of jobs affect women's and men's everyday experience of factory and work life. Women and men have different experiences of work in the kinds of work performed, the way orders are given, the degree of control over time and space, even to the extent of controls over going to the lavatory.[14]

Third, the institutions of marriage and the family are crucial to the sexual and social control of women. The institution of marriage has varied in meaning

and form historically and culturally, as has the meaning, structure and composition of the family household. But in whatever form or composition, marriage and the family have become contradictory for women. While these institutions make human physical survival possible and can lead to rewarding relationships, they are also institutions within which men exercise direct power over women.

Fourth, developments in the social organization of sexuality represent a continuing struggle for control between women and men of many aspects of women's lives. This struggle includes the control of women's reproductive capacity and modes of sexual expression. The struggle for control of women's fertility between men, the state and religion on the one hand, and women on the other, goes on. For women, the issue is to be able to decide when and if to bear children; for the state, the issue is expressed in terms of population control, with its broad connections to economic growth, while for the Church, control of fertility by artificial means is a sin. While there is some convergence of interests between the state and women (better and legal contraception and sterilization) neither the state nor religion supports women's right to control their own fertility.

The issue in terms of the sexual division of labour is the role of children. Children's role in the family household has been a source of contradiction for women, particularly women of poor and working-class households: on the one hand, additional children represent more income earners and more workers in the household; on the other, children increase the burden on women domestically and having many children is often at the expense of women's health.

Fifth, the sex–gender system has varying meanings for specific groups of women. These meanings are filtered by means of class as well as by age, marital status and a woman's stage in the life cycle. Access to economic resources can lead to a heightened sense of a right to sexual choice while the lack of it can lead to the sexual servicing of men within and without marriage. But a country's economic deterioration puts limits to women's options as more and more women have less and less access to social and economic resources.

Part II:
The Sexual Division of Labour in the
Philippines: precolonial and colonial legacies

4. The pre-Hispanic Period

This account of the historical intersection between sex and political economy begins with pre-Hispanic Philippines. This chapter looks at pre-Hispanic society, the changes wrought by colonialism and the continuities flowing from the persistence of Filipino culture. Changes and continuities are never simple, cause and effect, phenomena; they are admixtures of ideology and the material, accommodation and resistance, class and gender.

Social arrangements

At the time of the Spanish conquest in 1521 the population of what was to constitute the Philippine Islands was about 750,000.[1] The inhabitants of the Islands, later to become known collectively as Filipinos,[2] lived in widely scattered, ethno–linguistic communities of extended kinship groups. These communities were economic units engaged in subsistence production. Some groups were primarily shifting cultivators, hunters and fishers; other groups practiced wet-rice agriculture. Land was not privately owned and cultivation was by use-right. Communities were self-provisioning units, producing only what they could consume and hardly had any surplus.

Women's work in shifting agriculture involved gathering root crops or going out with the men to fish, while men hunted and fished. Among those groups where rice agriculture was more developed, men cleared and ploughed the land and built walls around the fields while women planted and harvested crops and worked with men in other tasks connected with crop production. In some mountain groups, women were the primary agricultural producers and men were not always available to work; men had to be on the alert to defend the communities from attacks by outsiders, or they themselves raided other villages.

There was no separate class of artisans, but both women and men were engaged in crafts production. Women wove, spun and dyed cloth as their major productive activities outside of farming. They also made pottery, processed food and extracted oils. Some women exchanged these products for other goods. A number of coastal communities traded with merchants from neighbouring islands and China.

Women's reproductive work consisted of cooking in earthen stoves, cleaning the house, washing clothes by the river, gathering firewood, fetching water from the well, and all the other tasks needed for the maintenance of the household. They also raised chickens and pigs and kept a vegetable garden. Men helped in some of these tasks. There was generally a complementarity of tasks between women and men in the household economy; but women performed the bulk of reproductive tasks while both women and men did productive work.[3]

The social divisions in these communities were neither elaborate nor rigid. Some communities were still in a communal state; others already had hierarchies, particularly those which had come under the influence of Islam. Rulers, in the person of chiefs, existed but their position was based more on personal attributes than on a system of exploitation. The chief was the administrative leader of a group composed of nobles (which included immediate relatives of the chief), freeholders and a dependent population of debt peons. Both freeholders and debt-peons rendered labour service or produce to the collective, represented by the chief. Peonage was by no means permanent; release from this dependence was possible by paying back debts, usually in the form of crop harvests. In some cases, women and children were sold or given as reparation for damages or payment for debts.[4] Since communities were also kinship units this form of servitude was 'generally benign'.[5]

The surplus produced from the labour of debt-peons was wealth in this type of economy. Thus, the number of working dependents a chief or noble had roughly corresponded with the amount of surplus in the household. These surpluses were used by the community for rituals and distributed in times of lean harvests.

Women who belonged to the family of the chief shared most of his privileges; however, they could either inherit the position only in the absence of male heirs,[6] or not inherit it at all.[7] Women in other social groups had similar rights and obligations as the men of the group. Women of lower rank provided services, for example, weaving, for the chief's household.

Kinship was determined bilaterally so that lineage was reckoned through both male and female lines. Historical accounts also point to a bilineal system of inheritance, which meant that both males and females inherited equal parts of the parents' property or use-right. In most cases the share of the inheritance was apportioned to children only at the time of their marriage. Where primogeniture was practised, the eldest child, male or female, inherited slightly more than any of the others.[8]

Women and men married in order to set up households as production and consumption units. Within the kinship system, a marriage was as much an institution for cementing kinship ties as it was for consolidating wealth. It was customarily arranged by parents although the final choice was still left to the couple; but people normally took spouses from the same social group. The practice of marrying people of comparable positions or similar resource-ownership meant that some control was exercised by the community and kin

over marriage.

Women were the valued people exchanged in the marriage transaction. The groom, depending on the extent of his resources and that of his kin, paid bride-price or provided bride-service to the bride's parents. Marriage was an arrangement that lasted as long as harmony prevailed, and divorce was socially acceptable and could be obtained by either party. However, because of the exchange of resources, relatives of both bride and groom had a stake in the stability of the union. Bride-price was either kept or returned depending on the circumstances of the separation.

Chroniclers noted the economic independence of Filipino women. Women had their own purse and were also custodians of the conjugal purse. The wife could acquire property, often own and administer it, and dispose of its produce without her husband's consent.

Monogamy was the common form of marriage but in areas where Islam had penetrated and in coastal regions which had frequent contact with Chinese and other foreign traders, concubinage and polygyny were practised. These practices were found among the Tagalogs and Pampangans in Luzon, the Warays in the Visayas and among Muslims in Mindanao and in other areas.[9] Keeping concubines and having multiple wives were practices associated with wealth: chiefs and nobles usually had more than one woman. Since marriage meant that men had to render bride-price, extra wives meant a diffusion of male wealth. When men desired sexual access but did not want to diffuse their resources, men acquired concubines. Ordinarily, concubines were women of lower status, while extra wives came from a similar social group as the men. Women added to the wealth of men because the increase of workers in the household meant an increase in the productive or labour resources of the unit.

Sexual relations were not confined to marriage so that premarital sexual relations were not rare.[10] Chastity was not valued by either women or men in most communities.[11] One account notes that women made it a point to have as many lovers as they could in this life because these men would then give them a hand in the journey to the afterlife.[12] Prescriptions for marital fidelity, however, fell more heavily on the wife. In some communities infidelity by either husband or wife merited roughly equivalent punishment but in other areas, if the husband was at fault, only fines were imposed, whereas unfaithful wives were more severely penalized. In some cases, if the husband was at fault, the bride-price was not returned, but if the wife was unfaithful, it was customary to return double the bride-price. Offences against men, then, were considered doubly serious.

There was a close correspondence between family size and the number of people the land or resources could sustain; the number of children a woman had was tied to the productive viability of the household. In a subsistence economy this meant small families. Infanticide as a form of population control was practised in some areas.[13]

Animism was the religion of the early Filipinos and the propitiation of evil spirits and the holding of other rituals entailed the presence of religious intermediaries (*babaylanes*). These intermediaries were predominantly older

women, although some reports say that men dressed as women also performed rituals.[14] *Babaylanes* were largely part-time religious functionaries and diviners as well as healers, astronomers, and interpreters of culture. Although this group did not constitute a separate professional priestly class, as religious intermediaries do today, and had no extraordinary rights or privileges, it appears they were an influential group.[15]

Gender relations: some observations

Gender relations in pre-Hispanic Philippines, it seems, did not consist of an uncomplicated complementarity of roles, as is often asserted, but of a complex set of gender-differentiated and autonomous spheres. There were spheres where women exercised some autonomy and other spheres where men's dominance was already in place. In the sphere of production women were workers in their own rights and were not dependent on men for their own survival; they had control over their labour and the fruits of their labour.[16] They also shared many productive tasks with men, although men did not uniformly share in women's household work. Women also had control over the number of children they had.

Women were also prominent in the cosmological system as religious intermediaries, although not, it seems, as deities. But political options were not freely open to women: economic inheritance did not discriminate against women, but political positions were either not available to them or theirs only on condition of the absence of male heirs. Political leadership was said to require masculine prowess because chiefs were called upon to lead raiding parties against other villages.[17] If status was the result rather than the determinant of a certain way of relating and exchanging with others,[18] then women were precluded from certain relationships. If a person's status derived from the ability to elicit the respect of others, then some avenues were not available to women by custom. The political sphere was not open to women.

Women, like children, were used to pay the debts of the household. Women were also the object of the traffic in marriage: they were exchanged for a price, to establish alliances, or for service, to set up household production units. Women's sexuality was in some measure regulated: marital infidelity was a more serious offence for women. But ideas about premarital sexual conduct did not seem to discriminate between the sexes and it is reported the unmarried women exercised their sexuality freely. The regulation of women's marital sexuality meant that marriage gave men control over women's sexuality. Sexual regulation among ranked groups indicated a concern for inheritance, whether of wealth or social position. The practices of concubinage and polygyny among privileged groups indicated a merging of a social and sexual hierarchy. The connection of sexuality to economic resources is also evident in the separation of concubines (lower-ranked women) from other wives (same-ranked women). In either situation, men were able to appropriate the labour of women.

In pre-Hispanic Philippines, then, men had social and sexual privileges; but women exercised some autonomy in production and in ritual domains. Thus, male dominance may have been normative but it was neither extensive nor systemic. Male dominance varied among the scattered communities and in some of these, social rankings intersected with a gender hierarchy to emphasize its consequences. There was no extensive political apparatus to regulate the activities of women and men, only kinship-based alliances where custom, more than a codified set of laws, prevailed. Custom sanctioned or censured the activities of women and men.

Spanish colonization was to gradually transform or reinforce social, economic and political practices: in some instances profoundly, in others superficially. Gender differentiation was to figure prominently in this transformation. Filipino reactions varied by sex and social position and ranged from negotiation to tolerance to outright rejection; and frequently mixtures of all these.

Indigenous ideas about sex were altered by colonial prescriptions which contained a male-dominated Christian view of sexuality. At the same time that colonial economic and political activity disrupted Filipino society, large numbers of unaccompanied colonial men also created the conditions for prostitution.

5. The Philippines under Spain: the first centuries (1521–1750)

Political and religious colonization

By the mid-sixteenth century, Filipino communalism had begun to disintegrate. Spanish colonial policy hastened this disintegration and imposed a Europeanized class structure on the emerging class formation.[1] In this new system, chiefs, and therefore males, became the intermediaries of Spanish rule, reinforcing the local practice of male prerogative in political affairs. Throughout the Spanish colonial period, women had no formal positions in the political administration of local affairs.

Spanish *conquistadores* established permanent settlements in much of the Islands; the major exceptions were parts of the southern island of Muslim Mindanao, which fiercely resisted Spanish intrusion, and the mountain regions in the North which were relatively inaccessible to colonial influence. The Spanish Crown carried out a policy of colonial administration in line with its mercantilist motives. For the first 100 years, Spain ruled by means of the *encomienda*, an administrative unit established for the purpose of exacting tributes and taxes from the Filipinos. Communities were assigned annual quotas of produce. Tributes were exacted initially only from unmarried adult men and from families, thereby redefining the basic unit of the social structure towards the nuclear form and away from the extended kin group, and giving men but not women formal ties to the polity.[2] Adult men were required to serve 40 days each year in a labour pool to perform public works; but women were also required to perform such work. Although women as individuals were not subjected to tribute, they were, as members of communities, forced to work to meet production quotas and to render unpaid labour as farm workers. As with the *indio* women in Spanish America, Filipino women also provided free services in convents; they pounded and husked rice and sewed garments for the priests.[3] Thus with tribute and draft labour, Spanish colonization gave more weight to men as individuals and to men's activities; men became heads of household units which paid tribute and male more than female labour was drawn into colonial activities and given recognition by the colonial power.

Spain attempted to create a free labour force but the inadequate resources of the Philippine settlement became a formidable obstacle.[4] Thus, the labour of Filipinos frequently went unremunerated and produce went unpaid.

Colonial exactions on the population meant that produce was extracted from a community that had little or no surplus and this produce went to the support of a group of people who did no work at all. The effects of these demands were exacerbated by the exigencies of Dutch war on the Islands and of encounters with the Muslim Filipinos of the south. Spain commandeered rice supplies and recruited men as shipbuilders, rowers and soldiers. Forced labour took away many men from the villages, although some men fled to the mountains to avoid draft labour, resulting in much hardship in the communities left behind. Women, children, and old men were left to do most of the work at home and in the fields; but the long months of absence of able men led to severe shortages and, finally, the abandonment of fields. By the end of the sixteenth century, as a result of these colonial exactions, many women and men became 'vagabonds'; some women became prostitutes.

The most fundamental economic change that took place in the first two hundred years was the introduction of the concept of absolute ownership of land. Religious orders gained control of large tracts and transformed agricultural practices into more intensive sedentary farming. Land became a source of wealth and its private ownership, a premium. Gradually, other privileged groups – the local chieftain class (*principalia*), Spanish officials, Chinese merchants and *mestizos* – also acquired large estates by means of purchase, foreclosures and outright appropriation.[5]

Spain's colonialist motives were not strictly commercial, though. The conversion of the natives to Catholicism had a prominent place in Spanish designs on the Islands. Indeed, it was the Spanish clergy rather than the Spanish civil officials who were more vigorous in their penetration of the interior. The clergy served civil functions and thus became the 'principal apparatus' of colonization.[6] Evangelization occupied a role of considerable importance in the consolidation of Spanish colonial rule.

The task of consolidating the people into compact villages (*reducciones*) fell upon the clergy. Resettlement made colonial administration and surveillance as well as religious conversion easier, but was against the interests of the local population. The Filipinos continually resisted this movement because they needed to live close to their means of subsistence: to farm, fish and hunt. Local opposition delayed the process of early urbanization and eventually induced a compromise: a municipal organization revolving around the *población-barrio-sitio* system.[7] The notions of 'government', state power and hierarchy of political administration soon became part of the everyday lives of the Filipinos. The reorganization of village life in terms prescribed by Spanish and Church law divided the population into discrete categories, redefining the nature and boundaries of women's activities.

Religion was to have different consequences for women and men. The content of religious ideology laid emphasis on the Virgin Mary as handmaid and mother, an emphasis which is said to have held her up as an ideal role model for women.[8] This was reinforced by the special attention paid by the clergy to the Holy Family, particularly the Mother–Child bond, a bond which was to have implications far beyond sex roles. In time, religion gave Filipino

women, who were becoming increasingly disregarded in community life, the sense of belonging to a colonial community. Religion became essential to many women's lives.

Women figured prominently in the work and lives of the Spanish friars, too. Because they competed with the clergy's role as religious intermediaries, *babaylanes* were quickly discredited and were called witches (*bruhas*).[9] Friars also concentrated their initial missionary efforts on chiefs, women and children[10] – partly for a practical reason: Filipino men were recruited for outside work and were often absent from the villages.

The Church attempted to do away with many Filipino sexual practices. The clergy objected to the bride-price and bride-service as a form of bartering and selling daughters; they also saw the practice of bride-service as condoning pre-marital sex. The Church discouraged polygyny but Filipino men resisted this and those other aspects of religion which required them to make personal sacrifices. However, the clergy themselves in part created obstacles to Church unions. Consensual unions were more common because priests imposed marriage fees which the Filipinos could not afford to pay.

The clergy also tried to regulate sexual behaviour in more pointed ways. As colonial exactions increased, women, in towns and cities especially, found it more and more difficult to survive from their productive work or from the fruits of their labour. Some became prostitutes, mistresses and vagrants. As their number increased, they became the object of regulation by Church and State. 'Undesirable' women were either housed in convents or public jails[11] or deported to the frontier region of Palawan where half of the population was made up of soldiers, sailors and convicts.[12] The view that undesirable women were elements of disorder and were social outcasts underpinned the institutional surveillance of women.

The clergy themselves, however, were not above soliciting (*solicitaciones*).[13] Parents (but it seems not of the chieftain class) were also reported to have encouraged their daughters to become the mistresses of friars, since any children that issued from these unions were well-provided for by the priests.[14] While such liaisons – evidently not unheard of in Spain – were against what the clergy preached, in the eyes of the Filipinos they were not reproachable.[15] These women, as one observer wrote, were 'privileged housekeepers'.[16] Nonetheless, some friars were known to have sexually abused Filipino women and some Filipino men were known to have offered their wives or daughters to the clergy or Spanish officials in expectation of material rewards or favours, to pay off gambling debts, or to maintain their 'vices'.[17]

For Spanish officials, on the other hand, Filipino women were mistresses more than wives, since marrying out of one's culture restricted entry into social and economic opportunities available only to 'pure' members of the conquest society.[18] But there were only few Spanish women in the colony. To redress the demographic imbalance, Spain attempted to enforce the order for officials to take their families with them and to give monetary incentives for this purpose throughout colonial rule.

The reactions of Spanish men to Filipino sexual behaviour, particularly

women's behaviour, ranged between outrage, discomfort and approval. Women, they noted, had the tendency to mingle 'freely' with the *conquistadores*.[19] Filipino women as a whole were 'modest' but many were far from 'chaste'.[20] In some communities women were given to premarital sexual relations and had many lovers.[21] Filipinos did not know the meaning of 'love', and were therefore 'licentious' and 'immoral'.[22] Some women in Manila were prostitutes; but 'they were modest and prudent, unlike European women who would walk and solicit loudly in the streets.'[23] On the other hand, women were 'ordinarily virgins' before marriage.[24] They did not give the 'liberty of their body (or affections) freely'[25] (although this could also have meant that women had to be paid); or that 'scarcely will one find a (Tagalog or Pampango) woman who will put her person to trade.'[26]

Varying reactions to women's behaviour may have derived from contact with different ethno-linguistic groups and were, in time, reinforced by the uneven impact of colonization and the plurality of sub-regional social and political developments. In any case, however, Spanish cultural representations of gender and sexuality were in stark contrast to Filipino meaning and practice. Historical evidence points to sexual permissiveness as the norm in Filipino communities and sexual access for exchange may have been customary in relationships between 'lovers' or 'sweethearts'.[27] And far from not knowing the meaning of 'love', the Filipinos simply defined it differently.

Whatever meanings the Filipinos gave to the sexual, however, were changed by the Spanish clergy. One channel of change was the confessional. Participation in the sacramental life of the Church was a key element of Spanish evangelization. Penance was one of these sacraments and its practice in confession was one of the more dominant modes of 'discursive exchanges' between Spanish missionaries and the Filipino converts.[28] As a guide to an examination of conscience of the Filipino penitent, Spanish missionaries wrote confession manuals.[29] The Spanish missionaries' view of sexuality that is contained in these manuals establishes the direct connection between 'sin' and 'sex'. The sinfulness of non-procreative sex was clearly established in these colonial–Filipino exchanges.[30]

Thus, while the official Church position was to similarly regulate the sexual behaviour of women and men, a configuration of factors came together to enforce standards of chastity more forcefully on women. Monogamy with concubinage prevailed because Filipino men, already exercising a sexual prerogative in Filipino society, had difficulty accepting the notion of conjugal fidelity and the permanency of marriage, and also because the male Spanish tutors themselves, religious and lay, for cultural and demographic reasons, had difficulty adhering to their own teachings. The practice in Catholic Spain of restricting female sexual behaviour and tolerating male sexual activity found expression in the behaviour of Spanish officials and priests in the Philippines. Filipino men were also frequently absent from the villages, which meant that the clergy did not have as sustained an influence on them as they did on the women. The outcome of this configuration of factors was the double standard.

Religion as a way of life also attracted both Filipino women and men. Men

were trained for the lay brotherhood and by the eighteenth century, more for lack of Spanish priests than for any other reason, Filipino men were admitted to the priesthood. Women's religious aspirations were accommodated rather belatedly by their acceptance into convents (*beaterios*), but this varied according to social position. Ordinary Filipino women who wanted to join first had to be servants, supplying the manual labour while sharing in the community's 'spiritual benefits'.[31] Filipino women eventually established their own *beaterios* but these did not have, as did their Spanish counterparts, the heritage of mendicancy. Filipino *beatas* were said to have earned their keep by the 'labour of their hands'[32] – although this meant in part doing domestic work for the male clergy.

The Church had different plans for Spanish women. It attracted a considerable number of the Spanish female population to its *beaterios*, replicating in the colony the Hispanic practice of removing women from economic and social involvements. But the Church also performed social services for the female Spanish community by provisioning dowries for the poor among them.

The practice among the Spanish of removing women from the public sphere laid the ideological foundations for a pattern of behaviour for Filipino women. Women's removal from the public sphere came to be, in colonial society, synonymous with wealth and prestige. The cloistering of women came hand in hand with the Spanish notion of education for women: women were to learn only religion and homemaking skills. To Spanish authorities and the clergy, the numerous limitations on, and prohibitions against, what colonial and Filipino women might or might not do, reflected the Spaniard's view of the role of women. This role centred on two basic institutions: the family and the Church.[33]

The Chinese in Philippine life

Another foreign element also began to figure more prominently in the lives of Filipino women at this time. Chinese traders had increased in number in the colony and had extended their commercial activities. These activities brought them into constant contact with the women traders: but, as well, the Chinese began to encroach on the trading activities of the women, although women were not usually engaged in long-distance commerce. Women handled the trading within the locality but Chinese goods had begun to make their way into these exchanges. Chinese contacts with women traders, along with the near-total absence of Chinese women in the Philippines, contributed to the rising number of intermarriages. By the eighteenth century, the children of these intermarriages, the Chinese *mestizos*, began to exert considerable influence on the commercial activities of the Islands.[34]

Filipino culture predominated in most of these intermarriages although some Chinese patriarchal traditions must have been a source of conflict in these marriages.[35] Children were raised as Filipinos and Christians, and Filipino

practices such as women's larger share in the allocation of household finances, not a practice in Chinese culture, were probably not drastically curtailed.

Many of the Chinese, as did the Spanish, lived in Manila, the centre of colonial activity. Manila had become the commercial and religious capital of the Islands and residence to the small Spanish population of merchants, functionaries and heads of religious orders. Manila was the entrepôt in the galleon trade between China and Mexico and this brought in some commercial activity.[36] The city prospered from this trade but this prosperity had little to do with the development of the national economy, as Philippine products figured minimally in the galleon trade. Manila's development as a metropolis isolated it from most of the countryside.

Manila had a number of paid labourers – those who worked for the Spanish officials and religious and Chinese merchants. These workers were exempted from draft-labour service and may have been the only Filipinos who paid tribute in money. The suburbs of Manila had quotas of female domestic servants for the convents but these women were not normally paid.[37]

The prosperity of Manila attracted large numbers of Chinese, although they did not confine their commercial activities to the city. The Chinese went into the towns and villages distributing imported merchandise to the natives and gathering, in turn, local products which they sold to the Spanish. In this activity the Chinese became the connection between the foreign and local economies.

There were some centres of commercial activity outside of Manila, where wealth had begun to accumulate from trade with the Chinese. Many of these had to do with women's productive activities. In Bulacan, a province near Manila, about 4,000 women were engaged in weaving and spinning cloth and making hats, some of which were exported to other countries. In Batangas, a nearby province, there were 3,000 looms operating in five towns; in Northern Luzon, around the Ilocos area, the making of cotton sailcloth was a fairly widespread activity; in Quezon Province and in the Bicol region, women wove mats and *abaca* cloth; and in the Western Visayas, Iloilo province had begun to be famous for its fine *piña* cloth, made from pineapple fibre.[38] Women's weaving activity was extensive and in some measure the reproduction of the system was dependent upon this activity. In areas where weaving activities were part of the household economy, women assumed a large part of the burden for the support of the household. Where weaving was the main support of the household, the burden for the survival of its members fell on the women. Weaving was an independent activity of women and thus they were far from mere auxiliaries of their husbands.

The penetration of the Chinese into the Philippine interior hastened the breakdown of indigenous economies and social structures. But in the first two centuries of Spanish rule, their economic presence was felt more in communities near Manila, where declines in population were observed because large numbers of Filipinos had moved to the city to enter domestic service, or provide such services (including prostitution) as the Spanish required. In these communities, people began to buy rice from the Chinese instead of planting it, so that rice production fell; women weavers sought other occupations as the

Chinese undermined the market for local cloth with cheaper imported textiles. Farmers had abandoned their fields and women their looms to work for wages in the city.[39]

Colonization, gender differentiation and Filipino responses

Throughout most of the first 200 years of Spanish rule, with the exception of Manila and its immediate areas, most of the Philippines retained a largely subsistence economy. Land was used primarily to supply the diet needs of the household and a small non-producing colonial population. The social division of labour was still simple. Communities in the countryside were basically self-provisioning units where life centred upon family and village according to tradition and custom. Only a few were paid cash wages so that barter was the predominant means of exchange. These exchanges, however, became increasingly unequal as foreign commodities – products of more advanced technologies – brought in by the Chinese were exchanged for the mainly handcrafted products of the villagers.

Other types of labour had become differentially appropriated according to gender by the colonial rulers. There was little division between household and social production but there was differential value placed on women and their activities: women's services for the Spanish – such as their labour in convents – were never intended to be paid for, unlike men's services, which only became forced labour because of the inability of the Spanish Crown to pay wages. There was, as a consequence, an unlimited appropriation of women's labour by the Spanish clergy and colonial ruling class.[40]

Colonization also changed the value placed on land itself and on men's work on the land. What emerged was that even though both women and men could inherit land and both worked on it, land became more closely tied to men because men initiated the labour process, giving them effective control of the land. This valuation gave men prominence in the economic sphere and reinforced male privilege in political administration.

The basis for the ideology of differential worth placed on women's and men's work (and on women and men as people) seems to have been implanted by the colonial power, although in some areas it was superimposed, on to an existing set of differential values. In precolonial society these were placed on people depending on their sex, based on tasks they performed, but there is little evidence that women were seen as inferior persons. However, colonial gender ideology is based on the notion of the inherent inferiority of women. Women in Spanish culture were not thought of as being particularly intelligent people; subjects which were 'unworthy' of the serious attention of well-informed people (that is, men) were *es cosa de mujeres*, things appropriate for women.[41] Indeed, the political apparatus embodied this ideology: Spanish law regarded women as the inferiors of men.[42] In the case of married women, the law severely circumscribed their rights and made them subject to their own husbands. Such laws probably affected women of the *principalia* classes and those in Manila

and large towns and cities more than those who lived in the interior and the countryside, but they served to define the boundaries of women's activities.

Thus, male prerogative in the sexual and political sphere was extended to the social and economic with the devaluation of women's worth and the denigration of women's work. Men's dominance and women's subordination had begun to be more generalized. A state structure was now in place to impose the domination of men as a group.

Filipino reactions to colonial impositions varied: the chieftain class accommodated colonialism primarily because their social positions were maintained; other groups engaged in sporadic rebellion, while still others lived outside the colonial administration and formed their own alternative communities (a few led by *babaylanes*, now a role played by men). But the majority of Filipinos lived in a culture of accommodation and resistance. One cultural framework of resistance was the religio–political movement. These movements took the form of religious societies or *cofradias* (brotherhoods, historians are given to saying) which were organized by clerics initially as sodalities to further reinforce evangelization efforts.[43] *Cofradias* were composed of both women and men or exclusively of one sex, male or female, bound to each other by an understanding of the socio–political situation in which they found themselves.

Religio–political movements recontextualized the twin impositions of colonialism and Christianity by forming an ideology which connected individual salvation to ideas of kinship bonds and political liberation. The Mother–Child bond between Mary and Jesus played a key role in this recontextualization. The *pasyon*, songs of the Passion and Death of Jesus Christ, and later the *awit* (songs) became the language for expression of grievances and a mirror of collective consciousness. Many of these songs were also preoccupied with the primordial bond between mother and child. These songs no doubt served to impress more deeply on the Filipino women their role in family life. But this bond also had subversive meanings. As the Child Jesus grows up there is the eventual separation because He has to carry out His 'Mission'. Filipinos saw in this Mother–Child separation many possibilities of separation: the separation from their own families to join societies and the separation from Spain, the mother country.[44]

These societies and the movement in general made little distinction between the sexes in their memberships and rituals and in their sporadic armed struggles against the Spaniards. Women were said to have carried arms in these encounters. Spanish priests reported that there was sexual license in these societies, but these are deemed by present-day historians to be unfounded because, it is argued, licentiousness was contrary to the codes of these societies.[45] Nonetheless, women were known to have been treated as sexual objects in these societies: young single women were used as instruments to prove the sexual potency (read power) of their leaders.[46]

By the second century of Spanish rule the differentiation by gender of much of the population had become more systematic. Religious and political forces were at this time more prominent in the process of differentiation. Although

these forces were not monolithic they had nonetheless become pervasive. The sexual privilege of men was reinforced with the emphasis on female chastity that attended the Christian, male-dominated view of sexuality. The double standard of sexuality and morality became a feature of Filipino sexual practice. The political privilege of men was endorsed by the colonial apparatus as they became intermediaries of colonial rule; the political sphere remained closed to women. The installation of a colonial state reduced people to discrete and hierarchical categories: men were household heads and women attached to men were subservient to them and lumped together with minors and other non-responsible categories of people. Women's productive work that came under the scope of colonial administration was valued differently from that of men; service work especially was rarely paid, very much unlike men's work which, in so far as the colonists were able or willing, was paid.

In those areas of the economy that the colonists had not yet sufficiently exploited, such as subsistence agriculture and cloth production, women and men still retained some degree of autonomy. However the reorganization of the economy from one of communal ownership of land to one of absolute ownership by individuals had begun to divide groups into more defined social classes. Among women and men there had emerged a division according to wealth and, in colonial society, its corollary of race.

Towards the third century of Spanish rule the Philippines had five principal social strata: the Spanish from Spain who ran the administrative and religious functions of the government: the Spanish born in the Philippines and the Spanish *mestizos*; the Chinese *mestizos*; the Filipinos, divided into the *principalia* and the labouring population; and the Chinese. Of these groups, the Chinese and eventually the Chinese *mestizos* – as the former were periodically restricted, expelled or massacred by the Spanish – played the most energetic role in the transformation of the Philippine economy.

Women as members of each class had different interests. Spanish women hardly had any social or economic involvements; Spanish *mestizas* and some members of the Filipino *principalia* class, in emulation of the pure-blooded Spanish, also had little to do with activities outside the home. As a Western male traveller noted of these women, 'they pass three-fourths of their time with maids around them, sleeping, lolling and combing their hair.'[47] In contrast were the bulk of Filipino women who did both reproductive and productive work for their own and their household's survival.

6. Spain's Last 150 Years: the development of export crops and the commercialization of the economy

By the late eighteenth century, political and economic changes in Europe began to affect Spain and the Philippines. England had been transformed by the Industrial Revolution into the strongest capitalist nation. Its commercial hegemony included the subordination of the Spanish empire, which extended to the Philippines, quickening the pace of the Islands' integration into the global economy.

Spain reacted to events in Europe by reorienting her colonial policy. She attempted to develop the country's agricultural resources and to widen the Islands' commercial contacts by opening the country to foreign trade. Spain encouraged the production of cash crops such as sugar, tobacco and *abaca* (hemp). Although some of these efforts were regional in character, the development of export crops profoundly affected Philippine economic life.

The connections to the global market destroyed the natural economy of the regions and led to a regional specialization of crops. The production of cash crops (tobacco in Northern Luzon, abaca in the Bicol region, and sugar in Western Visayas), together with the commercialization of rice production and the emergence of a national marketing system, meant the integration of women and men producers, at first to a national market, and eventually to a global market. These developments laid the foundations for the separation of reproductive and productive spheres and the marginalization of women from economic life.

The tobacco monopoly

The tobacco monopoly was established in 1781 primarily to raise revenues for the colony. Tobacco was a local crop and was popularly used by Filipinos, women and men. Spain took advantage of this widespread use by imposing a monopoly.

Tobacco was a very labour-intensive crop requiring constant care and its production was, for the most part, undertaken by women and children.[1] Preparing the field for planting was men's work; while all available family labour helped in transplanting. All other tasks were either shared or performed predominantly by women. Family labour, that is, wives and children, removed

worms and pests from the leaves; sometimes this work continued into the night by torchlight. When the leaves were ripe, they were gathered and taken to the shed for drying and curing by the women. This was followed by the laborious and delicate task of selecting and separating the leaves into classes, an operation done exclusively by women. Next, leaves were dampened to give some elasticity and then smoothed out and ironed, all female tasks. Thus, upon conclusion of transplanting, the man did nothing more, leaving the care of the field to his wife and children. At the cutting period the man transported the cut tobacco to the house by waggon where all other work was done by women. Yet it was men who were considered the tobacco farmers and it was men who conducted the transactions with the monopoly.

The work of manufacturing cigars also fell almost exclusively on women.[2] In Manila, as in Mexico, women were recruited for gender-specific reasons. The Inspector General believed the work better suited to women: they were expected to do the work with greater care and perfection and with less risk of fraud.[3] Towards the end of the monopoly in the 1880s there were about 4,000 cigar workers in Manila; as the century drew to a close there were estimated to be about 30,000.[4]

Cigar manufacturing made work which was organized along capitalist lines of production available to large numbers of women for the first time. The manufacture of tobacco took place in factories and their internal organization reflected the principle of division of tasks. Assembly-line functions were specific and line responsibility was practised.[5] Attendance, punctuality and performance were monitored and discipline was maintained. Supervisory, administrative and inspection functions were carried out by men. Work was performed for about ten hours each day and pay rates, paid weekly, depended on the duties performed and the type and quantity of articles produced. In the 1850s many women earned the equivalent of from US$6 to US$10 a month.[6]

Work and working conditions in these factories recall present-day 'sweatshops'. Women sat on mats in groups of 800–1000 in large rooms[7] where, as one traveller described it:

> One party selects, cleans and moistens the leaf; a second cuts; a third rolls; another packs them; and thus they are passed through a variety of hands before they are completed . . .
>
> Others hold in their right hand a flat smooth stone with which they keep continually pounding each leaf, in order to make these more susceptible of being rolled up. This drumming noise and the cries of several hundreds of workwomen, who, on the appearance of foreign visitors, handle their implements of stone with yet more energy, apparently out of sheer wantonness, the strong odour of tobacco, and the disagreeable exhalations from the bodies of so many human beings shut up together in one closed apartment, in a tropical temperature, have such an unpleasant, uncomfortable effect that one hastens to exchange the damp sultry vapours of the workshops for the fresh air without.[8]

Tobacco-growing households experienced a period of relative prosperity until the last two decades of the monopoly. By 1863, the government began to fall behind in its payments and had started to issue *papeletas*, or certificates of credit, which farmers were forced to cash at a 'ruinous' discount.[9] Eventually, as payments were not made, the monopoly deteriorated into a system of draft labour.[10] Artificial restrictions on the commodity had provoked opposition which took the form of smuggling and brigandry. In addition, anomalies and corruption among local officials continued to cut into monopoly operations and intensified the exploitation of the producers. Thus, the tobacco monopoly had turned into an instrument of colonial oppression in which Filipino *principalia* had an important role to play.[11]

As the last 20 years of the monopoly approached, levels of living in the tobacco provinces had declined considerably. By 1889 the monopoly had been abolished. But abolition was as much a reaction to deteriorating economic conditions, and of the unrest arising from it, as a response to the increasing pressures on the colony towards free enterprise and free trade.[12]

The abolition did not much alter the economy of the area. Men and women continued to grow tobacco and other women carried on their work in the factories, this time under the system of private enterprise.

The growing commercialization of the area arising from the tobacco trade attracted many Chinese. They took over the tobacco market and extended their scope to other commodities, especially textiles. By the 1880s, the Chinese dominated the regional market, especially in the distribution of textiles.

Abaca production

The export of abaca in the 1800s was directed mainly at the USA because of its use as marine cordage for the American Navy. By the end of the century – and this was perhaps its peak period – abaca accounted for nearly 40 per cent of Philippine exports and the Bicol region produced nearly half of the total crop.[13]

The exportation of abaca was the main stimulus in the increased commercialization of the region. In addition, abaca was the source of coarse cloth which the Filipino labouring classes used for their garments. Thus, an increase in abaca production also meant, at least initially, increased production in the women's weaving industry. But the wider commercialization of abaca-growing also resulted in a new activity for women in the region: Church censuses began to record the stripping of abaca, formerly a solely male task, as sometimes now the work of women.[14] Stripping was the most delicate and most arduous operation in the process of abaca-fibre extraction.

Most of the men in the region were occupied in abaca cultivation and stripping. Abaca production, unlike rice, was not seasonal and involved little preparation and maintenance.[15] It did not compete initially with rice production as abaca was grown on slopes and the uplands. Abaca-harvesting teams consisted of a man whose job was to strip the plant and a woman and child who chopped down the plant, cut away the pulp, sliced the *petiole* into

ribbons and hung the stripped fibres up to dry. Abaca was grown on land owned by members of the local wealthy classes and a system of contracted wage labour and share-cropping was the labour arrangement with the producers.[16]

Women were part of the abaca-harvesting teams but they were also weavers. Women weavers were primarily engaged in family or small-scale operations. Domestic outwork was not carried out on any significant scale. In the 1820s Camarines Sur, a province in the region, was one of those areas where there was said to be a 'loom in every house' and accounts in the 1870s noted that the possession of a loom was typical for peasant households.[17]

The 1870s and the years preceding must have represented the peak of the weaving industry. In 1870, in the province of Albay, there were roughly 19,000 women employed in weaving and other handicrafts, roughly 40 to 45 per cent of the adult female population.[18] But by 1903 there were 52,000 spinners and weavers in the region (including 20,000 in Albay) which was just 28 per cent of the women over 15 years of age,[19] showing an absolute increase in numbers but a relative decline in the proportion of weavers over this period.

This decline had its origins in what was becoming a widespread occurrence in the Islands. Commercialization of the regional economy arising from increased crop production attracted more Chinese and *mestizo* merchants, retailers of imported fabrics and other merchandise. The natives exchanged hemp, oil, abaca and other local products for cotton goods and other foreign items. Eventually, these imported fabrics, machine-made and thus lower priced, competed with and displaced the local handwoven fabrics, undermining the weaving industry.

Even in the 1850s when weaving was a prominent industry and one which undoubtedly meant cash payments, it did not earn as much as work usually performed by men. Men who performed field labour (for example, in rice production) received one *real* for ten hours work, and in fact women who worked in the field as planters and reapers generally received similar wages as men. Weaving earned considerably less: if a woman wove abaca to make a chemise, she was paid a quarter of a *real* plus food, but it took two days to make the cloth. Even the most skilful weavers of fine fabrics were paid no more.[20] With such low wages, weaving must have been only one of several productive activities of women.

Women were also engaged in the marketing of fruits, processed food, tobacco, and cloth made from other fibres. Marketing activities expanded as the commerce in the region intensified, but as in weaving, these were largely small-scale activities.

Commercialization also meant growth in the numbers of merchants and bureaucrats who were capable of supporting a retinue of workers.[21] The overall increase in activity began to open up other types of work for the Filipinos. These were mainly oriented towards servicing work (launderers, barbers, seamstresses, domestics) and were heavily concentrated in provincial capitals and larger towns where some commercial expansion had taken place.

Thus, the decline in both employment and production in the weaving industry in the Bicol region can be attributed to three factors: the increased

competition from imported, mainly English, lower priced cloth; the simultaneous availability, though limited, of service employment for women and men arising from the expanded economic activities in the region; and the general prosperity which arose from the commercialization of the region's chief crop.[22]

The weaving industry and sugar production in Western Visayas

In the late eighteenth and early nineteenth centuries, the cloth industry in Iloilo, in Western Visayas, grew rapidly. Iloilo women wove cotton, silk, pineapple and hemp fibres. Only pineapple was grown in the area: cotton came from Luzon, hemp from the Bicol region and silk was imported from China. Within the region itself, there were areas of specialization in weaving from these fibres. The extraction of fibres from the pineapple (*piña*) plant was, like abaca, a laborious process and weaving these into cloth was even more painstaking. The embroidery work that went into the *piña* cloth, one traveller noted, was 'largely dependent upon the Filipina's nimble fingers'.[23] The result, according to another traveller was 'of admirable beauty' which was 'impossible to imitate in Europe because the cost of production would be prohibitive'.[24] Iloilo's products found markets not only in Manila but in China, Java, Spain, England and the USA. These fabrics were very expensive and were worn locally only by wealthy people.

The growth of the cloth industry had a marked impact on several Iloilo towns; it produced the region's first substantial urban concentration as small factories were established, and the earliest recorded capital accumulation among the emerging local urban ruling class.[25]

By the late eighteenth century the cloth industry in Iloilo was already quite developed. Most families possessed one or two looms, but in the majority of the houses of the *mestizos* and wealthier Filipinos, some six to twelve looms could be found. Some accounts note that there were as many as 60,000 looms in the area.[26] If this is accurate, then, about one out of four of the population of 247,307 were weavers and since all weavers were women, then about half of those able to work were employed as wage workers or were independent artisans in the textile industry.[27] Local male contribution to the industry was the growing and processing of the raw fibre – although even these tasks were not exclusively done by men – and the construction of the looms.

The wages of women weavers usually ranged from between the equivalent of US$0.75 and US$1.50 a month (compare this to the wages of a male day labourer in Iloilo of US$0.13 a day, or about US$3.00 a month). A few highly skilled women were employed to set up patterns in looms and were paid between US$1.00 and US$1.50 a day. Chinese *mestizo* merchants practised a form of debt bondage to maintain control of their weavers; many weavers received wages for several months in advance and frequently spent years before paying off an 'originally trifling debt'.[28]

Agents collected the fabrics which women wove and took them to Manila

where they were sold, taken to other provinces, or exported to foreign countries. With profits from these sales, these agents purchased raw materials such as Chinese silk and local cotton and brought these back to Iloilo. Increasingly these purchases included English cloth. Since the agents took their principal profit from the *piña* goods woven by the Iloilo women, mass-produced English fabrics were sold at a relatively low mark-up in Iloilo markets. Within a few years English cloth had undermined the local cloth market and local cloth as an export was virtually eliminated from the area.

At the same time that English cloth was energetically promoted, English interests cultivated the region as a new source of supply for tropical produce: sugar. By the late nineteenth century English cargo arriving at Iloilo carried English goods, primarily cloth, and left with produce, principally sugar.

The Iloilo merchants, forced out of competition by English textiles, transferred their capital, accumulated from the weaving industry, to Negros Occidental across the strait, where they proceeded to acquire vast sugar *haciendas*. The Iloilo towns which depended on the cloth industry went into permanent decline (the total population in some of these towns declined by as much as 40 per cent in less than 20 years) and commercial activity was shifted to the foreign trading ports.[29] Weavers were replaced by waterfront stevedores as the main wage earners in the province.

In the sugar *haciendas*, tenant families cultivated the land, planted the cane, brought the sugar to the mills and received a share of the profits. Before the end of the century, fields had been cleared and tenancy was changed to contracted labour. As in the weaving industry, labour appropriation and control was also by means of debt bondage, assuring a captive labour force. *Hacienda* owners extended extremely high-interest loans, trapping the workers, their children and their children's children in debt.

But dependence on sugar eventually so dominated the economy of the region that not only was cloth purchased but rice also had to be bought. Crop famines in rice were frequent because of the immigration of rice farmers into sugar plantations. Consequently, export profits from sugar went to purchase products – cloth and rice – the region had once produced in quantities sufficient for local consumption and export.[30]

The weaving industry in other regions of the country had also declined so that by 1893, textiles constituted the largest single import of the country, amounting to 33 per cent of total imports.[31] What remained of the weaving industry were those local fabrics used primarily by the local population: these fabrics usually reached local consumers faster and with more variable designs that only hand-looms could turn out. This type of production continued into the early twentieth century.

The commercialization of rice production

As these developments in the export crop economy were taking place, changes were also occurring in staple crop production. In the Central Plain of Luzon

(and perhaps in other rice-growing areas, too) labour-use and land patterns were gradually shifting in orientation towards the commercialization of the economy. Prior to the eighteenth century the *inquilinato* system of tenancy was the dominant feature of lowland subsistence agriculture. In this system, *principalia* and Chinese *mestizos* had leased lands from the friars and apportioned these holdings to sharecroppers.

By the late eighteenth century, the system had been transformed into an instrument of resource and labour appropriation by Chinese *mestizos* and *principalia* to meet the challenge presented by a newly-emergent market economy.[32] Through a series of processes – foreclosures of mortgaged lands by means of the *pacto de retroventa*, loss of titles to land because of ignorance of land laws, and the purchase of royal estates – *latifundia* would reach significant proportions by the end of the century.[33] The *inquilinato* system which represented an alternative to commercial opportunities in an earlier period, had become, in later years, a convenient mechanism by which the ruling class claimed new land on agricultural frontiers in the Central Luzon Plain. In the twentieth century, rice *haciendas* would go through a stage of early formation and extension to a mature phase typified by the consolidation and elaboration of techniques of rent farming.[34]

Labour arrangements changed along with shifts in farming systems. Under traditional conditions of subsistence agriculture, labour requirements beyond the means of the immediate household were met by reciprocal labour exchange through patterns of cooperation among families, neighbours and friends. Harvest time, in particular, placed great demands on labour. In labour-scarce Nueva Ecija, these needs were met by large seasonal migration of families from the Ilocos Coast. Only when the population in the Central Plain was substantial enough to meet labour requirements during harvests did the share paid to harvesters shrink, and seasonal migration dwindle.[35]

The hiring of male and female labour was the earliest sign that a commercial rice economy was emerging in the Plain. The practice of hiring labour became more widespread, especially among *hacienda* tenancies and for such labour as transplanting that was paid for by the landlord. Independent smallholders continued to exchange labour as much as possible. Harvesters were still paid a share of the crop but the economic rationalization of wet-rice agriculture proceeded at a faster pace in Nueva Ecija than in other provinces.[36] By the 1920s, harvest labour was generally paid a wage rather than a share.

But commercialization did not improve the standard of living of smallholders. They were forced to sell their rice harvests to dealers for cash not only for payment of debts but also to meet their general consumption needs.

As frontiers closed, Nueva Ecija became a labour-surplus rather than a land-surplus area. The easiest path by which landowners could increase their wealth was by the acquisition of more tenancies rather than by intensifying land use with the goal of increasing yields. As a result, there was little socio-economic pressure on the peasantry to adopt cultivation techniques leading to higher yields. Nonetheless, there was pressure to increase production: as more lands were planted with cash crops, staple crop production was intensified in

order to provide for the needs of the cash-crop producers.[37]

Thus the real impact of the commercialization of rice fell more upon processing and distribution rather than upon methods of field production.[38] The Chinese merchants handled the marketing aspects of rice, extending their control of retailing and wholesaling functions in the provinces. They established a network of *sari-sari* (general) stores and had a monopoly over the milling process.

Women as members of smallholding households or as agricultural workers lived and worked in the same conditions as the men. They did productive work on their own farms, or on other farms as part of reciprocal labour exchanges, or hired out their labour on an individual basis. In labour exchanges, women also frequently cooked food for the labourers. As wage workers on farms, women generally received wages similar to those of men. The introduction of hand-powered and later of steam-powered rice milling eased the household work of some women because it fell upon them, as part of their household tasks, to perform the arduous job of pounding the rice before it could be cooked. But the price of milled rice limited its use to households with higher incomes.

The emergence of a national marketing system

The undercurrent of all these developments in the export crop economy and in staple crop production was the emergence of a widespread marketing system. Such a system, by the nineteenth century, served to integrate Western, Chinese and Filipino economies.

Prior to the mid–1700s, country-to-city trade was mostly a Chinese activity while barter trade between communities and provinces, and even trade between islands, was principally in Filipino hands. By the mid-eighteenth century a network of periodic markets had evolved, with the functional base and centre for the exchange-market economy located in the *población*. The periodic market (*tiangue*) was oriented primarily to horizontal trade, that is, trade between peasants, and involved mostly women. In these markets women were at the same time buyers and sellers. Often they were producers as well. The women traded items which they had made or processed – salt, dried meat, needlework, woven mats, coarse brown sugar, cloth, blankets and jewellery – for other wares. They also bought and sold rice, tobacco, poultry, fruit and vegetables and exchanged gold which they had panned. These markets served primarily *barrio* people and such horizontal trade as was predominantly done by women was at the bottom of the hierarchy of the marketing system.

Eventually the commercialization of the economy undermined this horizontal trade. Some regions became more specialized in specific crops so that these areas produced less and less for basic needs and increasingly needed to purchase goods – rice and cloth – which the Chinese came to provide through the *tiangue* or through the *sari-sari* store. Larger market transactions came to be handled predominantly by men, by Chinese and later Chinese *mestizos*.

Thus, although the commercialization of the economy augmented women's

trading activities, they were increasingly relegated to the lowest level of the trade hierarchy. Indigenous merchant women, limited as they were more by shortage of capital than by cultural restrictions on economic activity and long-distance travel, lost ground to Western merchant houses and immigrant Chinese retailers and shopkeepers.

A tradition of economic activity largely defined the behaviour of most women so that even those from wealthy groups were engaged in some type of productive venture. Women of the *principalia* class were known to have owned family stores and retail shops in Manila, employing a retinue of hawkers, sellers and cooks. But in time these enterprises were also eased out by Chinese merchants. Female productive activity across classes was simultaneously undermined and maintained by the development of capitalist relations.

Economic change, women's work, and gender relations in the last century of Spanish rule

All through the last 150 years of Spanish rule much of the Islands still retained a largely subsistence economy. Farming, fishing and weaving continued as the livelihood of most Filipino men and women. But few were rarely exclusively engaged in a single occupation. Men were farmers and fishermen but they were also hunters, artisans, livestock and poultry raisers and construction workers. Women were farmers but they were also weavers, vendors and artisans, and they gathered forest and field products, and raised livestock and poultry. Women and men moved from these activities with the seasons, and according to prices and opportunities, engaged in different tasks as befitted their needs rather than neatly confining themselves to employment in any one industry or area.

The local population, except for those who did waged work in the towns and Manila, were largely peasants rather than agricultural workers paid a wage. Peasant-type production predominated in most areas, even those already appropriated by landlords, the clergy and *hacienda* owners. There were few changes in the basic techniques of the organization of agricultural production. Producers remained responsible for a given area of land rather than for specialized tasks. Even in those areas where labour was contracted on a wage basis, this usually combined with a sharecropping arrangement, for example in abaca and rice production. Labourers' wages or shares were paid in advance, an arrangement which frequently ended up in a type of debt peonage and were sometimes accompanied by coercion and abuse. The practice of debt bondage encouraged a relationship of reciprocal obligations of debtor–client and patron–client which to this day defines hierarchical relations in many levels of Philippine social, political and economic life.

The exceptions to the pattern of this subsistence-level production were the regional economies that had come within the reach of the world market. But even in these areas the population almost always continued to be involved in subsistence production.

The situation in the last hundred years of Spanish rule was one of labour scarcity, land surplus and abundant natural resources, so that the struggle to survive was rarely a matter of life and death.[39] But the local population must never have been far from poverty or hunger. It must have been an endless effort to maintain a certain minimal standard of living – food, clothing, shelter and an occasional celebration. The struggle was exacerbated by the continuing transfer of food and food products to a non-producing population of colonials, clergy, Chinese *mestizos* and Filipino *principalia* who owned or controlled the means of production. One sign of worsening times was when root crops, which often served as a hedge against a temporary shortage of rice eventually became, with the rise in tenantry, unemployment and depression, the everyday substitute for it.[40] Women must have increased their household-based activities to make up for these shortages. Shortages and commercial incursions into subsistence production, increasingly became a feature of many regional economies. Many women and men migrated to other areas. In urban areas, particularly Manila, there was a notable increase in the number of prostitutes. Most of these prostitutes had formerly been cigar workers, domestic maids, sellers and dressmakers.[41] Women who were past the 'age of desirability' resorted to begging.

The linking of the agrarian economy to the world market affected village and town life in other ways. There was a marked reallocation of work effort within the household and within the peasant economy to meet world-market demands. There was also a shift from the production and consumption of household-produced goods to the expansion of agricultural production for export and the consumption of imported manufactures.[42] The variety of home-produced goods within the villages narrowed as foreign manufactures displaced them. To pay for foreign goods, self-provisioning gave way to the production of a marketable surplus. As trade and distribution increased, new divisions of labour were also created. In these changes indigenous merchant capitalists joined forces with colonial, immigrant and other foreign interests to redirect peasant production for export.

The intervention during this period of two types of capital, merchant and circulation, had contradictory consequences for women. Merchant capital, like circulation capital, is indifferent to the products it circulates: that is, it circulates products in demand, whatever the basis of that demand. The products it exchanges may be goods in excess of independent producer's immediate needs or specifically produced for exchange under a variety of conditions such as debt bondage or petty commodity production. But merchant capital as capital is driven to accumulate, initially at least, by making profit from unequal exchange ensured by control of trade. The expansion of trade equalizes the rate of exchange, so that part of the merchant's profits then go into this expansion and not that of production. With trade expansion, merchant capital penetrates deeper and deeper into entire branches of production dependent on it.[43] Eventually there is a necessity for increased productivity, 'a reorganization of the labour process, intensification of the social division of labour, and a restructuring of the social organization of

production itself, including relations of production.'[44] Merchant capital itself does not appropriate surplus through the buying and selling of labour-power but through its political control over the product of labour, ensured by its alliance with indigenous dominant groups.[45]

The difference with circulation capital is that the productive process is not a given but is that upon which industrial or productive capital operates. Circulation capital functions simply as an agent of industrial capital and serves to realize the capital invested in industrial production. Unlike merchant capital, it is closely tied to the demands of industrial capital and in the search for new markets for the products of industry it may undermine local domestic industries or destroy whole branches of production in competition with industrial capital. In so doing, circulation capital sets free the producer's labour-time for investment in other activities. If such activities are absent locally, this free labour-time becomes expressed in a redundant population. Industrial capital appropriates surplus labour through buying and selling labour-power. Thus when labour is 'freed' in one region, it may be in demand in another, or where it is freed in one sector it may be absorbed by another.[46]

Merchant capital, on the other hand, brought more women and men into productive activities or resulted in the intensification of their labour.[47] There was an increase in trading activity as more goods were sold, as more women became traders, or as women traders put more time into trading. More rice was sold in the market as a result of the expanded capacities of both the milling process and the distribution system. The production of cloth increased by drawing more women to weaving or by women putting in more hours at the loom. Export demands for tobacco led to more land cultivated and more hours devoted to tobacco production. But the conditions under which these goods were produced varied: from subsistence agriculture in rice, independent production at the looms, debt-labour in weaving and the tobacco monopoly in the closing years. Surplus was thus captured by the merchants primarily from control of the trade of the products of the peasant economy. The expansion of trade should have also benefited women traders but this was not the case. The commercialization of the economy expanded trade activities but women remained at the lowest levels of the trade hierarchy.

Circulation capital, on the other hand, led to the decline of the weaving industry and to the simultaneous development of sugar *haciendas* in Negros Occidental, and to commercialization arising from increased abaca production in the Bicol region. Circulation capital which undercut the local weaving industry in Iloilo became industrial capital for sugar production in another community, Negros Occidental. In the Bicol region the weaving industry was undermined, also by competition from imported cloth.

But there was a difference in the social relations of production. In the Bicol area, weaving was primarily a family or small-scale operation; in Iloilo, the link to the wider national and foreign markets precipitated a growing population of waged workers in weaving. Thus, although in both cases women weavers had become 'free', that is, obliged by economic necessity to sell their labour-power, the economic conditions of that release had different consequences for them.

In the Bicol region, the increased production of abaca afforded a measure of prosperity to farm households and weaving may have in time taken on a supplementary role. Prosperity and attendant changes in consumption patterns hastened the replacement of local cloths by cheaper imported textiles, easing out the cloth industry. In addition, the commercialization of the region generated other economic activities which absorbed some of the women released by the cloth industry, although this labour was oriented primarily to servicing, as, for example, laundry work and domestic service in the urbanizing economy or taxi-dancing in Manila.[48]

But in Iloilo, weaving was not adequately replaced by other productive work. Women's economic alternatives were adversely affected as the region's economy was transformed from one based on tertiary cloth manufacture to primary production of sugar. The population of the weaving centres declined rapidly through the rest of the century as the cloth exports declined. What then became of the women weavers?

Waged work that opened up in Iloilo involved principally male labour at ports. Labour that was recruited to clear the land in Negros Occidental was also mostly male. Sugar cultivation and production was largely a male enterprise. One can speculate what happened to the women weavers. Many of them must have continued to weave cloth for home consumption or for exchange on a small scale – but weaving was probably on a part-time basis since there was no longer a great demand for local fabrics. Others may have moved to Negros Island with the men to help in clearing the fields for sugar production. Some may have moved in with households of Chinese *mestizos* as domestic help. Perhaps, as in the Bicol region, other work became available in other parts of the province but in any case these were not numerous because commercial activities had diminished. A few may have gone to Manila to do servicing work, including prostitution. Women of smallholding households probably re-allocated their labour to the farm.

But many women no longer had access to productive work. These women became a redundant population and were largely relegated to household work since other productive activities which opened up did not absorb them. For these women, the decline of the industry had dire consequences: the loss of income from productive activity resulted in a general decline in their and their household's standard of living and this was especially true of households they headed. This deterioration was more acute where women's production was the principal source of income as was the case in Iloilo and also in the Ilocos provinces. Women's weaving industry was far from a supplementary form of income in these two areas: in fact in areas where landholding was largely fragmented and agricultural conditions were poor, the income from women's handicraft work sustained large populations. Hence, the loss of the weaving industry fell heavily on those who were least able to afford it.[49]

In terms of gender relations, it is not clear whether the release of women from weaving to other work led to an improvement in women's condition. Weaving may have been low-paid work and a laborious, arduous task but some women may have preferred it to work on the farm (which often went unpaid) or to

servicing work. For domestic outworkers weaving also meant a labour process which had to fit in with their reproductive work: as a household-based activity, it blended with household routines. Whatever work replaced weaving, its decline certainly was a net loss for the women because whether for home consumption or for exchange, weaving was independent productive work and the work which replaced it infringed on women's personal autonomy. Thus women weavers fell from the status of independent producers to unpaid workers in the family or paid workers who had neither control of the proceeds of their labour nor command over the production process. In this sense, women's economic position declined absolutely and relative to men when they abandoned, or were forced to abandon, their looms.

How did all these developments in the economy affect women's household work?

At this stage of capitalist development, much of women's productive work was still part of the overall household economy. In most areas, subsistence farming and domestic handicraft production were still integrated. It is unlikely, therefore, that systems of productive and reproductive labour were clearly separated throughout most of this period, except perhaps in the case of the cigar makers, weavers paid a wage, service workers and urban waged workers.

Moreover, productive work for women was not rigidly structured. Instead, women (and men) moved in and out of several types of work as was demanded by the economy. In peak seasons in agriculture, most labour was on the farm, and women who were independent weavers had to set weaving aside. During the off-season, women went back to weaving or traded some of the items they had processed or made while men moved into construction and other types of public works. But since agriculture was the basis of life in most of the countryside, work syncopated with the rhythm of the crop.

Expanded demands in agricultural production also meant that women and men put in more work on the farm. Since growth in production occurred with very little technological innovation, particularly in rice, more time was invested on the farm and more household labour was needed to work there; women were drawn away from weaving. But increased use of labour also meant that children, already part of household labour, became more important workers. Thus, the social conditions were laid for the importance of family labour and for large families.[50] With these developments, emphasis began to be placed on women's childbearing capacities, and the greater value placed on children eventually led to greater emphasis on women's mothering role.

Looking after children and maintaining the household did not initially conflict with the productive sphere as the organization of production and the labour process remained at the level of the household or village, and production retained a certain flexibility. Kin, older children and the elderly were also occasional child-minders. In this context it was unlikely that many women were engaged solely in domestic work; women's work was needed in a largely labour-scarce economy and there was hardly any surplus among the labouring population.

However, the increase in productive and reproductive activities did mean

increasing strains and burdens on women. Women carried the burden of reproductive work and were much more preoccupied than men: tending to the children and weaving by day, and pounding rice to remove the husk by evening, or planting or harvesting rice by day and selling their wares in the market-place by torchlight at night.[51] Male colonial observers noted that Filipino women were more 'industrious' than men, and had little leisure; while men had time for cockfights, cards, drinking and gambling – often with their wife's meagre earnings.[52]

Towards the end of Spanish rule the transformation in production relations, combined with developments in the international economy, led to a reorganization of social and economic life. The restructuring of the local economies away from self-provisioning and the encouragement of specific products, destroying some branches of production and fostering others, brought about radical social changes. Social differentiation among the local population increased. What had developed was a class of people who no longer had access to these means and were therefore forced to sell their labour and another class of people who owned the means of production and were able to buy this labour and make profit from it.

Thus, it is no longer proper to talk either of the Filipino population or of women as homogeneous categories. The emergence, with the agricultural export-crop economy, of a Filipino propertied and wealthy class meant that there was now a local group which had begun systematically to exploit the population. The people of this class had frequent interaction with the Spanish bureaucrats and Western merchants. Sons, but not daughters, of these classes had the advantage of education abroad. As the material base made it possible, women of this class took on the behaviour of European bourgeois women and withdrew from productive work and from the public sphere. Within this configuration of wealth and property arose, as well, the accentuation on legitimate paternity: a more extensive control of women's sexuality was necessary to determine legitimate heirs. Women's sexual behaviour, already regulated by religion and colonial practice, became even more circumscribed and their social behaviour was restricted to family life. Men's greater personal control over property was translated into an increase in power over their wives.

About 40 years before the end of Spanish rule, a book of manners appeared, directed mainly at the Tagalog propertied classes. *Urbana at Felisa* included a set of prescriptions defining the sexual behaviour of Filipino women and men.[53] Its defined audience was, for the most part, wives and mothers as nurturers of the young and as source of emotional and spiritual security. The meaning of marriage and the function of the family as laid out in the book reveal a sexual practice which had taken on Hispanic and basically Western meanings. Daughters should be taught to fear God, to take care of their virginity and to be modest so as not to be taken advantage of by men. Women should be taught to keep house and to love the home because, according to the Bible, the fortunes of the household lay on their shoulders.[54]

Married women were to devote their lives to family and home. A married woman is subservient to the man who is the head of the household. She should

serve her husband and look after his needs; she should be self-sacrificing and should bear with her husband's faults. Little is said of married men except that they are in charge of financial security and, like their wives, teachers of values to their children.

The embodiment of the women of this class was Maria Clara, a central character in two famous political satires of the time.[55] Maria Clara was the Filipino woman who embodied the Victorian ideology of the bourgeois lady. Centuries of economic, political and religious impositions had transformed the lively sexual assertiveness of Filipino women into a more prudish, cautious image of womanhood.

The sexual and social behaviour of women of the labouring classes was not as circumscribed as women of the propertied classes but they were no less objectified as sexual beings. The institutionalization of private property in the hands of men as landlords, colonial authorities and *hacienda* owners also led to the treatment of women workers as their sexual property. Landlords sexually abused or raped their women tenants. These cases must have been numerous and serious, since an end to sexual abuse was one of the major demands of tenants in their uprisings in Central Luzon.[56]

By the end of the Spanish period, therefore, economic developments had contributed to the relegation of women's trading activities to the lower levels of the economic hierarchy, the subsumption of their labour to men in export-crop agriculture, and the release of women's labour, as work in weaving declined. Although women were part of work-teams on farms, and even invested more time in farm production, agriculture had become a male-dominated sphere. Men were integrated into the modern sectors of the economy as heads of households, as farmers in cash-crop production, or as large-scale traders, while women, together with children and the elderly, were left with household tasks and labour-intensive market work. The manner in which women were drawn into the economy was defined by an ideology of gender and a sexual division of labour.

The Philippine Revolution and the First Philippine Republic

The economic developments in the nineteenth century served to consolidate the scattered communities into a national market and with this consolidation came political consciousness as a nation state. When the Philippines opened up to foreign commercial interests, ideas of liberalism, then widespread in Europe, entered the country.

As these ideas took root among the propertied classes, the foreign-educated young men among them (the *ilustrados*), gave voice to the movement for reforms. These elements agitated against restrictive colonial policies and monastic abuses. By the 1890s, an economic depression had begun to exacerbate grievances: hemp and sugar prices fell, rice was scarce and importation further raised its prices, and the currency had become unstable as exchange fluctuated. The economic conditions of the labouring classes were

made worse by natural calamities.[57]

When, by 1896, the movement for reforms failed, *ilustrado* elements were joined by peasants and workers in the Philippine Revolution against Spain. Women were active in the Revolution but rarely as combatants. Female leaders emerged but they were for the most part relatives of male leaders. Women formed their own groups for the armed struggle; and as in other revolutionary wars in other parts of the world during the period, women played the roles of messengers, nurses, and supporters of what were essentially male-led and male-defined struggles for political independence. But women were also victims: the military conflict gave men of both sides the license to rape women.[58] The Filipino leadership paid little heed to the sexual abuse of its rank and file; and so also did the colonial military officials of their own.[59]

The first Philippine Republic was established during this time but it was short-lived. Although the Republic was supported by the majority of the Filipinos it failed to further their interests because it reproduced the same instruments of dominance and control as that of the colonial power. It privileged the political interests of men as well; its constitution denied women their political rights.[60]

Within a period of four years, the United States had engaged and defeated Spain in the Spanish–American War, overpowered the Filipino revolutionaries and become the new colonial power. Within that same span of time, *ilustrado* alliances, first with Spain and later with the USA, undermined the Revolution.[61] Hundreds of thousands of Filipino men, women and children died in the Philippine–American War and although the war in the provinces lasted for a few more years, the leaders of the Philippine Revolution surrendered to the Americans in 1901.

In the period of American rule, the economic restructuring that had begun in the last century and a half of Spanish domination would intensify, resulting in an even sharper social differentiation within the population. The American period also saw the emergence of a more systematic effort at incorporation, first through superior weaponry and later through the educational system and economic projects, of non-colonized Filipino groups.

7. The Philippines under American Rule: 1901–42, 1945–46

American motives in colonization did not differ much from those of Spain. Stated motives were clothed in altruism, but the real motives were predominantly economic and political.[1] Capitalist development on the global scale was well into its imperialist phase and America had begun to challenge England as the foremost capitalist nation. The Philippines as an American colony served the imperatives of capitalist expansion and accumulation well.

American policy in ruling also did not differ much from Spain: the new colonizers used the local ruling class as intermediaries as well as Filipino men who already possessed political and economic power. As American policy reinforced the dominance of these groups, class and gender structures were preserved. Some *ilustrado* and *principalia* women, in support of their own interests and those of the men of their class, played a role in the 'pacification' campaign of the colonial power.[2]

As in Spanish colonial policy, American political administration had no place for women.[3] As in the Spanish period, a poll tax was levied, initially only on men. Suffrage was granted at first only to propertied and educated men but this was extended to the rest of the male population after a few years. Women were given the vote only in 1937 and then only after women had extensively campaigned for it.

Throughout the period of American rule, manufacturing developed on a significant scale; by 1918, there were about 5,239 factories and industrial establishments as well as sugar and rice mills.[4] Export trade was predominantly carried out with the USA.[5] The number of waged workers increased as did the range of economic activities of women and men. But some sectors released labour; tractors replaced human labour in sugar production and exports of locally manufactured items declined. There was also a marked difference between women's work in household industries and work in manufacturing establishments turning out the same goods in commercial quantities.

During the third and fourth decades of American rule there was considerable inter- and intra-regional movement among the population. This movement was in large part a response to a number of factors: the development of several industries, especially mining and sugar, increasing population pressure and deteriorating conditions in many areas. Manila saw a substantial influx of people from the provinces.

The economic developments which took place during the period stemmed primarily from the intervention of industrial monopoly capital on the local economy.[6] Monopoly capital in the USA was seeking new fields of investment and the export of capital to other countries meant higher than average profits. The Philippines was one of these countries and developments in export crops and the production of mineral and vegetable raw materials complemented production in the USA. Since Philippine production was geared largely towards the needs of American monopoly capital it did little to develop the economy to serve domestic needs. Economic development was highly uneven, encouraging only those areas of production which were of benefit to American interests.

The rapid expansion of commercial agriculture and the generalization of the money economy contributed to the deterioration of landlord–tenant relationships in staple-crop production and of wage-labour conditions in sugar plantations. The surplus from expanded activities in agriculture was captured primarily by American capitalists in alliance with sectors of the Filipino ruling class. Hardly any of the prosperity filtered down to the labouring classes. By the late 1930s sectors of the working population in the urban areas and peasants in the countryside, particularly in the Central Luzon Plain, were agitating actively for changes in the system.

Economic developments during the period had definite effects on women's work and the sexual division of labour. As capitalist relations intervened deeper into the economy, productive and reproductive work became clearly separated and women's independent production was transformed into waged labour at the same time that this production was increasingly undermined. Many women joined the industrial reserve army of labour and were forced to withdraw exclusively to reproductive work.

Colonial sexual prescriptions continued to affect Filipino sexual practice. The sexual behaviour of more and more women came to be defined by a sexuality which was primarily, if not exclusively, geared to procreation and the ideals of motherhood and family.

The Philippines, as an American colony, was drawn into World War Two and from 1941 to 1945 became the arena of conflict between Japan and the USA. Philippine economic and social life was severely disrupted during these years. Under the Japanese occupation there was a pervasive military control of national life and natural resources were exploited for the war needs of the Japanese population. The Philippines experienced a breakdown in social discipline during this period as the country faced inflation, unemployment, shortages of basic commodities, hunger and disease.[7]

My discussion of this period focuses on broad trends in the economic activities of the population and the responses of some sectors to economic developments. I look at trends through an analysis of censuses and surveys of economic conditions, including wages and the recruitment of labour. Filipino responses to American colonial rule for the most part took the form of strikes by organized labour, peasant uprisings and the emigration of workers.

Work, wages, economic conditions and Filipino responses

Economic conditions and the activities of the majority of women and men at the start of American rule are reflected in large part in the 1903 census report. Not surprisingly, the occupations of Filipino women and men were few in number and presented little variety. Factory production was on a limited scale, technology was at a low level, and there was little specialization in function. The majority of men farmed on a small scale, and those living in the coastal areas alternated this with fishing. Women did farm work and traded, but most women in the countryside also wove and spun. In abaca production, women were part of harvesting teams, while in tobacco, women did most of the field and processing work. In Manila and surrounding areas, many women were at work in cigar factories or were engaged in paid services.[8]

The census report states that about 30 per cent of the female population over the age of ten were in gainful employment, while the corresponding proportion for men was about 58 per cent.[9] These figures suggest that the majority of women were engaged primarily in housekeeping and that a good number of men also were not in productive work for most of the year. These proportions were in all likelihood understatements because accounts of the period reveal that, particularly in the case of women, they continued to work on family farms, tended livestock which they later sold in the market, or peddled produce from garden plots. Since these activities were not formally remunerated, they were not considered gainful. Yet women's home production for exchange continued to contribute significantly to family support and, in fact, helped families otherwise dependent on the meagre wage brought in by the men or from produce from marginal parcels of land. Thus labour-scarcity and largely subsistence conditions made it unlikely that the bulk of women were primarily housekeepers or that a good number of men were not gainfully employed.

Subsequent censuses in the American period included housework as gainful employment and called persons engaged in it 'housekeepers', but the shift did not change the social implications of housekeeping. Nor did it alter the position of women's reproductive work in labour–capital relations. Nonetheless, broad trends through the years show increasing numbers of women becoming full-time housewives.[10] In 1903 the proportion of housekeepers between two age groups showed only a slight difference: among women aged 15 to 24, 50 per cent were housekeepers: among women aged 25 to 54, 53 per cent. By 1960, women's withdrawal from productive work was more pronounced: among women aged 15 to 24, 53 per cent were primarily housekeepers, but among women aged 25 and over, the proportion was 70 per cent. (See Table 7.1.)

Occupations

The list of occupations, like that of gainful and non-gainful work, also appears not to represent accurately the type of work women and men did. The large number of women weavers was reflected in figures showing a high proportion of women in manufacturing but the small number of women listed as engaged in agricultural work understated the complexity of women's activities as well as

Table 7.1
Per cent female non-gainful workers and housekeepers to total population, by age, 1903 and 1960

Age group	1903 Non-gainful Workers	1960 Housekeepers
15–24	50	53
25–34	54	70
35–44	53	71
45–54	54	68
55–64	64	66

Sources of basic data: United States Bureau of the Census (1905), Bureau of the Census (1965).

the productivity of their labour. The problem was the insistence that people must belong to one category only (a 'major occupation'). Yet women's productive work, and men's as well, could not be so neatly delineated. In fact, the census report itself notes that 'few Filipinos devote themselves exclusively to one occupation'.[11]

Later censuses made a concession to the situation of multiple employment/ occupation by including the category, 'additional occupation'. This category may have allowed for varieties of work but definitions still failed to capture the integration of these types of work into the economy, particularly since they arose from different relations and forms of production. Nonetheless, a 'major occupation' like 'housekeeper' did gain increasing relevance with the development of capitalist relations.

Throughout American rule, the shifts in men and women's productive work – the increase and decrease of proportions in occupational groups by sex – give evidence of changes in the economy. Sexual divisions in productive work may be viewed in three ways: the proportion of women relative to men within an industry or occupation (per cent of female workers), the number of women within each occupation or industry relative to the total number of male and female workers (per cent in occupation or industry) and the proportion of each category of worker – waged, self-employed, unpaid – relative to the total number of workers within an occupation or industry (per cent of category of worker). (See Tables 7.2 and 8.2.)

Women's share in farm work increased throughout the period in contrast to that of men (Table 7.2). However, the increase in women's work was in two opposite directions: towards waged work and towards unpaid productive work. Proportions of labourers, tenants, and owners in crop production in the 1948 census indicate that the majority of Filipinos (as tenants and labourers) no longer owned the means of production (Table 7.3). This was especially true in cash-crop production: sugar, coconut, and tobacco. Staple-crop (rice and corn) production also showed higher proportions of tenants and labourers. But if such was the overall case, the proportions were much more marked for women as a group and proportions exhibited a gender hierarchy. In staple-crop and

Table 7.2

Gainful workers 10 years old and over, by sex and by occupation/industry, 1903, 1939 and 1948

	Sex and Year								
	1903			1939			1948		
	% in			% in			% in		
Occupation/	Occup./Ind.[a]		%	Occup./Ind.		%	Occup./Ind.		%
Industry	M	F	F[b]	M	F	F	M	F	F
All Occup./									
Ind. (100%)	(1,958)	(1,024)	34	(4,219)	(1,094)	21	(4,120)	(1,082)	21
Agriculture	59	9	7	77	43	13	69	38	13
Professional	1	c	8	2	3	37	2	6	42
Clerical	c	c	c	1	c	c	c	c	c
Mining and Quarrying	c	c	c	c	c	c	3	c	1
Manufact./ Mechan.	12	70	75	9	24	44	6	19	46
Trade/ Commerce	6	7	39	4	9	37	5	13	41
Transp./ Comm.	c	c	c	5	c	c	c	c	c
Services	21	14	25	4	19	55	9	23	61

Sources of basic data: United States Bureau of the Census (1905), Commission of the Census (1941), Bureau of the Census (1954).

a $\frac{\text{Number of males/females in occupation/industry}}{\text{Total number of males/females for all occupations/industries}}$ = % in occupation (industry)

b $\frac{\text{Number of females}}{\text{Number of males and females}}$ = % female

c Less than one percent

Table 7.3

Gainful workers 10 years old and over in agriculture by sex, selected crops and relations of production, 1948

	Sex and Relations of Production											
	Total			Labourer			Tenant			Owner		
	(000)		%[b]	% of category[a]		%	% of category		%	% of category		%
Crop	M	F	F	M	F	F	M	F	F	M	F	F
Rice	1,514	222	13	35	77	24	29	9	4	35	14	6
Corn	496	96	16	34	66	27	31	23	13	34	11	6
Coconut	289	19	6	43	51	48	16	12	5	31	31	6
Sugar Cane	85	10	11	85	92	11	7	2	c	3	3	c
Tobacco	17	4	19	39	85	37	21	6	c	9	9	c

Source of basic data: Bureau of the Census (1954)

a $\frac{\text{Number of males/females in category (labourer, etc.)}}{\text{Number of males/females in crop (rice, etc.)}}$ = % of category

b $\frac{\text{Number of females}}{\text{Number of males and females}}$ = % female

c Less than one percent

tobacco production especially, considerably more women than men were labourers: men were usually the farmers, and women the farm workers (Table 7.3).

Services work was also an area of waged work for women and men. In 1903, 14 per cent of female workers were in services and of this 68 per cent were in domestic and personal services; the corresponding proportion for males was 21 per cent and 12 per cent (Table 7.2).[12] Thus, although there was a very narrow range of occupations, services work was not a substantial category for women. The majority of women in domestic and personal work were launderers rather than household help, prompting the 1903 census report to note. 'It is very unusual for women to be engaged in domestic service outside their own home.'

By 1939, however, proportions of females in services were higher than those of males and the increase continued through the years. By 1948, 23 per cent of women workers were in services, and of this 94 per cent worked as household help while the corresponding proportions for men were 9 and 37 per cent (Table 7.2).

Changes in sex ratios in services work in the Manila work-force during these years were more dramatic. In 1903 some 93 per cent of all female service workers were domestics and this proportion was roughly maintained through the years. What is remarkable is the change in the sex ratio among servants and household help. In contrast to the more balanced sex composition of the occupation in 1903, mid-century proportions reveal an overwhelmingly female category.[13]

The shift in sex ratios in the service sector suggests that while productive work in other areas, for example, agriculture and manufacturing, was still available, women did not enter domestic and personal service work in large numbers. Meanwhile, men's labour could not be adequately absorbed by the formal economy so that men became employed in this type of service work as well. But when work in other services became available in the modernizing sector, men were hired in preference to women. And as women's options for work in manufacturing and agriculture diminished, the women then entered domestic and personal services work, taking up the slack left by men. Within services work, then, men become integrated into a wider range of activities, while women remain in low-paying domestic work. The question of who does paid domestic work then appears to be as much about definitions of women's work and men's work as the capacity of the modern sector to absorb labour, especially male labour.

In the broad category of trade there were many more men involved than women. One likely reason fewer women were listed as traders is that women's irregular vending at subsistence level was not considered gainful work. Through the years more women were reported to be engaged in trading, and proportions increased relative to other female occupations (Table 7.2). But women's trading activities remained at the same level as in the Spanish period – market-vending and tending home-based *sari-sari* stores – while men's trade involved general merchandizing and distribution of dry goods. Expansion in men's activities included waged work, as salesmen, and independent trading.

Professional occupations understandably had the smallest proportions of both women and men. Throughout the American period, proportions of women in the professions relative to men and to other women's occupations increased but this increase concentrated largely on one type of profession – teaching – while men engaged in a broader range of professions. During most of the Spanish period the few Filipinos who were educated to a secondary level were mostly men. Education was heavily religious in character but men were also taught some science and politics, while women were taught home-making skills. As women were needed to educate other women, a few female teachers emerged, but they were lower-ranked.[14] Within American colonial policy, education was a high priority consistent with the need both to have a trained labour force and for the wider dispersal of American values. During this time almost as many women as men were trained as teachers.

The bureaucratic needs of an expanding social and economic superstructure and of the colonial office were met for the most part by male typists, secretaries, stenographers and telephone operators. Such servicing work within bureaucratic, and later corporate, organizations came to be increasingly done by women in the post-war years – a similar pattern to that of men's departure from, and women's later predominance in, domestic and personal services. The character of the work was redefined in the process: secretaries, for example, became handmaidens and office servants and were no longer administrative or managerial assistants. As the sex of the person usually performing a particular job changes so too do the characteristics of the job – its requirements, wages and conditions.

One economic activity which markedly declined was women's manufacturing work. In 1903 and into the second decade, manufacturing was dominated by women as weavers. There were close to one million women (or about 70 per cent of female productive workers) engaged in manufacturing, mainly in textile production (Table 7.2). But by 1939, with increasing demand for foreign fabrics and reduced demand for local cloth and crafts, the proportion of women in manufacturing had dropped substantially to 24 per cent (Table 7.2). Mechanical mills were brought in to make production more competitive but local needs in textiles were never adequately met.[15] The mills also hired men, so that although many women continued to work in manufacturing, fewer and fewer were involved in the machine production of textiles. Other women were outworkers and this type of work was in fact encouraged 'because it enabled housewives to earn family income without leaving the home'.[16] Women and men also began to work in the manufacture of commodities which were emerging as consumer items: shoes, slippers, neckties and ready-to-wear clothes.

Rural industry as a whole continued to decline rapidly throughout the period. Other trends give further evidence of this decline: household industry as a proportion of total manufacturing value added was about 60 per cent in 1903 and only about 13 per cent by 1939.[17] As activities in household-based industry diminished, labour was freed for other tasks. Labour engaged in agriculture expanded, in the case of male workers, from 59 per cent in 1903 to

77 per cent in 1939, and of women workers from 9 per cent to 43 per cent (Table 7.2). Thus much of the growth in the agricultural work-force resulted from the release from manufacturing work of both men and women, but more significantly, of women.

However, the economy was not uniformly able to absorb released labour and sexual divisions in the work-force show the precariousness especially of women's productive work. Women's high unemployment levels indicate diminishing economic opportunities for women relative to men: unemployment among men was 16 per cent, but among women it was 31 per cent.[18] There were also high levels of unemployment among households headed by females (27 per cent).[19]

Wages and incomes

Wages in the 1903 census are, for the most part, not distinguished by sex so that differences have to be inferred from sex-segregated occupations. In general, occupations where men clustered paid higher than predominantly female occupations. Male carpenters, boat builders, tailors and distillers received daily wages ranging from (Philippine pesos) P1.50 to P4.00 while female seamstresses, hat makers, and weavers received wages ranging from P0.40 to P1.50. On the other hand, women and men in tobacco cultivation were paid the same (P0.50) for a day's work.[20]

By 1939, wage differences between women and men were more clearly defined. In agriculture, women labourers averaged 79 per cent of what men were earning, while in the professions, the average was about 62 per cent. In certain types of manufacturing, female operatives were earning, on the average, 60 per cent of male wages, while among managers and officials, women earned only 40 per cent of male wages.[21] In some factory establishments women workers were paid much less than men for similar work. Female employees in textile, cigar and cigarette, pottery, shirt and laundry factories and rice mills were paid lower wages than female and male workers in other factories. Average wages for women in these establishments were as low as P8.00 a month,[22] while average monthly wages for other female workers were P12.00 and for male workers, P37.00.[23]

In rice agriculture, men were paid P0.80 a day and women P0.60,[24] but this work was seasonal. Cash crops paid reduced wages to workers. In *copra* (coconut) production tenant families received only one-fourth to one-third of the selling price of *copra*. In this crop women worked as part of family work teams: they husked and opened the coconuts and dried the meat but they did not commonly receive wages independent of their husbands (or their fathers).[25] Industrial wage earners on the other hand earned P200 a year[26] or roughly P0.74 a day, in full-time employment.

But these incomes were below minimum levels of subsistence. Real wage rates were in fact lower in the American period than in the latter part of the Spanish period. In Manila, four out of five families were on the poverty line.[27] In 1907, average wages in Manila were P1.00 a day; compare these rates with the price of food: one lb. of pork cost P0.80; one piece of bread cost P0.01; and

one lb. of fish cost P0.30.[28]

In the countryside, particularly in sugar production, poverty was more widespread. Sugar production paid male labourers P0.75 a day in peak season (P0.50 during the slack season) and women and children, from P0.35 to P0.50 a day.[29] An annual income per household in sugar was only P185 in 1939.[30] This figure was only 49 per cent of the sum considered adequate for bare subsistence per household.[31] Yet sugar was the most profitable sector of the economy at that time. Sugar *haciendas* were among the richest areas in the country but sugar workers lived and worked in some of the worst economic conditions. The surplus that accumulated from the increased export of sugar during American rule was captured by only one per cent of the resident population, the bulk going to Filipino exporters, Americans and other foreigners.[32]

Filipino Responses

The deterioration of economic conditions among the labouring classes increasingly led to unrest in urban areas and in the countryside. Work in factories was carried out in what the Bureau of Labor described as 'sweatshop conditions',[33] while outwork meant low-paid or unpaid family labour and long hours, often continuing into the night by the light of the moon or a kerosene lamp. By 1913, worsening conditions of work and inadequate wages led to a number of labour strikes.[34] One of the main issues in these strikes was the protection of women and child labour. By 1925, in reaction to more labour unrest, the colonial government set up protection laws for women and child workers and established a separate section for them in the Bureau of Labor.[35] By 1935, women were demanding equal pay for equal work.[36]

A labour movement had emerged during the American occupation as more and more Filipinos entered waged work. But membership in labour unions remained small; most waged workers and farm labourers were unorganized: by 1940 only five per cent of the more than five million in paid work were organized.[37] Most of the organized women workers and the more active among them were those found in the food and clothing industries, cigar and cigarette manufacture, and a few agricultural associations. But women were rarely union officials.

Many of the unions were primarily political in nature; they had as their main aim broad changes in the economy and polity, leading towards socialism. Efforts were made by some of the urban leadership of these unions to take in the peasant struggle as landlord–tenant relations continued to deteriorate in the countryside. The strength of the labour unions waxed and waned with changes in political and economic conditions but peasant movements escalated.

Responses to worsening conditions of living took other forms. During the commercialization of the economy in the Spanish period, families had kept marginal plots to reduce the risks of fluctuations in foreign market demands. During American rule, Filipinos maintained these marginal plots, but increased population pressures and the shift increasingly to a money economy necessitated other measures. Incomes derived from a combination of sources:

waged labour and trade, weaving and work on the farms, waged work in construction and subsistence production in agriculture all continued but work became more intensive and less mutually complementary. Survival was possible only on a family or household basis with members (including children) contributing to collective subsistence by means of a variety of activities. There was considerable economic heterogeneity within households.

As capitalist relations intervened further in the economy, however, non-capitalist relations were not eliminated. At the same time that wage-labour relations became firmly established in some sectors of the economy (factory work, *hacienda* labour) varying forms of relations of production (subsistence production on the farm, trading, independent crafts production) persisted in other sectors. Agricultural workers were not only 'de-peasantized', providing a labour market for capital; they were also 're-peasantized', selling their labour-power while at the same time reproducing part of it outside capitalist relations.[38] Thus having many jobs and several income earners in one household, customary practices in an earlier period, lost their complementary character and became the immediate response to a specific type of capitalist development.

Another response to deteriorating living standards was the emigration of large numbers of men, to work plantations in Hawaii. By the 1920s, labour requirements in the Plain had been sufficiently met by increases in the local population so that labour migration to the Plain dwindled and there was a large redundant population of male workers in the Ilocos region. Emigration became a rational response to increased labour surplus. By 1932, there were 125,000 Filipinos employed in Hawaii, most of them Ilocanos and most of them men.

Many of these men were married, as may be inferred from the larger numbers of households headed by women in those areas that sent labour abroad (the Ilocos region) or to other provinces (for example, Capiz and Antique) which sent seasonal labour to work in sugar plantations in Negros. In these areas, the proportion of households headed by women ranged from 13 to 19 per cent of the total. In the country as a whole about 11 per cent of households were headed by a woman. Women heads of households put in more hours of work as they bore the double burden of both household and paid work to an even greater extent.

Other women responded differently to declining levels of living. In stark contrast were the women who in some measure benefited from these economic developments: the propertied women. The American period witnessed a widening gap between women of different classes.

Gender, ideology, sexuality and class in the American period

The American period inherited the nineteenth-century ideology of domesticity and familialism and this remained the framework within which sexuality was organized. There were modifications in the form this ideology took; in some

ways, it was reinforced and the various elements continued to be articulated differently through the filters of class and age, as well as regional differences.

Loss or decrease of land parcels meant that marriage was not as closely tied to the availability of land to set up a household and, as a result, parents had less control over the timing of their children's marriages and mate selection. Church and state were now separated, but religious forces were not necessarily less powerful in regulating women's lives. In many of the social campaigns that took place, the American missionary enterprise, both Catholic and Protestant, was an important ally, marshalling the forces of politics for legislation and government action. What emerged during this period was the regulation of sexuality and of morality by means of colonially directed collective action and of state intervention rather than of an obtrusive ecclesiastical authority.

What distinguished these years in terms of gender relations was the entry of wealthy and middle-class women into the public sphere. American education and cultural practice had definite effects on the sexual and social behaviour of women, particularly among the propertied and middle classes. Along with capitalist relations, liberal ideas and attitudes had changed the manners, dress, and way of thinking of men but especially of women, above all in Manila and other urban areas.[39] Men of the *ilustrado* class found the American educational system had an 'unsettling' effect on gender relations. Concern was expressed over the 'loss of Filipino women's inherent virtues' and the increased popularity of liberal Western notions which includes women's participation in sports, coeducation, and even beauty contests.[40] Women had been taken away from the 'all-encompassing' environment of the home and into dormitory schools, and the result was Filipino women who behaved like American women. An example of the *ilustrado* male's reaction to the behaviour of women of his class is an article written during the first decade of American rule:

> She passes before me, chatting in a strange language, in her hand a bundle of books in English. Shall this new Filipina, the unconscious victim of Modernity . . . be allowed to lose . . . her characteristic simplicity? . . .
>
> The Filipina soul should not be allowed to disintegrate! . . .
>
> Women that have come under a minimum of Anglo-Saxon influence are already walking out alone, a little handbag under the arm, just like true bold little American misses. They have taken up reading so that they are inevitably with a newspaper or a little magazine in English in hand . . . We shall soon see her crossing our streets, looking through smoked glasses at the large signs over the stores.
>
> We shall soon come to hear her voice joined to that of the rabble throng in a cry against some person in authority. We shall soon see her approach the coffers of the State to receive fat salaries. On that ominous day, they shall have obtained all that they could ever desire.[41]

By 1930, an article in a magazine had appeared, entitled 'Who needs Maria Claras anyway? They belong to the Past.'[42]

Women's sphere began to extend to industry, the professions and social

affairs. But the activities of these women did not stray far from the framework of American colonial dominance and reflected concerns proper to their class and to their responsibilities as wives and mothers. These interests also mirrored such 'respectable' causes as espoused by American women in the USA: care for the indigent, literacy, suffrage, public vice and morality.[43] These interests could be pursued but they were not to detract from women's responsibility in the home; for almost all these *ilustrado* and middle-class women, entry into public life was contingent on their being, first, exemplary mothers and housewives. Bourgeois and middle-class women's entry into the public sphere became an expression of their social and moral purpose: these women took the ideology of domesticity, which had shaped their existence, and transformed it by engaging in a host of social campaigns on its behalf.[44]

As these changes in women's lives were taking place, they were discussed in debates among the educated classes which converged around two issues: the increasing number of women entering waged work and the professions and the ideology of woman's place. These debates found more concrete expression in the suffrage movement.[45] The movement, in large part the result of initiatives by some American women, had similar terms of reference to the American one. Many Filipino men argued that suffrage and entry into the professions were not proper for women because such involvement would be detrimental to family and home life. The Filipina suffragettes, mainly from the propertied and middle classes, turned the reasoning around and argued for the propriety of women's increased participation in political life: far from drawing them away from the home, suffrage would in fact enhance their activities in the home and family sphere. The importance of suffrage, especially of the owning and middle classes, was that it enabled women to participate not only in electoral processes but also to be themselves representatives of the governing apparatus.

What had gone almost unnoticed as the sphere of propertied and middle-class women widened was the growing number of female servants at whose expense these women's activities were made possible. Although women of the propertied and middle classes were discouraged from pursuing careers, their access to financial resources gave them privileges had by neither men nor women of the other classes. As women they clearly experienced the private–public dichotomy of home and work-place, but however much the home was their realm, the work in it was done by working-class women.

Lost also in the concern for the liberalizing effects of American colonial rule on women's behaviour were the structural changes that underpinned them. Americanization had the effect of replacing many, particularly Hispanic, forms of female subordination while reinforcing those forms which coincided with economic developments. In late nineteenth- and early twentieth-century America, cults of domesticity and true womanhood that proliferated were the ideological reflections of the increased wealth that allowed some women not to work.[46] These ideas made their way to the Philippines where, reinforced by the Hispanic legacy, limited economic prosperity had a roughly similar effect. A gender ideology accompanied the development of the Philippine economy along capitalist lines of production, with the growing separation of home and

work-place, the increasing dependence of women on men's wages, and emerging consumerism. As the dichotomy between home and work-place continued to assert itself in women's and men's lives, the notion of women and men's proper roles sharpened and motherhood became further idealized. The ideology was reflected in political life and the media[47] and it would seep into consciousness at all levels of Philippine life through a major instrument of the colonial state, a mass-based educational system. Girls were encouraged in the housekeeping role with an emphasis on Home Economics courses.[48] But the educational system also served another purpose: it took older children, traditionally housekeepers and mother substitutes, from the home, thus limiting, too, the options of mothers to go into productive work.

The emphasis on women's natural connection to home and family coincided with the persistence of sexual purity and the double standard of sexuality. Monogamy had become the typical marriage arrangement, giving evidence that the acceptance of the Christian ideal of matrimony had taken root among the Filipinos, although mistresses were far from rare and this was in spite of the availability of divorce during the American period.[49] Americans were more hostile to the *querida* practice as an institutionalized sexual relation outside marriage, perhaps because it had no precedent in the American way of life. Thus, while in the Spanish period it was tolerated because the *querida* was not unusual in Spain, in the American period, the widespread practice of keeping a mistress was 'vigorously' opposed.[50] Nonetheless, within colonial society, particularly in Manila, with its surplus of single foreign males, the *querida* was tacitly accepted.

There were also multi-racial brothels in Manila. In 1903, the census noted that the number of female prostitutes in Manila was 473 but only 141 of these were Filipinas.[51] Subsequent censuses did not repeat this count, but in 1918, the narrative report noted that there were more female vagrants than in 1903. Their numbers must have increased and the trade must have been profitable, particularly in Manila, since there were a number of newspaper exposés of police protection of illegal prostitution. In the meantime, American entrepreneurs had introduced public dance halls (*cabarets*) with companionable dancing girls as employees. Dancing had become a highly popular form of recreation among the wealthy and middle classes and for many of the sponsors, *bailerinas* were soon either substitutes for, or indistinguishable from, prostitutes and *queridas*. Eventually these dance halls became the object of morality campaigns by middle-class and bourgeois women because they were fronts for prostitution and a source of 'venereal contagion'.[53] Although parts of these halls were deemed respectable, the controversy over the morality of dance halls continued throughout American rule and the halls were opened and closed. Prostitution was not done away with but American moral indignation had provoked some definite measures. In 1918, the Manila mayor rounded up the prostitutes in the Gardenia quarter of Sampaloc and summarily deported them to Davao, one of the frontier provinces in the south,[54] repeating the actions of Spanish clerics two centuries earlier.

By 1919, the red light areas in Manila were closed, and prostitution no longer

operated within distinct boundaries. Many saw this move as more detrimental to society, because it meant that arrest became more difficult.[55] Furthermore, the law was seen as defective because prostitutes had part-time employment – doing laundry or working as waitresses and professional dancers – and were not really vagrants. Thus, the need was expressed for a law which made conviction easier for both women and their male customers.[56] But as the number of prostitutes grew there was a clamour for more regulation. The Philippine Medical Association, concerned over the rise in venereal disease, opposed the reopening of the districts. Social and religious women's clubs echoed this opposition and continued their campaign against prostitution.

As the campaigns against female prostitution continued to be couched in terms of health and morality, they obscured the material conditions and the ideology of male sexual needs that had engendered it.

American colonization: a summary

Throughout the period, the economic restructuring that had begun in the latter years of Spanish occupation quickened and the effects became more widely felt. The increased penetration of industrial capital had altered the production process and market relations.

Women's household manufacture of cloth, hats and mats for exchange was undermined, and in those areas where it was more profitable became a factory industry turning out goods in large quantities, thus transforming what had been women's independent production into wage labour. With the decline in household manufactures, many women became principally housewives while others were drawn into waged work in domestic and personal services. A number of women, mostly of the wealthy and middle classes, were educated and went into certain professions: teaching, nursing and pharmacy. But larger numbers of women from smallholding households had to increase their share of agricultural work without a corresponding increase in their share of the remuneration. Some productive work of women was subsumed under that of the male head of household and went unpaid as family labour; but such work as was paid was clearly supplementary in terms of wage rates. Women's reduced wages served to increase their dependence on men. The diminishing land-base also intensified the search for outside sources of income. Large numbers of women had to maintain households on their own as men left to work elsewhere.

Some households experienced economic prosperity. The women in these households emerged as emancipated 'little American misses' but at the same time they also became fully dependent on men and more firmly tied to the home.[57]

The ideology of woman's place took root among the labouring classes as capitalist expansion increasingly separated home and work-place and made women largely dependent on male incomes. By the end of the American period the economic situation of women had been reversed: there were more women who were occupied primarily with housekeeping than there were with productive work.

PART III:
The Sexual Division of Labour in the Postcolonial Period (1946–89)

8. Work, Wages, Ideology and Women's Responses: an Overview

Social and economic conditions

By 1945 civilian government had been restored in the Philippines and in the following year the USA gave the country her political independence. Political and economic relations were not altered with independence, primarily because the interests of dominant groups were preserved. Philippine economic and political policy would undergo several modifications in the next four decades, but the legacy of colonialism continued into neocolonialism and defined the direction of Philippine economic development.

Through the first three years of the post-war period, duty-free trade between the USA and the Philippines continued. But by 1949, American goods had flooded the country, draining most of the dollar reserves. To check the outflow of dollars, import and exchange controls were imposed. The import-substitution programme which arose from these controls fostered nationalist measures and protectionist legislation with the purpose of boosting national industries. The programme allowed some industrialization to be carried out, but this was haphazard and selective; most of the industries were Western subsidiaries.[1] A number of families in the Filipino ruling class benefited in some measure, but the USA maintained a strong position in the economy.

Through the 1950s and into the early 1960s, the economic activities of the work-force were changing but these were relatively slow-paced and directly affected only certain sectors of the population. These changes stemmed largely from the nature of the import-substitution programme. The programme favoured capital-intensive, large-scale, urban-based industries; as a result, although industrial production rose during these years, comparatively few workers were hired. Of the few hired, most were men.

The rural sector, on the other hand, could not absorb the expanding labour-force and was unable to overcome the effects of growing population pressures on the scarce available land. By the 1950s, an estimated two-thirds of the rural population were landless and the numbers continued to rise, especially in those areas where capitalist production was becoming more developed. The early 1950s saw the peak of a peasant class-based rebellion. In this armed struggle women were for the most part supporters, couriers and nurses; a few went to battle.[2] But within the decade, the rebellion was crushed with massive American aid.

In the countryside, capitalist penetration was carried out through a programme of agrarian reform. There was a drive to increase productivity by means of the promotion of modern farm technology and an increase in foreign investments. However, the increased activity and productivity only served to sharpen income inequality. In 1956, the richest 20 per cent of the population owned 55.1 per cent of the nation's wealth, the lowest 20 per cent, 4.5 per cent; by 1971, there had been little change: the richest 20 per cent still owned 53.9 per cent of the wealth, the lowest 20 per cent, now only 3.8 per cent. The decrease in the share of the poorest households was particularly pronounced among rural families.[3]

By 1962, exchange controls were lifted because of pressures from disadvantaged sectors of the owning classes and from foreign capital. The package of economic innovations that de-control necessitated, namely import liberalization, currency devaluation and the provision of low-paid labour and raw materials for use by transnational capital, had dramatic consequences for sectors of the Filipino ruling class, the labouring population, and the state. The working classes saw their real wages decline by 10 per cent, and some Filipino entrepreneurs had to go into joint ventures with foreign capital to survive. But agricultural exporters, especially the sugar bloc, reaped large profits. Foreign capital enhanced its position and expanded its hold on the national economy, increasing its appropriation of Filipino raw materials and low-paid labour.

Since the late 1960s, export promotion has been the primary industrial objective of the state.[4] The emphasis on external markets requires the maximum reduction of production costs, principally wages, in order to enable local products to compete on the international level.[5] The availability of low-paid labour, therefore, becomes a key determining factor of investment. Since the Philippines is abundant in labour, it takes this 'comparative advantage' by opening its economy to the labour-intensive operations of transnational capital. Low-paid women workers figured prominently in the export-industrialization programme.

Export-led growth, however, has only made the Philippines extremely vulnerable to fluctuations in the world economy. The country became almost completely dependent on export markets and, as world prices fell for its key exports and an international recession limited the growth of markets in the West, found itself importing more but exporting less. As the country's chronic balance of payments deficits went from bad to worse it became necessary to borrow heavily from international financial institutions to cover deficits.[6]

The recent model of capitalist development has been accompanied by the growth of the state's role as manager and as capitalist, the extended control over the community and family by the state, the increased incursion of the military into civilian life, and the repression of the labouring population and political dissidents.

In the past two decades, the country has witnessed major political upheavals and economic crises: a civilian dictatorship was installed in 1972 and ruled until it was dismantled in 1986 by a combined military mutiny and a massive civilian demonstration. A nationalist movement emerged during these decades

and an armed class-based struggle gained ground. There were also ethnic and religious struggles for autonomy. By the late eighties, sectors of the military had begun to challenge civilian authority.

Economic and political development under relations of subordination to international forces resulted in significant changes in Philippine social structure. At the end of the colonial period the major social forces in the Philippine landscape consisted of a foreign dominant class, an emergent local capitalist class engaged in domestic production of a few commodities, petty capitalists, a small working class, landowners, peasant landholders, and agricultural labourers engaged in crop production for local consumption and for export. By the 1980s, class groupings formed by processes of transnationalized development had engendered a diversity of interests: a foreign dominant class, a local finance-capitalist class, a managerial bourgeoisie and technocratic staff, a landowning class, a salaried intermediate strata, a peasant landholding group, various social and institutional forces such as the military, the church and students, and at the bottom of this extraordinarily complex social structure, a small but expanding and maturing working class and a diverse group of surplus and impoverished population in the cities, towns and countryside. Roughly 55 to 65 per cent of the population are dispossessed of their traditional means of existence and are unable to obtain regular employment at wages or incomes adequate for subsistence.[7]

In 1985, the richest 20 per cent of the population still owned as much as 52.6 per cent of the country's productive resources; the poorest 20 per cent, still as little as 5.2 per cent.[8] The national economy is controlled by 200 families. The proportion of Filipinos living below the poverty line has increased from 42 per cent in 1972 to 66 per cent in 1986.[9] In 1989, an estimated 77 per cent of Filipino households could not afford to meet the minimum daily food requirements.[10] Roughly one-third of the labour-force is underemployed and real wages continue to deteriorate.[11]

All these social, economic and political developments have had varied effects on gender relations, sexual practice and the sexual division of labour. This chapter takes a look at the overall situation with respect to women and men's work, wages, and ideological considerations and ends with a brief survey of organized women's response and resistance to social and economic developments.

Work and sectoral patterns

Throughout the contemporary period, both women and men have been drawn, although disproportionately, into waged work. However, the process embodied in this trend has been uneven and incomplete because proletarianization has been characterized, especially in the case of women, by a growing incidence of temporary and subsistence wage-labour and by forms of labour subjugation which are generally not capitalist in nature. Shifts in the industrial and occupational composition of the working population – contraction in

Table 8.1
Gainful workers by sex and industry 1960, 1975 and 1980[a]

				Sex and Year					
	1960			1975			1980		
	% of industry[b][c]		%	% of industry		%	% of industry		%
Industry	M	F	F[d]	M	F	F	M	F	F
All Industries									
(100%)	(5,986)	(1,952)	25	(9, 374)	(3,045)	25	(10,902)	(3,272)	23
Agriculture and									
Related Ind.	73	39	15	64	26	12	61	19	9
Mining	i	h	4	i	h	6	i	h	5
Manufacturing	6	23	54	8	18	40	7	17	40
Food. Excl.									
Beverage	h	h	(14)	h	h	(19)	h	h	h
Textiles	h	h	(60)	h	h	(65)	h	h	h
Footwear/									
Apparel									
Made-up Text.	h	h	(78)	h	h	(68)	h	h	(67)
Miscellaneous	h	h	(88)	h	h	(61)	h	h	h
Construction	3	i	1	4	i	7	6	i	2
Electric/Gas	i	i	7	4	i	9	i	f	9
Commerce/									
Trade	4	12	48	6	17	49	4	15	51
Retail	h	h	(51)	h	h	(55)	h	h	h
Transport	3	i	2	5	i	4	7	1	5
Services	7	24	51	10	37	54	10	41	56
Government	h	h	(11)	h	h	(21)			
Community/									
Business	h	h	(53)	h	h	(55)	h	h	h
Personal	h	h	(73)	h	h	(72)	(36)	(47)	(63)
Finance[g]	f	f	f	f	f	f	2	2	39

Notes to Table 8.1

Sources of basic data: Bureau of the Census and Statistics (BCS); 1960 Census of Population and Housing, Manila, 1965; National Census of Statistics Office (NCSO); 1975 Integrated Census of the Population and Housing and its Economic Activities, Manila, 1978; NCSO, 1980 Census of Population and Housing and its Economic Activities, 1983.

a A gainful worker is any person, 15 years old and over (for 1970 and preceding years, this was 10 years old and over) who has been working for at least 10 hours a week for not less than 26 weeks, or half of the year. A gainful worker works for pay for an employer, for profit, or fee in own farm, business, private practice of, profession or trade, or without pay on family farm or enterprise.

b Percentages do not add up to 100 because residual categories (not stated, not elsewhere classified and not adequately defined) are excluded.

c Number of males/females in industry_ = % of industry
$\overline{\text{Total number of males/females for all industries.}}$

d Number of males/females in industry_ = % Female
$\overline{\text{Total number of females }and\text{ males in industry.}}$

f Data not available for category.

g Finance was not a separate category until 1980 census

h Percentages for sub-categories were not calculated.

i Proportion was less than one per cent.

some sectors, expansion in others – and divisions along sexual lines also give evidence of contradictory processes intersecting with gender divisions. As a result, the experience of proletarianization has been substantially different for women and men. Indeed, when women are drawn into capitalist production they do so under very specific conditions of low pay, irregular or casual employment in low-wage industrial enclaves and a general intensification of pre-capitalist relations.

During the 1950s, the economic programme of import substitution absorbed relatively few workers, most of them male. As a result, in the 1950s and into the early 1960s the largest numbers of men (73 per cent) were still in agriculture (Table 8.1). These proportions declined slowly at first, then rapidly by the 1960s. Of the women workers, more than a third were also in agriculture but by the next decade many had left the sector (Tables 8.1 and 8.3). The majority of men who remain in agriculture are still the farm operators or owners while women continue to be unpaid family workers (Tables 8.2 and 8.4). From 1960 to 1975 proportions of unpaid labour in agriculture declined for women as well as for men. The bulk of women's labour shifted to waged work on farms as did some of men's work (Tables 8.2 and 8.4). The broad context of this shift was the combined effects of the penetration of local and foreign capital in agricultural areas, the drive towards increased productivity and the consequent growth of a cash economy. The majority of farm households were adversely affected by these developments. Many were eased out of the market by competition or by inability to meet cash outlays; eventually women who were unpaid family workers on their own farm either had to offer part of their labour for a wage on other farms or, as the households lost their land, became primarily wage workers.

In smallholding households or among subsistence producers, men have had to leave their farm for work outside agriculture. But male wages are often inadequate so that families have also had to rely on their small plots of land, which are now worked by the wives. Thus, the incomplete separation of direct producers from their means of production has spawned a specific labour process that is unique to the Third World: that of semi-proletarianization, the combination of wage-labour and subsistence and commodity production. Women form the larger grouping in this semi-proletarianized population, as their labour is appropriated through mechanisms other than the wage.

The decline in agricultural employment in the 1960–75 period was accompanied by an increase in the average number of hours worked on the farm by both women and men. But women tended to invest more hours than men: the average total increase per week for men was one hour but for women, 3.5 hours.[12] What these increases suggest is that as men take on non-agricultural employment or as they devote less hours to farm work, women in the household then begin to devote more time to agricultural production, in terms not only of number of hours worked but also of number of tasks performed. Thus, women who remain in agriculture intensify their labour, as agricultural employment declines for both women and men.

Manufacturing through the 1950s and 1960s still absorbed many women (23

Table 8.2
Gainful workers by sex, industry and category of worker, 1960, and 1975[a]

Category of Worker and Year[e]

Industry	Wage and Salary 1960 % of category M	F	%[d]	1975 % of category M	F	%	Self-Employed 1960 % of category M	F	%	1975 % of category M	F	%	Unpaid Family Worker 1960 % of category M	F	%	1975 % of category M	F	%
All Industries	27	35	29	39	55	32	52	29	15	46	26	14	21	36	36	15	17	27
Agriculture and Related Ind.	12	8	11	17	21	14	61	17	5	60	21	4	27	75	32	23	57	25
Mining	92	60	3	91	69	4	6	26	15	5	18	18	1	14	33	1	7	26
Manufacturing	58	27	35	78	47	29	33	55	66	19	44	60	9	18	71	2	7	72
Food. Excl. Beverage	(67)	(52)	(12)	(87)	(80)	(18)	(25)	(24)	(14)	(11)	(16)	(25)	(8)	(24)	(33)	i	(3)	(44)
Textiles	(51)	(24)	(42)	(79)	(32)	(42)	(35)	(54)	(70)	(15)	(54)	(87)	(14)	(22)	(70)	(5)	(13)	(83)
Footwear/Apparel	(54)	(39)	(72)	(52)	(49)	(67)	(41)	(50)	(81)	(45)	(47)	(69)	(5)	(11)	(87)	(2)	(3)	(75)
Made-up Text.	(23)	(6)	(66)	(65)	(25)	(37)	(50)	(71)	(91)	(31)	(57)	(75)	(27)	(23)	(86)	(4)	(16)	(87)
Miscellaneous	78	66	1	81	80	2	20	23	44	18	20	f	i	10	3	i	f	5
Construction	98	78	6	98	97	7	2	17	i	1	1	13	8	5	33	i	i	22
Electric/Gas	39	22	34	40	27	39	53	59	51	56	65	53	8	18	68	3	7	70
Commerce/Trade	(32)	(21)	(41)	(29)	(22)	(47)	(59)	(60)	(52)	(67)	(70)	(56)	(9)	(19)	(68)	(4)	(8)	(71)
Retail	82	90	2	81	90	4	17	7	1	7	h	h	3	3	7	h	h	h
Transport	91	92	51	92	93	54	7	7	49	7	5	43	1	1	68	i	i	62
Services																		
Government	(100)	(100)	(11)	(100)	(100)	(21)	(5)	(9)	(26)	(7)	(17)	(7)	i	(1)	(1)	i	i	
Community/ Business	(85)	(95)	(55)	(91)	(97)	(56)	(15)	(16)	(60)	(3)	(7)	(17)	(1)	(1)	(49)	i	i	(50)
Personal	(83)	(90)	(75)	(81)	(91)	(74)	(26)	(60)		(7)	(17)		(1)	(1)	(72)	i	i	(66)

Notes to Table 8.2

Sources of basic data: Bureau of the Census and Statistics (BCS); 1960 Census of Population and Housing, Manila, 1965; National Census and Statistics Office (NCSO), 1975 Integrated Census of the Population and Housing and its Economic Activities, Manila, 1978. Category of Workers by sex was not available in the 1980 census report.

a Please see Note a, Table 8.1.
b Please see Note b, Table 8.1.
c *Number of males/females in category* / Total number of males/females for all categories = % of category
d *Number of females in category* / Total number of females and males in category = % Female
e The census uses the category ('class') of 'own account' for 'self-employed': without any paid worker; and 'employer': with one or more paid workers. I use 'self-employed' to cover both categories. The 'employer' is a very small proportion of own account workers. Previously, 'own account' was called 'in own business'.
f Data for category not available.
h Percentage for sub-categories were not calculated.
i Proportion was less than one per cent.

= % Female

Table 8.3
Gainful workers by sex and occupation, 1960, 1975 and 1980[a]

Occupation	1960 % w/in Occup. [b c] M	F	% F[d]	1975 % w/in Occup. M	F	% F	1980 % w/in Occup. M	F	% F
All Occupations (100%)	(5,990)	(1,954)	25	(9, 374)	(3,044)	25	(10,902)	(3,272)	23
Professional/ Technical	2	6	51	3	12	59	3	17	60
Prof./Teachers	h	h	(67)	h	h	(74)	f	f	f
Nurses/ Midwives	h	h	(78)	h	h	(82)	f	f	f
Administrators/ Managers	1	i	14	1	1	21	i	i	19
Clerical/Kindred	2	2	23	3	7	42	3	10	47
Sales	4	13	51	5	16	52	5	15	50
Salespersons	h	h	(55)	h	h	(58)	f	f	f
Agricultural Workers	74	39	15	63	26	12	59	17	8
Farm/ Managers	h	h	(5)	h	h	(5)	f	f	f
Farm Workers	h	h	(29)	h	h	(23)	f	f	f
Miners	i	i	2	i	i	4	f	f	f
Transport/ Comm.	3	i	2	6	i	2	f	f	f
Crafts/ Manufacturing	7	22	50	12	16	32	22	16	18
Spin/Weavers/ Knit./Dyers	h	h	(71)	h	h	(61)	f	f	f
Tailors/Sewers Embroiderers	h	h	(84)	h	h	(72)	f	f	f
Service Workers	3	16	66	4	21	62	5	22	57
House/Serv./ Cooks	h	h	(80)	h	h	(81)	f	f	f
Stevedores/ Labour.	3	i	4	2	i	6	f	f	f

Notes to Table 8.3

Sources of basic data: Please see Table 8.1.

a Please see Note a, Table 8.1.

b Please see Note b, Table 8.1.

c $\dfrac{\text{Number of males (females) in occupation}}{\text{Total number of males (females) for all occupations.}}$ = % of Occupation

d $\dfrac{\text{Number of females in occupation}}{\text{Total number of females and males in occupation.}}$ = % Female

f Data for category not available.

h Percentages for sub-categories were not calculated.

i Proportion was less than one per cent.

Table 8.4
Gainful workers by sex, occupation and category of worker, 1960, and 1975[a]

Occupation	Wage and Salary 1960 %cat M[b,c]	Wage and Salary 1960 %cat F	Wage and Salary 1960 %F[d]	Wage and Salary 1975 %cat M	Wage and Salary 1975 %cat F	Wage and Salary 1975 %F	Self-Employed 1960 %cat M	Self-Employed 1960 %cat F	Self-Employed 1960 %F	Self-Employed 1975 %cat M	Self-Employed 1975 %cat F	Self-Employed 1975 %F	Unpaid Family Worker 1960 %cat M	Unpaid Family Worker 1960 %cat F	Unpaid Family Worker 1960 %F	Unpaid Family Worker 1975 %cat M	Unpaid Family Worker 1975 %cat F	Unpaid Family Worker 1975 %F
All Occupations	27	35	29	39	55	32	52	29	15	46	26	16	21	36	36	15	17	27
Profess./Technical	86	93	53	89	94	61	14	6	33	9	4	40	i	i	51	i	i	53
Prof./Teachers	(100)	(100)	(67)	(99)	(98)	(74)	—	—	—	—	—	—	—	—	—	—	—	—
Nurses/Midwives	(56)	(75)	(83)	(71)	(82)	(84)	(41)	(24)	(68)	(27)	(17)	(74)	(3)	i	(45)	(1)	i	(62)
Administrators/Managers	69	29	7	63	43	15	30	57	24	36	53	28	i	14	67	i	14	64
Clerical/Kindred	99	97	23	99	98	41	1	2	32	f	i	—	i	i	78	i	i	67
Sales	30	20	41	31	22	43	60	61	51	65	69	53	9	19	68	4	8	70
Salespersons	(48)	(36)	(47)	(48)	(35)	(50)	(34)	(31)	(52)	(44)	(50)	(61)	(18)	(33)	(69)	(8)	(14)	(70)
Agricultural Workers	11	9	12	16	20	14	62	16	4	61	22	4	27	75	32	23	58	25
Farm./Managers	i	i	(5)	(3)	(3)	(5)	99	98	(5)	(96)	(96)	(96)	i	i	(23)	(64)	f	i
Farm Workers	(25)	(10)	(14)	(35)	(25)	(17)	(4)	(1)	(8)	f	i	(5)	(71)	(89)	(89)	i	(74)	(26)
Miners	94	40	1	98	85	3	5	43	15	i	5	15	i	17	43	i	8	21
Transport/Commun.	81	87	2	82	89	3	18	9	1	16	9	9	i	4	7	i	i	3
Crafts/Manufacturing	66	25	27	78	44	21	28	57	67	20	46	52	6	18	75	2	8	69
Spin./Weavers/Knit./Dyers	(40)	(28)	(59)	(77)	(42)	(46)	(44)	(52)	(72)	(17)	(47)	(81)	(16)	(20)	(73)	(5)	(10)	(74)
Tailors/Sewers/Embroiderers	(42)	(38)	(83)	(48)	(48)	(72)	(51)	(52)	(84)	(49)	(48)	(71)	(7)	(10)	(87)	(2)	(2)	(75)
Service Workers	89	91	67	90	92	63	10	8	62	7	5	52	i	i	67	i	i	60
House./Serv. Cooks	(99)	(99)	(81)	(99)	(97)	(81)	i	i	(74)	f	i	(74)	i	i	(67)	i	i	(70)
Stevedores/Labour.	98	98	4	93	91	6	1	i	2	5	4	5	i	i	20	i	1	11

Notes to Table 8.4

Sources of basic data; Please see Table 8.1.

a Please see Note a, Table 8.1.

b Please see Note b, Table 8.1.

c Number of males/females in category = % of Category
 Total number of males/females for all categories.

d Number of females in category = % Female
 Total number of females and males in category.

e Please see Note e, Table 8.3.

f Data for category not available.

h Percentages for sub-categories were not calculated.

i Proportion was less than one per cent.

per cent of all industries) but this declined through the years and by 1975 manufacturing as a sector had, for the first time in the post-war period, larger proportions of men than women (60 per cent in 1975 and into 1980, compared to 46 per cent in 1960–1 (see Table 8.1). But for both women and men, proportions in manufacturing continued to decline relative to other sectors.

Men made some inroads into the traditionally female garment industry, and, as well, more jobs in manufacturing had opened up for men (Table 8.1). In 1960, mechanical, electrical and transport equipment and materials made up only two per cent of total manufacturing; in 1975, this figure was roughly 20 per cent. But women also made some slight inroads into what had become a male industry (food and beverages), and increased their participation in textiles, which had become male-dominated when the industry mechanized in the early part of the century (Table 8.1). The increase of women in these two industries was largely due to the export industrialization programme. The increases in jobs were concentrated in labour-intensive operations within industries, mainly in electronics, food and food-processing and garments. This meant the absorption of more women and availability of more waged work for women. But while women relative to men continued to constitute a sizeable proportion of the waged labour-force within manufacturing, especially textiles and garments, the larger proportion of women workers still remained self-employed and unpaid family workers (Tables 8.2 and 8.4). In 1975, 78 per cent of men but only 47 per cent of women were waged workers in manufacturing; there remained twice as many women as men who were self-employed (Table 8.2).

The sectoral pattern of industrial growth in the capital-intensive areas of manufacturing has therefore tended to favour male employment; and even in those sectors where there were higher proportions of women the trend has been to absorb men into the wage sub-sectors leaving the bulk of women in low-productivity self-employment.

In the commerce sector there were roughly similar proportions of men and women through the 1960s and early 1970s (Table 8.1). Activities of both women and men in the commercial sector concentrated, particularly for women, in two main occupations in retail trade: as working proprietors and as sales-people.[13] There are slightly different proportions of women and men in these categories – there are more women than men as sales-people but slightly more male proprietors. The larger difference is in category of worker: there are larger proportions of women as unpaid family workers and self-employed in sales occupations (Table 8.4) and within the commercial sector (Table 8.1).

Women in the commerce sector continue to engage in low-productivity petty trade, market vending, or hawking activities, all of which come under 'self-employment'. Large concentrations of women in this type of work indicate the difference in work allocation by sex within the trade hierarchy: men are likely to be working proprietors or merchants and sales agents at the top of the hierarchy while women continue to be at the bottom as petty traders and more recently sales-people.

The service sector absorbed more women through the 1970s and this

increase corresponded with the decrease in their numbers in agriculture. In 1980 the largest proportion (and the largest number) of women workers were in services (41 per cent – see Table 8.1). Through the mid–seventies proportions of women rose in government and related services work although men still outnumbered women (roughly 3:1) in this subsector, partly as a result of the growth of the military (Table 8.1). A new 'finance-services' sector also absorbed more men than women (Table 8.1).

Domestic service continues to be a large recruiter of women. By 1975 roughly 533,000 women were doing some type of paid housework; two out of three workers in domestic service were women and one out of five women workers was in domestic service.[14] Domestic service is perhaps the largest category of women for whom a wage is the dominant relation. The largest proportion of women in waged and salaried work then has been in employment in domestic service and the civilian state apparatus and not in the industrial sector.

Professional and technical occupations through the post-war years have increasingly been filled by women. By 1980, 60 per cent of people in the professional–technical field were women, primarily because of female teachers: in 1975 roughly 60 per cent of professionals were teachers and 74 per cent of all teachers were women (Table 8.3). Another large proportion of professional women were nurses. In the professions, women continue to be concentrated in servicing and nurturing work. In teaching, supervisory roles and positions of authority are commonly held by men. Men have had not only a more varied range of jobs within the professions but also the senior positions within those sectors of employment filled by women.

Administrative and clerical occupations have higher proportions of men but these proportions are decreasing (Table 8.3). The majority of men in administrative or managerial categories are waged and salaried workers, but in recent years there has been a large increase in the numbers of women in waged work (Table 8.4). In the clerical category, women waged workers are usually secretaries, typists, stenographers, clerks and perform a variety of other subordinate servicing roles within corporate organizations. The proportion of women in clerical work has increased in the post-war years, both absolutely and relative to men, as a result of several factors: increases in the numbers of women with secondary and tertiary education, the expanded role of the state and state bureaucracies including the extension of state activities into the productive sector, and the expanded rationalization of work processes which has meant the creation of complex business operations entailing additional correspondence, record-keeping and general office work.

In summary, broad sectoral and occupational trends through the post-war years show a clear preference for men in those categories of employment which are more directly connected to capital-intensive industrialization, while women remain in low-skilled, low-productivity sectors (such as services), in subsistence activities in agriculture and trade, or in non-productive sectors (such as the state apparatus). Where women are in modern-sector employment, these are usually in labour-intensive areas, such as garments,

electronics, food and food processing. Men at work also occupy higher levels of the job hierarchy (as in trade and the professions).

The overall patterns of industrialization indicate therefore that the relatively little employment that has been made available by the industrial sector has gone largely to men. As a consequence, women have been, by and large, left out of the industrial labour-force and continue to be absorbed into low-productivity self-employment and unpaid family work. The recent absorption of particular groups of women in the labour-intensive operations of multinational firms is a capitalist strategy to cut down on labour costs, taking advantage of a reserve pool of low-paid labour with particular 'feminine attributes'.

Wages and incomes

Differentials in wages continue to reflect the sexual division of labour and the different worth attached to the work of women and men. These differences have in fact increased: in 1960 women earned P0.60 for every peso earned by men; and from 1978 through 1986, this was roughly P0.54.[15] In the early 1980s women in sales earned 46 per cent of male earnings; in manufacturing and transport, 50 per cent; in professional and technical, 60 per cent; and in administrative, managerial and executive, 79 per cent.[16] Agricultural and related work paid the lowest proportions for women, 22 per cent, while clerical work paid the highest, 95 per cent. Services paid almost twice (41 per cent) that of agriculture but domestic services as a subsector paid the lowest rates.[17]

However, wage differentiation within the labour market operates through the assignment of women to low-paid levels within *all* occupations rather than through direct wage discrimination or through a rigid segregation by occupational category. Across occupational categories, women are to be found mainly at the lower end of the income scale and within each occupation, lower grades coincide with lower levels of pay, responsibility, privilege and power and these are assigned to women. Women are also to be found in the lower productivity, self-employed or unpaid family worker categories rather than in waged work.[18] Women's assignment to these levels is determined by ideological considerations which have to do with physical attributes, capabilities of women and men and gender-based social roles.

But apart from the sex differentials in wages there is also the issue of the level of the wage itself, that is, the purchasing power of wages (or real wages). Workers' wages are pegged on the daily needs of the worker and the worker's household, that is, a 'family wage'. The emergence of the family wage in the Philippines appears to have been largely the result of colonial definitions of the sexual division of labour rather than, as occurred in the West, the result of struggles between female and male workers and between workers and capital.[19]

Just what a family wage means in the day-to-day life of Filipinos can be seen in the comparison between a day's supply of nutritious food and a day's wages. In 1974, a day's supply of this food cost P18.16 for a family of six in Manila.[20]

When expenses for clothing, rent and other basic necessities were added, the cost of living amounted to P37.91 a day.[21] Yet minimum wages were P10.00 a day. Thus, the combined earnings of a family with two full-time earners both receiving minimum wages were just enough to cover expenses for food. Since only about half of the labour-force is covered by the minimum wage this means that a sizeable portion of the working population lives below minimum subsistence levels.[22] In the early 1970s, an estimated 45 per cent of the country's households lived below or on the poverty line.[23] Through the years, real wages remained at roughly similar levels. In 1986–7 a family of six needed at least P217 a day;[24] but the minimum wage was P64 for industrial workers, and P54 for agricultural labourers.[25] Low wages and a large surplus population combined with economic crises to exacerbate further already deteriorating standards of living: during this period an estimated 66 per cent of households fell below the poverty threshold.[26]

Ideological considerations

The differences in men and women's experience of proletarianization – in earnings, in distribution in the work-force and the work hierarchy – reveal an industrialization process differently affecting men and women's labour. This differential impact is a reflection of material forces working through ideology and gender relations that, in turn, affect these forces. Other aspects of this interaction can also be seen in rates of unemployment and underemployment, age-specific rates of participation, educational attainment and retrenchment practices.

Women consistently have higher rates of unemployment and under-employment.[27] Indeed these rates would be much higher if estimates included the unofficial pool of female labour – the housekeepers. Housekeepers continue to be viewed as an undifferentiated mass of voluntarily unemployed or idle people rather than largely as 'discouraged' workers who are unable to find adequately paid work or women who have little option but to stay at home.[28] As well, however, women are not only less likely to be employed, they are also more likely to be made redundant. While women and men are both displaced in times of recessions and crises, and while the group made vulnerable also depends on which sectors of the economy are hit by the recession, it has been largely the case that women are relatively more expendable either because they are in positions which are lower skilled or because they are seen as a secondary work-force. Furthermore, in times of capitalist expansion, the same work-force of men who are laid off are usually rehired, but the same is not true of women. Instead, women laid off are usually replaced by younger women.

Retrenchment practices also discriminate against women. One study shows that while actions taken against male workers in manufacturing firms in 1981 were caused mainly by misbehaviour (such as absenteeism and violation of company rules), during an economic recession employers first considered

female workers for suspension or lay-off. An average of 60 per cent of those laid off during economic losses, retrenchment or partial shutdown were women.[29] One would have expected that the greater misbehaviour of men during normal circumstances would have led to their being first to be laid off during a recession. But women were laid off instead, suggesting that the ideology of men as the primary-income earner was more important than the usual efficiency considerations among employers. Men were liable to dismissal on grounds of individual bad behaviour but women were liable on the grounds of collective characteristics based on the ideology of woman's place.

The merging of gender ideology with economic factors is also manifested in the influence of non-market factors on work participation rates. Male labour-force participation rates increase steadily throughout their life-cycle until these reach a plateau between the ages of 30–49 years, after which they decline gradually.[30] Female participation rates, on the other hand, are not only lower at each age level but also show considerable variation. Female participation rates, particularly those of married women, show a double peak pattern – the first decline occurs when women marry and raise children and then picks up only after they have completed their child-rearing responsibilities (Figure 8.1). In the 1970s, married women's participation rates increased but the peaks became more pronounced and ages of participation shifted (Figures 8.1). Postponement of the first peak reflects the greater availability of education and of the rise in the average age at marriage among women,[31] while the earlier incidence of the second peak can probably be attributed to changes in women's fertility as a result of birth-control and their ability to space out births.

The marked effect of marital status on market work can be seen in the much lower, age-specific participation rates of married women than those of widowed or separated women, or those who have never married. For this latter group of women, rates increase steadily and substantially until women reach their late 20s and then decline gradually from the end of their 30s; while for those of married women, work-participation rates increase only very gradually and then only reach a peak when they are in their 40s (Figure 8.2).

For married women in urban areas, the double-peak pattern is even more marked, suggesting that child-care and household responsibilities are a greater constraint to urban employment. One national survey illustrates, for example, that the presence of infants and pre-school children reduces the amount of time spent (about four hours) by working women in productive work.[32] But these women also spent as much time on housework and only slightly less on child-care than the average spent by all women with children. This means that the combination of market and household work impinged on the already little time women had for themselves.[33] In rural areas there appears to be more flexibility in time allocated by women to productive and reproductive work because of the seasonal nature of crop production. But the shifts in time available to women are determined for the most part not by an increase or decrease in the husband's share of work, but in the availability of mother-substitutes, particularly kin and older children who are assigned to do specific tasks.

Figure 1
Age-specific labour force particiation rates by sex, 1960 (enumerated) and 1970 (adjusted)

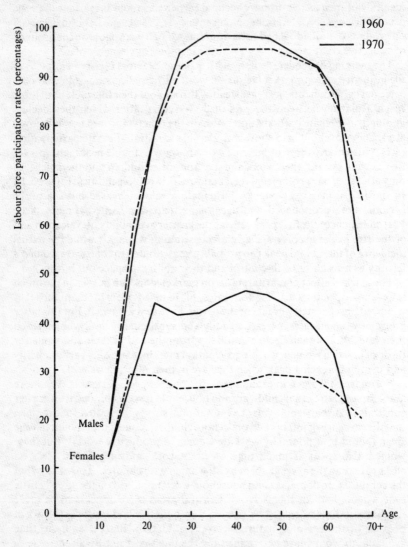

Source: Kabeer (1987) based on UNFPA (1977).

Figure 2
Age-specific labour force participation rates of females 10 years and over by marital status, 1970

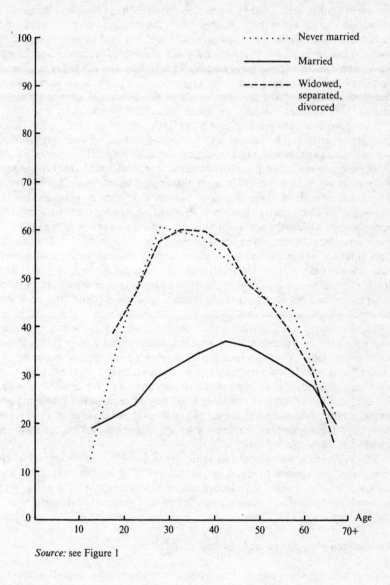

Never married · · · · · · · ·

Married ———

Widowed, separated, divorced — — — —

Source: see Figure 1

In my own study on time allocation I estimated that women engaged in productive work spent an average of roughly 20 more hours per week than their working husbands in combined household and non-household labour.[34] Employed women are left with much less of their time than either their husbands or full-time housewives. Whether in the city, town or countryside, the amount of time devoted by women to relatively fixed economic and social responsibilities is more than doubled when the demands of housework and family are added to the time spent at paid work. Yet husbands have not been inclined to do their share. And when husbands did indeed perform some chores, these were the more peripheral household activities and the wives remained responsible for the core of domestic obligations. The plight of the women with the double shift and the women's bond to the household cannot be more clearly demonstrated than in their use of time.

The power of ideological forces in influencing women's entry into productive work can be seen as well in the connection between educational attainment and the labour market. Literacy rates (a national average of about 80 per cent) do not differ much for women and men, although rural and urban differences are more marked. There are also negligible differences at every level of education; indeed, there are more women than men at graduate levels; although this also means that women relative to men need more education at entry points within the work-force or in order to advance to higher-level positions. Nonetheless, educational parity is not translated into labour-force participation. At every level of education, women's labour-force participation rate is lower than that of men and this difference is particularly large at lower levels of education.[35] In addition, particularly in the case of women, there is no clear connection between formal educational requirements and the type of job to which women are assigned.

The argument then is that ideological considerations determine what women and men do within and outside the household and in large part account for the negligible effect of education on women's participation in the work-force. The demand for a particular type of labour is linked primarily to gender and only secondarily to educational attainment. To put it another way, educational parity has not challenged the gender segregation in the labour market; rather education has served as a 'screening mechanism' in a situation of a large labour surplus, but only after a 'prior screening' on the basis of gender has been effected.[36]

The evidence across a series of indices – sectoral and occupational work categories, wage rates, labour-force participation by age, marital status and educational attainment, unemployment and underemployment rates, and retrenchment practices – shows a clear pattern of gender differentiation.

Organized women: responses and resistance

Women's responses to economic and political changes in the second half of this century were expressed in several ways. One major response was by collective

action through membership in labour unions. The orientation of the labour movement in the American period shifted towards 'economic' unionism, that is, towards enhancing the members' wellbeing through the process of collective bargaining. This continued into the early post-war period. Organized labour gained in strength and included political issues of foreign domination on its agenda. But by the 1950s, the state had banned the most militant and largest of these organized groups. In the 1960s, labour began to regroup; but most workers remained unorganized. By the 1980s about 90 per cent of workers still remained unorganized.[37]

Women's membership in unions increased as more women became waged workers in industry. Some waged workers in plantations also joined agricultural unions. But female membership relative to male membership remained low: in 1969 female members were only 13 per cent of the total membership in affiliated labour unions and 22 per cent of independent labour unions.[38] By the early 1980s, female membership in labour unions had increased only to 25 per cent.[39] Women's small membership relative to their numbers in the work-force stems largely from the nature of women's productive work in the informal sector or unpaid family work in agriculture, and to women's reproductive work, which put restrictions on their participation in labour activities.

But unions were also prejudicial to women. Union struggles reflect male privilege: male-led unions which mobilize around employment, wages and conditions tend to ignore the specific needs and demands of women workers and to belittle gender issues, especially those which confront male dominance itself; for example, skill levels, wage differentials and sexual harassment. Their numbers and relative segregation in the work-force gave women little bargaining power.

Union organization also embodied a gender ideology. Women were usually the rank and file while men were the officials, even in unions where women outnumbered men.[40] Women who became officials held gender-based positions in the labour hierarchy.[41] Male members argued that female workers were too young and too inexperienced to be union leaders.[42] Some unions with mixed memberships had discriminatory policies against women workers because men believed women competed with men's jobs and were therefore a threat to men's employment.[43] Recent developments in union practices indicate, however, that as a result of their growth in numbers, increased confidence and consciousness of their rights as workers, women have begun to be more assertive; unions have begun to take women's issues more seriously.

In the last few years, after a period of repression of labour rights, a working-class movement has re-emerged. This movement has grown in proportion to the accelerated pace of Philippine industrialization, which has produced an increasingly self-conscious (although often fractured) working-class population of women and men. This population has exhibited a capability for collective organization in defence of its own interests and increasingly in support of the interests of many sectors of an impoverished non-wage-earning population of rural and urban labourers. But its bargaining power continues to be weighed

down by the magnitude of a surplus population.

The other major response of women was the mobilization for rights and roles traditionally denied them as a social group. The first of these types of organized response was on the issue of suffrage. The suffrage movement was part of the broader agitation for liberalization and political rights within a colonial framework. After suffrage was won, and with political independence, women's groups directed their efforts towards legislation empowering women with certain rights, especially with respect to property and working conditions.

The second of these responses emerged in the late 1960s and continued into the early 1970s. The broad context of this second response was the struggle against class and foreign domination. This struggle was predominantly male-led. But for the first time, women raised the separate issue of women's liberation from economic exploitation and gender oppression. The material and ideological contradictions of women's position had surfaced and had begun to be expressed in a 'women's movement'. The reaction of men in and outside the struggle ranged from ridicule to dismissal. Eventually as questions of divisiveness and pressures from the male leadership grew, the 'woman question' had to be subsumed to the 'more pressing' concerns of class and imperialism.

When Martial Law was imposed in 1972 a repressive state stifled the open movement; some members of the women's movement, together with those organizations under the National Democratic Front, were forced to go underground: others were imprisoned, a few were killed. Within the armed struggle that emerged alongside the open movement, women were once again the organizers, propagandists, and couriers; a growing number were armed combatants. Throughout the rest of the dictatorial regime, women's groups within or outside the National Democratic Front alliance, including women's religious groups, were engaged in pressure politics. They often took their activities to the legal limit. Military confrontations with women active in the struggle would sometimes end in sexual harassment, sexual abuse, rape or death. But women as wives, mothers, sisters or daughters also became casualties of war.

By the mid-1980s, with a succession of economic crises and the collapse of the political legitimacy of the dictatorial regime, the country became a site for political and economic agitation, as the anti-dictatorship movement and the anti-imperialist struggle found some common ground. The women's movement was revitalized during these years and became an important force in the dismantling of the dictatorship. This movement had a broader base, including women from the middle and wealthy classes and professional groups.

In large part, the women's movement of the 1980s grew out of the nationalist and liberation struggles of the 1970s. Many of today's organizations, barely ten years old, have once again raised the issue of women's liberation in the context of nationalism, socialism and a 'national democratic' liberation.

The present women's movement is heterogeneous and pluralist, reflective of the ideological, economic and political divisions of the larger social scene.

Some women's groups view women's roles within traditional frameworks. Some of these groups see socioeconomic changes as threatening women's role in the family and thus support campaigns which seek to maintain women's role in the home; others make demands that will give women more rights and an improved position within their own family-household: these demands include access to better employment opportunities, control over their property, a right to share in the marital assets in separation, and the right to divorce.

Other groups seek a transformation of the gender hierarchy, often together with a transformation of social structures. The demands of these groups cover a wide range of issues but the more urgent ones have been: women's right to work and to a decent wage; the state's provision for social services, particularly child-care; the commoditization of women; women's health and reproductive rights; the right to organize and to speak against the state's repressive measures; and violence committed against women. Some have set up livelihood activities for poor women. Many women's groups have multi-class affiliations and are largely led by the middle class; but the bulk of memberships draw from both women productive and reproductive workers in the cities and the countryside.

The women's movement is emerging as a major social force in the Philippines. As it seeks to transform a deeply rooted gender hierarchy, it has to confront historical as well as contemporary issues. The next section looks at this present-day configuration across details of economic life.

9. Women's Work: Some contemporary configurations (I)

The sectoral and occupational studies discussed in this section show that while subordination may be the common lot of women, its expression takes many forms and guises. Subordination is expressed in the way sexual stereotypes and a gender hierarchy define work women can and cannot do; the way women and men are differentially integrated into production; the manner in which specific economic and political projects merge with gender relations and a sexual division of labour either to support or restructure that very division; the way women are broken down by age and marital status in the name of 'increased productivity'; the way the family household and work in it figures in women's freedom to work outside it; and the extent to which women have access to technology. This section gives details of these forms and guises across a variety of work.

The types of work discussed are in agriculture, rice farming, sugar production, other crops and the banana-export industry; in manufacturing, garments, textiles, handicrafts and microelectronics; in clerical and administrative work and in professional, entrepreneurial, managerial and executive work; in the informal sector, subsistence commerce and domestic service; prostitution; and a phenomenon closely linked to work, domestic and overseas migration. The survey ends with a brief discussion on women and work in cultural communities.

The agricultural sector

Rice farming
Women's productive work in rice farming, although varying primarily with their and their household's relation to productive resources, also varies with the level of technology, specific labour requirements arising from different tenurial contracts, and stages in the family life-cycle. Women's work in rice agriculture is more properly seen within the context of the household as a unit of production and consumption and in relation to men's work.

By the 1920s, hired labour in rice agriculture had begun to replace reciprocal labour exchanges in most of the Central Luzon Plain.[1] Hired labour was provided by both landholding and tenant families and landless farm labourers.

Throughout the American period, the increasing penetration of capital, continued fragmentation of land, and growing population pressures led to a rise in tenancy rates and in the numbers of landless labourers. By 1948, roughly half of all agricultural workers were landless farm labourers.[2]

Into the 1950s, share tenancy was still the predominant system of labour appropriation in Central Luzon and in many other rice-growing areas. In this system, women of smallholding households hired out their labour on their own or joined labour gangs. In this gang, the head negotiated a labour contract, received payment and paid the workers. Women also worked as part of pooled family labour on other farms. These women rarely worked on their own farms, since higher production yields benefited the landlord more than the producers; surplus yields were often absorbed by high rents and debts.[3] Among landless farm families women hired out their labour individually or joined labour gangs.

Work on the farms was seasonal so that women in agriculture did outwork such as hat-weaving and garment-sewing; but this was on a small scale. Women also did laundry or hired themselves out as domestic servants. These activities off the farm generally paid very little. During the off-season male farmers and farm labourers also worked on jobs off the farm, for example, in construction or carpentry. There was little class differentiation among these households because the work done by tenants and smallholders and landless farm workers was almost interchangeable.

But by the 1960s, an economic package of technological innovations and high-yielding varieties (the 'Green Revolution'), together with infrastructural expansion and the shift in tenurial contracts to fixed rent, brought about changes in men and women's work arrangements. The expanded productivity of the land, together with the shift to fixed rent, increased the share of the cultivator–producer. Smallholding households began to use family labour extensively in order to reduce the total cost of hired labour. Women of these households concentrated their labour on the family farm and consequently became largely unpaid family workers. Such tasks as transplanting and harvesting were still handled by hired labour, so that women landless workers benefited in some measure from increased production and wages rose as well.[4] But with higher productivity, social division among agricultural households became greater.

Households which held larger landholdings or held more productive land were able to capture some of the surplus from enhanced production and from control of the marketing of the yields. In addition, during this period, food grain prices rose in the world market. Villagers had an increase in cash-flow. Women of larger landholding households began to withdraw from farm work to engage in other paid work such as managing *sari-sari* stores or trading; while others withdrew from productive work altogether. As a result of these developments, a system of subtenancy emerged: hired labour now performed the routine tasks of the farm as less and less family labour figured in farm operations.[5]

Increased prosperity was very selective and shortlived. Wages of landless

labourers failed to keep up with inflation; their economic conditions worsened. Standards of living among smallholders also deteriorated. Smallholding households became precarious units with the increased commercialization of the village economy; competition forced many out of the market. Some lost their land as they failed to meet mortgages taken out to finance capital outlay on the farm. Others were dispossessed of their land by agri-business interests. By 1975, there were three-and-a-half million landless farm workers, which was still 47 per cent of all agricultural workers and about 25 per cent of the total labour force.[6] Of this number, roughly one in three was female.

An agrarian reform programme implemented at this time also adversely affected landless labour and small farms. Typically of land-reform programmes, this one was limited in scope and failed in the main aim of reform – the redistribution of wealth.[7] The high valuations of land in the transfer of ownership to tenants and the increased cash outlay needed for the high-yielding crop varieties resulted in growing debt for many farms. To minimize production expenses, farmers had to cut down on labour, thus adversely affecting the employment of landless farm workers, both women and men.

By the mid-1970s, partly as a response to increased competition among landless labourers, a new labour arrangement arose: a weeding–harvesting system where workers weeded a plot without a cash wage provided they had exclusive right to harvest the plot, keeping one-sixth to one-seventh of the share of the crop. For the farmer, the system meant diminished cash outlay; but it also meant that landless labour bore the full risk for the crop. If the crop failed, the work would go unremunerated. The arrangement also represented a decline in real wages; in one survey in the Visayas, this decline ranged from 31 to 71 per cent of the wages for harvesting.[8] Although the arrangement tended to release women family labour on the farm, it increased hired labour's role.

In summary, the work of women of smallholding farms varied with the economic situation of the household. In these farms, women's family labour was used extensively to increase productivity during the process of capital accumulation. When some accumulation had become possible, women withdrew from productive work on the farm. Hired labour, or technology, then replaced women's family labour. But when there was no possibility of any accumulation, and in most cases there was none, women's work was indispensable. Thus, female labour became extensive; women not only did unpaid work on their own farm, they also did paid work on other people's farms.[9] In rural areas the participation of women in agricultural production then is directly related to poverty. The Green Revolution also had specific effects on women's work-share on the farm.[10] The new short-statured varieties required a sickle, a labour-saving device which helped ease women's work. The direct-seeding process skipped the laborious transplanting operations: male and female hired labour thus became redundant, although disproportionately for women, as more of them were engaged in transplanting. The use of the dry-seeding method had the same labour-reducing effect as wet seeding. Weeding, which involved mainly women and was the most labour intensive of

the farm operations, increased with the use of high-yielding varieties. Labour-intensive operations in rice agriculture usually recruit more female labour, but so do lighter operations such as cleaning and winnowing which are tasks left largely to women and children. But female labour was displaced when threshing, a largely female activity, was mechanized and men operated the machines.

The new varieties made double-cropping possible: this meant increased harvests for farmer households and also more work for hired labour. But the need for this labour was more evenly spread, levelling off labour peaks, so that men were available for work, and women were not as needed. Higher yields meant higher incomes for farmer households but there was a release in total labour, particularly hired labour. As the population grew, the new landless labour force could not be absorbed and standards of living deteriorated.

Overall, landless women's share in farm production declined, for the most part because of the decreasing labour-use requirements in operations where women had larger inputs – transplanting, harvesting, and threshing. Double-cropping augmented labour in typically male activities, such as land preparation and fertilizing, which also increased with the crop area. These activities largely made up for the decrease in the use of male labour in other operations. With regard to the use of new technologies, then, women's contribution to rice production decreased both absolutely and relative to that of men. However, at the same time that men operated the new machines, women entered into what had formerly been men's work: some women now clear fields and maintain the dykes.[11]

These developments point to the connections between the sexual division of labour within agriculture, the demand for men to engage in non-agricultural work and the level of productive forces. Women intensify their labour or become a reserve to be incorporated into phases of agricultural production as men move into mechanized operations or away from farm work. But some women have no men contributing to the household, and this defines their productive work. Women heads of households in rice agriculture on the average work longer hours on the farm than men.[12] These women form the group who scavenge among the threshed stalks of rice, gleaning any kernels that might remain.[13] In the absence of a secondary adult productive worker, households headed by women are poorer than the average landless worker household.

Recent trends in crop production have further begun adversely to affect women's share of productive work in the sector. Agriculture is now shifting towards cash-crop production, primarily for foreign markets. Cash-cropping has in the past tended to employ more men than women. Cash crops (particularly bananas and pineapples) were grown as the country's major exports at the same time that staple crops – rice and corn – increasingly became major imports. The rationale for the shift, which is part of the policy of export promotion, is the competitive edge of cash crops in the international market. The shift to cash crops had been accompanied by the entry of multinational corporations into the food industry. But cash crops have generally not been

profitable for farmers because the market is dominated by big capitalists and multinationals. Cash-cropping techniques have also tended to be labour releasing: in multinational operations in Mindanao, the labour to land ratio is one worker per hectare; in Negros where two-thirds of the best lands are devoted to sugar, the industry employs only one-tenth of the local labour force.[14]

Sugar production in *Hacienda* life

Sugar was, for a long time, one of the more important foreign-exchange earners. At peak periods in the 1970s, sugar accounted for a quarter of the country's dollar earnings. Sugar production, unlike rice, has not been affected by tenurial contracts so that changes have largely to do with increases in productivity.

Before the 1950s, sugar production was limited because of quota restrictions imposed by the USA, the main buyer of Philippine sugar. Plantation owners (*hacenderos*) had tenanted part of their large estates or plantations (*haciendas*) to resident workers for rice cultivation. In the 1950s, government policy changed and planters were encouraged to grow more sugar because production had fallen short of the export quota and, in the 1960s, because the USA stopped importing sugar from Cuba. Planters then reconverted tenanted land to sugar. Since that time workers have become fully dependent on wages.

The fact that the sugar crop is directly tied to the international economy has made it vulnerable to extreme price fluctuations. As prices rise and fall in the global market so do local sugar production and employment. Since the 1950s, the price of sugar has peaked and dropped in cycles of roughly four to six years, and every downward trend has resulted in a decrease in sugar hectarage and employment.[15] In 1977, with a downturn in prices, 182,000 farm workers – about one-third of the total sugar work-force – were displaced.[16] Of those who were retained many were hired for only two or three days of work and a large number did not receive wages.[17] In 1987, after another downturn, over 250,000 workers were displaced; and nearly half of the sugar mills and 60 per cent of sugar lands were made idle.[18]

Sugar in Western Visayas, mainly Negros Occidental, accounts for 68 per cent of the Philippine crop. Of the province's 1.8 million population in the mid–1980s roughly 90 per cent were dependent on the sugar industry.[19] Today roughly 90 per cent of the population of Negros province is landless. Out of the total 332,000 families, 330 own about 45 per cent of the sugar lands.[20]

Women and men's work in sugar occurs under a different set of production relations to that of rice. Labour in sugar is contracted either as daily waged work or as piece-rate work. Sugar production is highly seasonal: there is steady employment only for specific tasks and these are all done by men.

Workers can be permanent, casual or seasonal. Resident permanent workers live on small plots and housing units (huts, really) inside the *hacienda*. These units, in which about 87 per cent of the workers live, are provided by planters in order to secure a permanent labour force. Casual workers do not live on the *hacienda* itself but on subsistence plots near it. Seasonal or migrant workers

(*sacada*), comprising about ten per cent of the work force, come from other parts of the region. Women workers constitute approximately one-third of the labour-force in sugar production and most are wives and daughters of resident and casual workers. Few of the *sacada* are women.

As in most farms, there is a sexual division of labour on the *hacienda*. Women generally do the 'lighter' but labour-intensive tasks.[21] Women prepare, cut and plant cane points and apply fertilizer while men do the transplanting and weeding by trowel. Other tasks are performed by both women and men. Tradition and the preference of most of the women themselves, both seem to govern the allocation of work.[22] Accounts in the early part of the century describe women doing the same tasks they do today and, most likely, work was assigned to women for similar reasons: some tasks, for example, planting cane points, were noted as being 'more economically' done by women and children,[23] meaning their wages were lower. In present-day *haciendas* tasks off the field are also differentiated by sex. Men are given supervisory roles and positions of authority, such as overseer and foreman, while women are preferred as timekeepers or bookkeepers because they are 'better suited' for this type of work.[24]

Payment for work depends on the tasks performed: some tasks are paid on a daily basis and others on a piece-rate or contract basis. Piece-rate arrangements frequently undercut the minimum-wage law. In some *haciendas* women and men are paid the same wages because they perform similar tasks.[25] But in as many others, women are paid much less than men, for similar work.[26] However, those jobs that are exclusively men's, such as cutting, loading and hauling, are considered the most onerous tasks and are also the highest paid.

In some areas, women are treated as workers in their own right: they are paid on the basis of their work and their names appear on the payroll.[27] In other areas, this is only true when there is a demand for their labour. In these areas women's labour is subsumed under men so that often a man, woman and child are found working the fields and together they are paid the total of a minimum wage.[28] Planters report that they pay a minimum wage but fail to add that they pay it to one person for the work of three.

During periods of economic contraction, men are usually assigned work because they are heads of households, although women who are heads of households are also given work.[29] But wives and daughters are not given work. If wives do some work during these times, their work becomes part of the household quota of paid work.

Reduced wages in the industry, then, are predicated on the exchange of women's (and often, also children's) labour: planters pay men lower wages because women are paid even lower wages as well. Two full-time earners may scrape together a family wage in this way, but this is rare. The common case is that men are underemployed and women are unemployed in the off-season and many women are underemployed during the peak season.

Reduced wages are widespread in sugar production. A survey of sugar workers in the mid–1970s in 83 *haciendas* in the Western Visayas revealed that 58 per cent of the workers did not receive minimum wages. Workers were also

not given labour benefits: 54 per cent were denied social-security benefits, 90 per cent did not receive workers' compensation and 65 per cent were not given Medicare.[30] Wages have also been slow to rise.

Options for other work are limited. *Hacienda* residence provides women with some security of employment, however irregular, but it limits women's access to other productive work. The *hacienda* is the matrix of community life and women are largely dependent on the planter and the *hacienda*. Some women raise a chicken or a pig, or tend a small vegetable plot by their home. Daughters work as domestic help outside the *hacienda*, usually in nearby towns and some of them send money back home to help out in family expenses. During the off-season a number of women do laundry, make charcoal or do other similar low-productivity work; a few sell basic necessities in their homes, but selling does not last long because women lack capital. In large plantations, wives or female relatives of *hacienda* officials operate *cantinas* and residents buy from these stores, although items are higher priced than in town stores. Most women are generally isolated from productive work, which is only to be had by those living outside the *hacienda*.

By the early 1980s, mechanization had eroded many existing labour arrangements. When tractors were introduced in the early part of the century the demand for male labour to harness animal power was reduced, but men were still needed to operate the tractors. However, recent mechanization has affected women workers more than men.

The specific effects of mechanization are seen in two recently mechanzied *haciendas* in Western Visayas. Within the two-year period (1980–2) in which these *haciendas* became fully mechanized, 35 per cent of women workers and 53 per cent of child workers were released.[31] For example, a machine which did a variety of tasks replaced the work of 20 women. Only a few of the women who remained in the *hacienda* had regular work and most were working only part-time. Large numbers of women workers and limited work meant a decrease in the individual's share. As a consequence, women's contribution to household income dropped from 30 per cent in 1980 to 18 per cent in 1982.[32] Other machines came to replace the work of more women, children and some men. As more machines were used, allocation of work by sex also became more selective. Men were hired over women because they were heads of households;[33] resident households then became fully dependent on the wages of the male head. The number of resident workers was also restricted: sons and daughters were no longer taken in as permanent workers. In addition mechanization undermined women's home production as sugar hectarage was extended further, reducing the size of women's garden plots.

By the mid–1980s, 25 mechanized *haciendas* had reduced their labour-use by 89 per cent while productivity had increased by 38 per cent and costs reduced by 12 per cent.[34] Planters' investment in mechanization, it has been said, meant the acquisition of a capital asset rather than a 'social responsibility'.[35]

Among displaced labour, men were given preference when work was going: they were given small livelihood projects such as raising livestock and tree-planting, although these consisted of only a few days' work. Women were not

involved in so many projects, which were, in any case, short term and even lower paying. An export-crop diversification programme is now underway in the province but this has become an entry point for the expanded activities of agri-business multinationals and will benefit primarily the *hacienda* owners rather than the worker.

Women who have been displaced in *hacienda* work now compete with the increasing numbers of other women and girls who try to find work in towns and cities. Displaced women and men have swelled the squatter population of Bacolod, Negros Occidental's largest city; by the mid–eighties close to 30 per cent of the city's population lived in squatter areas.[36]

With mechanization in sugar, therefore, the productive work of both women and men is made more precarious. But the process has disproportionately affected women, as other productive work is no longer available to them. The loss of paid work in sugar and the absence of paid alternatives has meant further deterioration in levels of living. In 1987 an estimated 82 per cent of the population of the province lived below the poverty line.[37] Malnutrition levels among sugar-plantation workers, already among the highest in the country, have become worse with the displacement of workers.[38] In the mid–eighties 33 per cent of the children in Western Visayas were undernourished and 50 per suffered from second- and third-degree malnutrition.[39] In sugar production in Western Visayas, therefore, higher levels of productivity also meant a higher incidence of poverty and malnutrition. Profits in sugar production have been far, far 'too concentrated'.[40]

The expansion of wage-labour relations in Western Visayas was accompanied by the emergence of an organized working-class movement. Continuing deterioration in the workers' standard of living has brought a class-based struggle to the fore. Worker-struggles in the sugar industry have been for the basic minimum wage and basic benefits. As dominant political and economic groups have repressed this struggle, a culture of violence has been spawned. The region is the scene of militant, and often violent, encounters between the ruling class, the military and paramilitary groups, on the one hand, and the working class, on the other.[41]

The prospects for the sugar industry are not bright. It may experience some resurgence with increases in American quotas, but sugar production will most likely not re-establish its previous profit margins. Because of pressures from consumers, industrial countries have shifted to synthetic or organic substitutes which are produced within these countries. This shift means a contraction of international demands for Philippine export crops. Coconut production is experiencing the same fate. Many food manufacturers have replaced highly saturated palm and coconut oil with less saturated soybean and corn oil, also produced in the USA. Coconut, palm-oil and sugar production will decline and will release more labour. The traditional role of the Philippines and other Third World countries as supplier of agricultural commodities and raw materials is rapidly declining.[42]

Other work in the sector

Women's work in other crop production and in other areas in the agricultural sector is also worked out within the same set of determinations that define their work in rice and sugar production; primarily their relations to productive resources and to men, and such factors as their age, the composition of the household, the nature of crop production, and the organization of the production process.

In other staple crops, women's labour is not as extensively used, while in growing vegetables and fruit women generally put in more time than men. In upland and subsistence farming, women plant root crops and the lower level of productive forces means women's work is both more intensive and more extensive.

Women who are engaged in subsistence farming are mostly tenants or independent producers; but women who farm export crops have a direct link with the global market. For example, onion and cabbage farming in Central Luzon, involving some 7,000 tenant families, was tied to international and national capital in a package of seed, fertilizer and produce. Monopoly was exercised by means of a package of technology imposed on tenant families by capitalists. In this type of arrangement, surplus was captured at all stages of the production and marketing process: from the technology package to the underpricing of the produce. But the main source of surplus was the very low wages paid to farm workers. These workers were mostly the wives and daughters of peasants, and a few out-of-school youths who earned P4.00 a day (about 54 per cent of the minimum wage in the early 1980s) for extended hours of work.[43] Multinational investment in onion and cabbage farming is one example of the use agri-business has made of family structures and a cultural gender-based division of labour to increase profits.

In fishing communities, women traditionally sell the catch of their husbands – the fishermen. More recently, however, motorized *bancas* have eliminated women's role: men now bring their catch straight to the market. This new arrangement may bring in more income to men and to the household but women no longer have access to market work. The fishing methods of big capitalists and foreign firms have also depleted the fishing banks and destroyed the coral reefs in Philippine waters,[44] further marginalizing large numbers of households and limiting women's access to income and food sources.

In the agricultural sector as a whole, women find sources of supplementary income in raising small livestock or 'share-breeding', cultivating garden plots, and gathering forest products and small fish or sea plants. But agricultural chemicals, industrial wastes, dynamite fishing and increasing encroachments in the ecological system have poisoned or otherwise destroyed many of the household's and women's food and income sources. Deforestation, for example, has increased soil erosion, further reducing not only agricultural productivity but also the general availability of fuel, water and forest products.

Agri-business: the banana-export industry

The banana-export industry started in the late 1960s and by 1978, it was

directly employing 30,000 workers and many more casual workers.[45] The industry is located, for the most part, in Mindanao, where bananas are either grown on land leased directly by multinational corporations or on large plantations owned by wealthy local agriculturalists, or the work is contracted to smallholders. Most of the bananas, until the late 1970s, were exported to Japan: now the market is more diverse.

In smallholding grower farms contracted to multinationals, women's labour is used much in the same manner as family-owned rice farms, that is, as part of household production units.[46] Wives and daughters work as family labour on their own banana farms to cut down on labour costs. This is because households which have converted their lands to banana production in order to improve standards of living have, in fact, experienced the contrary. These households are now in a continued state of debt to multinationals as a consequence of their shift from staple-crop production to banana production for export. Multinationals advance the money for the costly conversion of crop lands to banana production as well as for other farm inputs. But growers are unable to meet the resulting debts at harvest, because price increases for farm inputs outrun banana purchase-price increases.[47] Growers then try to save on costs and to increase production. What emerges as the most common and convenient way to cut down production costs is to use family labour: wife, children and other relatives. Still the cash share which growers receive from the company after expenses are deducted is barely enough to constitute a subsistence wage.

The nature of banana production also severely limits efforts at other types of productive work, particularly for women. Chemicals used in operations are hazardous to people and often fatal to livestock. Thus, having a plot of vegetables has become risky. For fear of contamination, most banana-growing households have to purchase all the food they eat. As a result, these households have become fully dependent on a cash economy.[48]

Women workers in the factory operations of the industry, however, are integrated into the economy in a different way. They are a different group too: they are usually younger, in their late teens and early twenties (because they are 'easier to deal with'), and have a higher than average level of education (most are at least high-school graduates). These workers are part of a larger group of young women with relatively high educational attainment who enter agri-business, but who otherwise would probably not accept work in agriculture. Agri-business is able to impose these educational requirements because of the large reserve of women of this age group. These women are mostly migrants to the area, coming from 'economically depressed' provinces within the region.

Tasks in agri-business enterprises are more sharply delineated. Field work, 'heavy' work, skilled work and supervisory positions in the plantations as a rule go to men and these are higher paying than women's work. In some plantations, male prison labour is assigned these tasks.[49] Women do the 'lighter', repetitive tasks and the more 'delicate' operations. Women are assigned to these tasks because of sexual stereotypes. But women's assignment to these tasks in agri-business also has a material base: work is irregular and

almost always lower paying. Since women are seen as auxiliary income-earners, they fit into this type of work.

One such task is in the packing operations of the banana-export industry. Thirty per cent of the work-force in the industry consists of women involved in packing and a few field operations.[50] Within these firms, women basically perform assembly-line functions – one of the few jobs in the industry that approximate factory work. These have to do with packing operations: cleaning, dehanding and weighing bananas. Young women are preferred for this work because, it is said, of the delicacy of the operations. Bananas have to be handled carefully for packing because bruised bananas are priced lower in the foreign market, if they are exported at all. (Although women also work in non-delicate operations: in one multinational firm, four women workers, in a room three by five metres in size, do nothing but fold chemically treated newspapers and plastic bags all day.)

But women are also preferred for another reason. Packing operations are crucial in the timing of banana production.[51] Once bananas are brought to the packing plant, they must be prepared and packed for shipping immediately before they ripen. Ships always leave on schedule so that while there are bananas to be packed, women have to continue working. During peak times, this may mean 16–20 hours of continuous work. Since wages in packing, however, are on a piece-rate basis, workers get no overtime pay. Pay is based on the total production of the unit (the number of boxes packed per day) divided by the number of employees. Pressures on workers are high: there is pressure to produce at similar, usually high, levels and slow workers are eventually eased out. In some cases women workers are not directly hired by the company but through a subcontractor who deals directly with management. In this type of arrangement, firms are not directly responsible for women's labour. The contractor pays the wages of the workers after deducting a 'service fee', so that if the firm pays P0.20 per box, the contractor gets P0.05 and the workers get P0.15. Wages do not always reach minimum levels on the basis of an eight-hour day.[52]

The important implication of a piece-rate wage is that workers are not permanent but casual or part-time. If there are no bananas to be packed, they have no work, and therefore do not get paid. Workers try to work as much as they can during peak periods to compensate for times when there is no work. Women are usually contracted to work from three to six months, but they are not always rehired. As a labour-control strategy, contractors hire a different group for each season of work. Women workers also do not get labour benefits.

Women then are suitable not only because of their docility and the delicacy of the operations but also because packing is a part-time operation and is also piece-rate work. Women are a secondary labour force which can be absorbed or withdrawn at any time with a minimum of repercussions in the economy. Gender-based characteristics of women's work and women's position in the labour market converge with a capitalist labour process to make women a preferred labour force.

Work conditions in the industry and multinational practices have also affected the life chances of women and men workers. Work-related conditions have been detrimental to the health of many workers: there are many cases of workers having contracted skin diseases or respiratory problems from chemicals used in field and factory operations.[53] Multinationals also extend their control over labour by regulating fertility and sexual behaviour: plantations have family-planning programmes and women and men who undergo sterilization are given cash advances as an incentive.

As in other corporations, banana plantations have a hierarchy of labour and a few women workers are in a position of some authority. Some of these women live with their spouses, also employed in the firm, in upgraded housing units within the compound. They comprise the labour 'aristocracy' of the lower working classes and their identification is usually with 'our company' and workers are 'their girls'.[54]

But for the majority of women, living conditions in the banana plantation correspond to work demands. In some plantations, women and men live within the compound in separate, but overcrowded and inadequately equipped, bunkhouses. Provision of residence is the means by which managers control the work-force and are assured of readily available labour. Some women workers view their bunkhouses as strategically placed near packing plants so that management can more efficiently draw on their labour when and as long as needed.[55] A few married women live with their husbands in their bunkhouses but other couples have to live apart, and see each other only occasionally.

As in sugar *haciendas*, the centre of life in the banana-export industry is the plantation. Women are unable to engage in any other productive work because they have no outside contacts. Since most of the women workers are also migrants, their whole social life is on the plantation. One consequence of this situation is that women have sexual relationships with men on the plantation. Some marry workers, including prison labourers, but these men are not always single. Some of these men already have families outside the plantation but still start another family inside it.[56]

Despite the density of living arrangements in these plantations, however, there is no sense of community life. As one priest describes it:

> Plantation life is . . . like a bunch of strangers living together. From the highest American executive to the lowest agricultural worker, no one is really at home in this place. The church is not theirs, the community is not theirs, so there is not much effort to build for the future.[57]

There is also no sense of security of employment in the multinational firms. Labour unions are rare, despite deteriorating working conditions, because there is always the threat of these firms pulling out once wages rise. When these firms do pull out, they leave behind a depleted soil and an army of over 30,000 people without work. Already, in the past years, there has been a recession in the industry. Bananas began to glut the Asian market and Japanese

consumption fell markedly. As a result, production and employment have been cut down.

Gender in agriculture

Women's labour in agricultural production ranges from unpaid family labour to hired farm labour and factory work. The bulk of this labour, however, is appropriated as unpaid family work or as hired farm labour. Unpaid family work, especially, is a most common social relation among women in agriculture. But the reason is not that agricultural production is seen as a cooperative household production process, and therefore household members collectively work as a unit, but rather that women are seen as peripheral to the production process. Agriculture is viewed primarily as male work. Men are the farmers and women the farm workers. Filipino women's role in agriculture is almost always seen as 'helping out', regardless of whether or not they put in more time or perform more tasks in crop production. This is because women are deemed unable to cultivate land independently: they are seen as not possessing the required strength or skills to see through the complete cycle of farming operations.

This view of women, however, is very specific to lowland agriculture; in another area of the country among the highland Bontoc Igorot, women see through the complete farming process. In fact, in these villages, women are the primary agricultural producers. In lowland Philippines, gender-based stereotypes keep women's work in agriculture peripheral and unpaid. Clearly, ideological forces are at work in defining women's position in agricultural production.

A 'helping-out' role in agriculture, which derives from a merging of women's primary responsibility for the home and from stereotyped notions of the different abilities of women and men, has several consequences for women. It often means women are not paid similar wages to men; they are not given preference in hiring for farm work but, once given work, they are routinely assigned to the 'lighter' or labour-intensive tasks whether on their own farms, on large *haciendas* or on multinational plantations: they are not the primary beneficiaries of training programmes which increase crop productivity or introduce new technology. In other words they are 'rationalized out' of the transfer of technology; and they do not ordinarily have primary access to projects which provide credit or productive resources. In brief, women's economic production is minimalized.

Yet the evidence shows that even in the lowlands, women are not really auxiliary workers; among the landless and smallholding families, women's farm work is crucial to the agricultural process and to the survival of the household; among the largeholding families, women's family labour may be released from farm work but it is nonetheless replaced either by the labour of hired women or men, or by mechanization if the production process is to be completed. The productive work women perform is work that cannot be dispensed with. Thus work becomes a matter of 'helping out' only if women do it; men who do women's work when women are not available are not seen as

'helping out'.

Women in agricultural areas also contribute a considerable amount of energy to family survival from their household-based work. Estimates of 'full income', which included the value of household work, were twice as high as women's marketed income from the job market: women's share of the household income was roughly 20 per cent but they contributed almost 40 per cent of full income.[58]

Recent economic processes in agriculture have had contradictory effects on women. As these processes have taken men away from agricultural production or converted them into cash-crop farmers, more and more women have become solely responsible for staple-crop production, especially subsistence production. Many more women are no longer merely 'helping out'. On the other hand, the increased productivity in agriculture has led to a marked decline in the employment of women. Male labour has taken over many of the shared tasks in rice cultivation while mechanization in the sugar industry has eliminated work opportunities for women. Yet agri-business firms with their emphasis on export have not tended to absorb the same work-force of women. Instead they have tapped a different group of women.

The industrial sector

Manufacturing

Manufacturing in a much earlier period meant the independent production of women weavers, spinners, and embroiderers. Now it represents one of women's most direct links to international capital. Manufacturing is considered one of the most forward-looking of the industrial sectors, but for women it also embodies one of the most anachronistic of capitalist forms of labour appropriation.

Within the last decade, non-traditional manufactured exports have increased phenomenally, and the leading export industries are predominantly labour intensive and are women's work: garments, handicrafts and electronics. In each of these subsectors, the production process has intersected with a gender ideology and a sexual division of labour in different ways, but with roughly similar consequences for women.

Garments

The garments industry did not have as important a position in export manufacturing until 1961, when a law allowed firms to import raw materials tax-free for processing. Previous to that year, the industry employed 10,000 regular workers and 100,000 subcontracted or domestic outworkers. Between 1959 and 1968, garments exports increased from $8,500,000 to $38,200,000. From 1971 to 1977, with the energetic promotion of the export platform, garments exports increased 560 per cent to $249,700,000.[59] This growth was accompanied by an increase in the number of foreign-owned garments firms in the Philippines: these firms accounted for the largest share in the export trade.

But by 1982 a decrease in foreign demand led to a drop in garments-export earnings by close to 20 per cent. Many factories closed down or laid-off or rotated workers. By 1983 there was an increase of 44 per cent in the number of workers made redundant.[60] The industry also suffered a decline in demand as protectionist measures were adopted by major importing countries such as the USA and England. The industry bounced back in 1986 with increased demands in the foreign market, but this is seen as a short-term resurgence. Recent trends in automation and other cost-cutting strategies in the First World may soon permanently override the advantages of labour-intensive (that is, low-paid) women's work.

The low capital investment involved in garments production has had the effect both of engendering many small-scale subcontractors, supplying garments to big firms, and of these firms expanding into other areas with relatively low-labour costs. The situation and characteristics of labour in garment production are the outcome of technical factors in combination with the labour requirements of export-led industrialization.[61]

Most garment firms operate on a consignment system where a foreign principal and a local operator enter into a job-service contract. In a majority of cases, materials are shipped to the Philippines for manufacture into finished or semi-finished garments and then shipped back to the country of origin. The local connection may operate an establishment, or farm out the entire job or certain stages of it to subcontractors. In 1981, there were about 1,000 establishments and about 2,000 manufacturing contractors: most were located around Metro Manila, a few were in the export-processing zones. In 1978 these establishments and contractors put out work to some 500,000 homeworkers and employed about 214,000 factory workers.[62] Based on these estimates, the majority of the outworkers are paid a piece-wage. The other part of the work-force consists of factory workers paid a daily wage. The industry therefore consists of a two-tiered labour force and the existence of such an arrangement is evidence both of the capitalist system's contradictory operations and of its extreme flexibility in incorporating varying economic conditions as it expands.

Payment by piece and payment by a daily wage are different in form but are in essence the same.[63] At different stages of capitalist development both forms of wages have existed side by side, at the same time, in the same branches of industry. Each form has its own advantage for capital depending on such factors as the nature of the production process, the availability of labour, structural conditions in the manner of operations and technological development. But payment by piece is the 'more favourable to the development of capitalist production'[64] because: 'The quality of the labour is here controlled by the work itself, which must be of good average quality if the piece-price is to be paid in full. Piece-wages become, from this point of view, the most fruitful source of reductions in wages.'[65] There is no problem regulating the work in a piece-wage situation since:

the quality and intensity of the work are here controlled by the very form of

the wage, super-intendence of labor becomes to a great extent superfluous . . .
Given the system of piece-wages, it is naturally in the personal interest of the
worker [to] strain his [her] labor-power as intensely as possible . . .[66]

The labour intensity inherent in piece-wages is a significant point,
particularly for women's work, because it is the same labour intensity that is
obscured when women work as unpaid family labour, when they are in
low-productivity self-employment or subcontracted labour and when they do
housework as well. The illusion lies in the sense of freedom, independence, and
control over work that appears to characterize piece-work and the self-
employed work of women.

Garment-factory workers are principally paid a wage according to time
worked, but they are in fact also paid piece-rate because of the quota system.[67]
As competition intensifies in the domestic and international garment markets,
capitalists have to increase production without a corresponding increase in
wages; thus, manufacturers have imposed higher and higher quotas. In some
factories, daily wages are not paid until quotas are reached.[68] The labour
intensity inherent in piece-rate work, then, has been incorporated into the
quota system in which workers earn a time-based wage in order to increase
production.

Cottage industry workers and domestic outworkers in the cities and
countryside are paid mostly on a piece-rate basis. As piece-rate workers, they
are not covered by the minimum-wage legislation and do not get any labour
benefits. Because sewing is done at home or in small cottages there is little or no
capital investment for overhead costs in production. Those directly employed
by manufacturers (about 25–35 per cent) do waged work in small cottage
'factories'. Many of these workers live within the factory compound so that
lodging (and sometimes board) is subtracted from their wage. The outworkers
work in their own homes, within a putting-out system: they are supplied raw
materials by contractors and are paid a piece-wage for the work they do on
these materials. Home sewers are not in any sense independent producers.

In the garment industry, the relationship between the two types of workers,
the factory and outworkers, is not one of complement but of competition.
Factory work for a wage is the labour form by which capital is assured of a
constant and disciplined work-force, but factory workers are in a precarious
situation because of a large pool of outworkers in the countryside. Factory
workers can be released and work transferred to outworkers, a situation which
has already taken place in a few firms.[69] At the same time, the large labour
surplus also mitigates against higher piece-wages for outworkers.

Outworkers earn very little. In 1960 they were paid P0.30 (about $0.06) for
each baby dress. In 1980 it was about P0.50 (about $0.04).[70] The most that a
worker can finish in a day is a dozen baby dresses, for which she is paid an
average of P7.50 ($0.63). (Compare this to the daily rate of P17 [about $1.42] in
agriculture). Yet each baby dress would sell for at least $30 in American or
European department stores. Moreover, work is available only for about
two-and-a-half to three weeks a month so that total monthly earnings averaged

about P146 ($12.13).[71] Part of the reason for the reduced wages in the sector is the intense competition which results in price-cutting. In fact, provincial sub-agents and sub-contractors are unable to capture much of the surplus: most of it is accumulated at the other end of the contracting process by foreign principals.

Piece-rate work is expedient for the industry in other ways. It is deemed very suitable for garments because the industry is highly changeable: fashions, styles, and demands fluctuate as tastes and consumption patterns change. These fluctuations mean that work is available only if there is a demand in the export market. Piece-rate work is also eminently suitable for women. It is commonly argued that most garment workers are women because this is traditionally women's productive work: Filipino women, with the historical tradition in this type of work, provide almost ready-made skills. Furthermore, home-based industry is encouraged because it is a viable arrangement for women; they are able to combine paid work and household chores with a minimum of conflict. Piece-rate, irregular and casual work intersect with women as a sex and as supplementary earners.

In the countryside, piece-rate work usually takes a secondary role to agricultural work, because it is better paying. At peak periods in farming when women have some option, they commonly do not work in garments. The increased numbers of landless agricultural workers, however, have narrowed this option so that sewing becomes not just off-season work but the main productive work of women. Yet, as one survey shows, although work in garments was women's main productive activity, it earned them only between 25–33 per cent of their husband's income. For this reason, women considered themselves secondary earners. Nonetheless, women also saw themselves in this light even when they were in fact the main earners: in this same survey, one out of four male heads of household did not have regular or permanent employment.[72]

The majority of women factory workers are also from farming and fishing villages. Two or more women from the same family may work in the factory; even so, their combined earnings still fail to meet minimum subsistence needs. Some women, meagre though their earnings, are able to send remittances to help support family in the countryside. On the other hand, during slack periods, many women depend on some type of assistance from these villages in the form of money or food. There is then a two-way subsidy, however small, among the labouring population because of the irregularity of waged work in towns and cities and the inability of earnings or wages to meet subsistence levels in the countryside. At the structural level these two-way subsidies embody the processes of depeasantization and re-peasantization; at the personal level, they present conflicts between the social aspirations of women and the economic dependence of their families.

Work in many garment factories is carried out under sweatshop conditions: work takes place in crowded and inadequately ventilated rooms and the movement of workers is limited. Pollution from chemicals and fabrics leads to a high incidence of tuberculosis and other respiratory diseases among garment

workers. Low wages combined with sweatshop conditions in garment factories have resulted in frequent strikes in the industry.[73] It is not rare for female garment factory workers to be sexually harassed or abused by male supervisors and employers.[74] Fertility has also been subject to regulation. Women are given monetary incentives if they use contraceptive devices, or if they are sterilized.[75]

For most women in garment production this work is no longer a matter of choice – often it is the only option open to them. Their dilemma is between having a job with an inadequate wage or no job and no wage at all. This is the reason women have very little bargaining power with their wages. Whether paid a daily wage or by the piece, women workers have not benefited from the increased productivity in the garment sector.

In recent years, as higher technology was introduced into the process, work became more fragmented, and jobs were redefined and became available to men. One multinational garment factory, engaged in the manufacture of blue jeans, shows a distinct sexual division of tasks and wages.[76] Roughly 95 per cent of operatives in this factory are women, most of them single and most of them high-school graduates. In this company intermediate floor supervisors are sometimes women, but senior middle-managers are almost always men. In a long line of assembly-type functions, women and men have specific tasks: males are cutters ('this job is too hard for women'), pressers (the highest-paid assembly workers), sewers of pant cuffs (because men have to carry the piles of pant legs – work which is 'too heavy for women') and put in zippers (this is at the top of the piece-rate scale and a task 'too hard for women'). Men's work in the factory also tends to entail more advanced technology. Women sew the distinctive back-pockets (this section gets a low piece-rate wage) and insert the copper rivets at stress points; other women with more skills work on the difficult seams and are paid middle-range piece-rate wages.

The work process in these at once mixed and divided operations indicate several things. As men enter a female industry and as the industry becomes more mechanized, the tendency is for men to receive higher wages than women because their work is 'heavier' or 'harder' and because men are assigned higher technology operations. But it is also men as management who create and implement employment strategies. These strategies have been in the direction of creating work which is defined as low-skill (and therefore lower paid) and subsequently of placing women in these types of work or of defining work as low-skilled because it is women who do them. In other words, it is the sex of those who do work rather than the work itself which leads to its identification as skilled or unskilled.[77] These strategies have the effect of strengthening men's monopoly of higher skilled, higher paying work even at the expense of efficiency from capital's point of view.[78] The categorization of what is men's work and what is women's work then is constructed by human subjects on the basis of skills and strength which distinctively privilege the interests of men. Skill, an objective category, becomes implicated with subjective gender ideology to pre-empt women from higher technology work and higher wages. With gender as the basis of job placement on the factory floor – where women

become located at lower ranks and lower pay in the industrial hierarchy – gender has come to determine class.[79]

Textiles

Textiles is an allied industry of garments although it has not seen as phenomenal a growth because its market is primarily domestic. But the essential relation of the two meant that increases in demand for garments also increased production in the textile industry.

The manufacture of cloth has been women's traditional work. Throughout most of the Spanish period, as we have seen, cloth-weaving was a widespread activity among women. But towards the end of the nineteenth century, the numbers of weavers had declined, largely because of the loss of the market to imported textiles.

By the time large-scale textile production was introduced into the Philippines during the middle years of American rule, home weaving had diminished considerably. From more than half a million weavers and spinners in 1903, the manufacture of cloth involved only 91,000 in 1939, and most of these were part-time weavers. At this time, mechanization was not on a significant scale and growth rates in the industry were slow. This stemmed from the neglect of the sector: profits in textiles were relatively low so that emphasis was given to the more profitable cash crops. In the 1960s and through the 1970s, because of increased production in garments, the labour-force in textiles increased tenfold.[80]

But textile production, which had had a predominantly female work-force in the past, had become largely a male industry. In other words, women did not follow their traditional task of weaving into the factory. In the past decades, textile manufacturing employment has been, on average, about 67 per cent male and almost all have been waged workers. Mechanization in the industry made production less labour-intensive and thus recruited more men; men continued to be hired as the industry became more and more mechanized. But in recent years, proportions of women have increased and this in spite of the 'growing technological complexity' of the industry.[81] The greater number of men in textile manufacturing today and the more recent trends toward the replacement of male by female labour may be attributable to shifts in the industrialization strategy. Textile production has been a relatively stable industry: it has not been subject to extreme competition, a situation which is advantageous to male employment. However, the increasing international integration of the industry with export-oriented industrialization – a consequence of its direct link to garments – has led to a degree of competition. Competition tends to act against male advantage in employment; as capitalists try to keep production prices down, women are recruited as low-paid labour.[82] It has also been suggested that this strategy of recruiting cheap female labour was adopted in the textiles industry because it had proved successful in garments.[83]

Within an industry then, technological change usually induces greater productivity and thus higher wages which attract male labour. Hence the

'masculinization' of the production process with technological change. But as the industry becomes subject to competition, women are brought in and a 'feminization' of the industry takes place with the lowering of wages. Gender divisions in the work-place intersect with economic forces to reconstitute the labour-force.

Sexual divisions in textile factories are not always clear cut: women as well as men are factory operatives. Some establishments assign operations according to sex; others do not. On the average, male and female differentials in wages seem not to reflect sex differences so much as tenure on the job.[84] On a case-to-case basis, however, some establishments do have different wage rates for women and men for similar work so that women receive approximately 84 per cent of male wages.[85]

With respect to factory operatives, then, the major reason for relatively undifferentiated wage rates for women and men appears to be the almost equal proportions of the sexes performing basically similar tasks. It is when men perform tasks which are defined as male in a female industry, for example work in the blue-jeans factory, that there is a difference in wages. When men are employed in a predominantly female industry, they are either assigned to higher skilled, higher paying tasks, or paid more because they are assigned male-defined tasks. But, where there are basically similar tasks, women and men's wages tend to be similar. As well, when there are more men the tendency is for women's wages to approximate that of men, that is, wages tend to be higher. The more female the industry, the more it tends to be lower paying. There is, therefore, a close connection between the proportion of men in the industry, the similarity of tasks women and men perform, and the extent to which male and female wage rates converge. (Mixed operations in agricultural systems exhibit similar convergences.) Hence, in the connection between gender, skill and wages in the Philippines where conditions of work are roughly similar, it matters as much *what* is done as *which sex* does it.

There are also other ways in which the sex of a person figures in access to productive work. Female applicants in several establishments have to be single, while males need not be. A reason frequently given for the preference for single women is to avoid paying maternity benefits. Promotion also favours men. Thus, establishments not only impose less restrictions on men in hiring; they also give preference to men when it comes to promotion.

Handicrafts

Women's work in handicrafts production is carried out in very much the same manner as work in the garments industry. Handicrafts work is an allied manufacturing industry which has grown rapidly in the past decade. In 1970, handicrafts exports were $6,500,000; by 1975 these had grown to $78,200,000.[86] Handicraft production includes, among other things, embroidery, bamboo, rattan, and other native crafts. The industry directly and indirectly employs more than a million workers, the majority of whom are women.

Many women who work in handicrafts in the countryside belong to households who subsist on a combination of small-scale rice farming, coconut

production, small-scale fishing and waged labour. Some of these households belong to ethnic minority groups. Wages in the industry are low. In a 1983 study, the highest-paid female crafts workers earned only 50 per cent of the minimum wage and relative to wages of other female workers, 66 per cent of the average.[87] Yet female earnings contributed almost half of monthly household income.[88] This means that the income of handicrafts workers is far from being a supplementary income source; it is the main economic activity of many women and a principal source of livelihood for the household.

Handicrafts is also a very changeable industry and does not offer women continuous full-time employment. The demands for specific handicraft articles are extremely shortlived so that fluctuations are frequent and sometimes severe. For example, in 1972 the foreign demand for shell necklaces dropped markedly, causing a near collapse in the shellcraft industry concentrated in Cebu province. In the same year the demand for bags and baskets more than doubled, only to fall again in 1977.[89] There is a constant change not only in designs but also in the type of product, so that there is usually less flexibility in production, skills and raw materials. A drop in shellcraft demand is not easily replaced by a new demand in hat weaving in the same area, although some skills are easily learned. But what exacerbates the fluidity of the industry is the practice among subcontractors of recruiting labour from different regions as a cushion against fluctuations. One type of work-force is dropped in one region and a different work-force is recruited in another. This practice has had disastrous effects on communities whose main source of livelihood is dependent on a specific craft.

An example of women's work in handicrafts production which demonstrates the fluidity of the industry is what happened to hat weaving in Aklan province in the late 1970s.[90] In this agricultural community, women wove hats during the off-season. They were independent producers on a very small scale: they bought the raw materials (palm leaves) from people in upland villages and made hats out of them for sale to traders in town. These hats were usually sold in the market for P0.40. In this way, women were able to have some control over prices and sold to the highest bidder.

The export enterprise started when a handicrafts contractor in the province received an order for one and a half million pieces of a certain type of hat. For this hat, women weavers were offered a higher price. About 800 women and children were recruited to weave an average of 20,000 hats a week. The exporter provided cash advances and goods on credit, plus small loans. When women had become dependent on this work the exporter reduced the price of the hat from P0.70 to P0.60. In the meantime, the price of the local hat went up to P1.00 as a result of diminished supplies. Because of their debts, weavers continued to make the hat for export. But even with the high-priced export hats, piece-wages were still very low. A woman who wove hats for eight hours a day produced about 40 hats a week, for which she received P24. Deducting the cost of raw materials, her income per week was P16, or a daily income of about P2.50. At that time rice was P2 a kilo and a household of five consumed about 2.5 kilos of rice a day. After a year, there was no longer any foreign demand for

these hats and women went back to producing local hats – which, with the increase in supply, went back to their former price. Based on these earnings, weaving hats was really a supplementary earning activity. But during the off-season, weaving was the occupation of most members of the household because no other jobs were available.

In Aklan province, then, work for the export market provided only short-range employment for women. But the benefits of employment and of the additional income were counteracted by the prospect of low pay, dependency and instability. Women's ability to become independent producers or sellers to supply a broader market is inhibited not only by a lack of capital but also by the lack of control over prices. Fluctuations in foreign-market demands were also a major cause of the instability of women's export-oriented work.

The rise in exports of handicrafts and garments has largely been at the expense of the standard of living of both women and men in the countryside. The promotion of small-scale industries, an important programme in export-directed industrialization, because of indiscriminate links with transnational capital, has obviously benefited only a handful of people.

Microelectronics

The most modern kind of women's productive work, work which puts women in the vanguard of industrialization, is also work which makes the most blatant use of gender stereotypes and female sexuality. Women workers in electronics are only a small portion of the female work-force but they epitomize the extent of export-directed industrialization.

Women's work in microelectronics is a very recent phenomenon, the industry being only about two decades old in the Philippines. In 1973, export sales of electronics, mostly integrated circuits, amounted only to $11,000,000 and employed only a few thousand workers. By 1977 exports had multiplied several times to $124,000,000, second only to the garment industry.

The establishment of the electronics industry in the Philippines was part of a world-wide movement by electronics companies in the West to cut down on labour costs. For the industry the world is one global assembly line where, by means of job fragmentation, labour-surplus economies perform the labour-intensive operations in production. These operations are exported to off-shore plants because of low wages in these countries. With this new international division of labour, transnational capital – through joint ventures or by means of local subsidiaries – is able to capture more of the surplus, and during recessions, slow down production or simply close down off-shore plants.

These transfers have concentrated in Latin America and the Asian region and the pattern of operations of these electronics companies shows a continuing strategy of cutting down on labour costs. In the 1960s, American electronics companies set up operations in Hong Kong, Taiwan, and South Korea. After a few years workers began to organize, the supply of labour dropped, and wages began to rise. As a result, the companies looked to other countries in the region, to Southeast Asia. After a few years of operations workers again began to organize, labour became more scarce and the wages again started to rise.

The electronics companies moved into Singapore in 1969, Malaysia in 1972, and Thailand in 1973. By 1974, the Philippines and Indonesia were the most attractive prospects.

More than any single industry, microelectronics (and in particular, the manufacture of semi-conductors) is characterized by a rapid pace of innovation, giving rise to pronounced cyclical fluctuations. The industry, like the garment industry, exhibits the classic features of price competition, the primary form of which is price cutting. Plants not operating efficiently enough to keep apace have to close down and so labour is made redundant.

In the Philippines in the 1980s the electronics industry, especially its semi-conductor operations, employed a work-force consisting mostly of young, single women from 18–25 years old with at least a high-school education. (In 1981 roughly 90 per cent of the 35,000 electronics workers were women).[91] They are the 'preferred' labour-force in the industry.[92] Women are recruited because, it is argued, they are best suited to the work: the work is extremely painstaking, demands patience and needs much dexterity. It consists of slicing silicon wafers which are two to four inches in diameter into 500 separate chips of 25 sq mm and bonding these chips with as many as 50 gold wires, the size of a strand of human hair, to circuit boards.[93] Workers use a high-powered microscope and must work at top speed because individual quotas run as high as 800 chips per worker per day.[94]

Women are suitable for this work, it is further argued, only when they are young and single. Women at this stage of life are seen as more submissive, more 'docile' and 'easier to control'.[95] Moreover as young women presumably with no family and financial responsibilities, they are an expendable, low-paid work-force in an extremely fluid industry. There is, too, the added advantage of a work-force that is relatively inexperienced in industrial labour practice.

The electronics industry has also been blatant in its reinforcement of sexual subordination through management practices. Management has extensive control over the lives of its women workers and continually reaffirms sexual stereotypes of women both as consumers and as objects of consumption. Women are encouraged to put emphasis on physical attractiveness, for example, company shops promote cosmetic products; they are exploited for their sexuality, through sexist items in company newsletters; and eventually they become objects of consumption in company-sponsored beauty contests.[96] These contests, which come under the recreational programmes of companies, are held in electronics companies based in the Philippines and Southeast Asia. Such practices in the Philippines, however, exacerbate the already inordinate emphasis on the physical attractiveness of women. Why such practices occur more frequently in electronics than in other sectors has much to do with the type of labour-force and the nature of the work. Reinforcements of sexual stereotypes become necessary 'to keep turnovers down'. Contests and recreational activities are held because the discipline in electronics companies is very strict and workers are made to orient their lives around factory operations and schedules.[97] Companies also try to control workers by creating a family atmosphere within factory work. Family life is duplicated in the

portrayal of the factory as a family, with the manager as a father-figure and the male supervisors as brothers. The family analogy legitimizes the combination of discipline and 'indulgence' in recreation.[98] As recreation and social life become tied to factory work, there is little room for outside activities.

Electronics work illustrates how gender stereotypes justify women's assignment to particular tasks while at the same time creating the conditions which characterize women's work. These ideological considerations merge with the sexual division of labour and the distinctive practices of the electronics industry as it embodies, in its more advanced stages, a new form of the international division of labour. Gender relations and the sexual division of labour are then played out within the international arena.

A case study of electronics workers in the Bataan Export Processing Zone (BEPZ) gives more detail about working conditions in the electronics industry.[100] The BEPZ, opened in 1975, is the most export oriented, world-market dependent of the country's economic structural strategies. Firms within the Zone are for the most part local subsidiaries of multinational corporations. They are granted such incentives as export privileges and exemptions from specific taxes and the payment of minimum wages.

In 1978, the Zone employed close to 25,000 workers, most of whom were factory operatives in garments and electronics. Nine out of ten of these workers were female[101] and of these, more than eight out of ten were single women aged 15–24.[102]

In microelectronics operations in the Zone, managers recruit young women because they are 'easiest to mould', 'learn faster', and 'endure poverty well'.[103] Women are also recruited in these factories because these companies employ them in their factories at home. Companies routinely carry out orientation and job-training programmes in order to instill a sense of discipline in the work-force, an orientation to a company hierarchy, and a feeling of advancement within the company as a personal goal. Women with no experience are preferred, and those who transfer from another firm and have already acquired skills are still considered apprentices. Apprentices receive reduced wages, so companies extend training periods way beyond the requirements of the learning of the skill. Companies require six or more months of apprenticeship for work that can be learned in one or two weeks.[104]

Yet skills learned in electronics have limited application in other industries. When women are no longer efficient for the industry, that is, when they retire in their mid-twenties, because their vision has blurred and they can no longer meet production quotas, they hardly have any reusable skill.[105] Blurred vision, however, is only one physically damaging effect of electronics work. Throughout the production process, electronics workers are exposed to chemicals and other disease-causing substances. In fact, electronics work is considered very high-risk work.[106]

Most of the women in the Zone were first-generation wage earners and almost all were first-generation factory workers.[107] Many came from peasant families. Before they came to the Zone, their main task was housekeeping and their options for paid work were either paid domestic service or wage labour on

the land, both extremely low-paying jobs. Employment in the Zone has brought these women squarely into an 'internationally induced wage-labor to capital social relation':[108] thus, class polarization between international capital and a female working class has been a sudden and dramatic experience, in contrast to women workers in farms and *haciendas* where there has been a more drawn-out process of proletarianization involving a network of precapitalist and capitalist relations.

It is perhaps this dramatic experience combined with the concentation of workers in one place which has engendered militant collective action among women in the Zone. Women's militancy has inevitably brought them into conflict with factory management but it has also brought them into conflict with the trade-union officials, almost always male, earning higher incomes and reluctant to support their efforts.[109] Filipino women workers in export zones are among the most militant in the country, and this in the face of strong ideological arguments about women's docility. Women's compliance has been (and continues to be) held in check by the police and military.[110]

Work in the BEPZ and other zones has also had the effect of cutting women off from a way of life which provided a support system. The system from which these women came meant that in times of market recession and unemployment, their families still had some access to land and were still able at least to feed themselves. With wage relations, if their labour is not hired, women workers cannot survive. Between 1975 and 1976 about half of the workers in the BEPZ had been out of work for an average of three months.[111] As a result, these laid-off workers had to obtain assistance from their families in rural areas. But when the women had work, they sent remittances home. This is another example of the two-way subsidy and the extra-market mechanisms needed to cover the reproduction costs of the worker. Thus, lay-offs affect not only the worker but a whole network of people around her, belying assumptions that these women are responsible only for their own survival.[112]

In spite of lay-offs, however, women rarely contemplated returning to their families in the rural areas. In their home provinces, women's social and sexual behaviour was much more circumscribed. Parents, particularly fathers, restricted daughters because of the value placed on female chastity. The social freedom that came with waged work away from home was therefore valued highly by women.[113] Independence allowed women some options, one of which was to delay marriage and childbearing, although part of the delay arises from the unmarried daughter's obligation to contribute to household income by means of remittances. In large measure, women's lack of autonomy derived from economic dependence on the family arising from their inability to have an independent cash income.

But the social freedom connected with living away from home and independent waged work was achieved at great expense. Wages in the Zone have been low for both women and men compared with other industrial workers outside Manila, but women as a group received even lower wages: 40 per cent of the women received less than the legal minimum wage compared to 17 per cent of the men.[114] The wages of Filipino women are among the lowest

($0.30 per hour), relative to those of their counterparts in other Asian countries.[115]

Living conditions add to women's difficult life in the Zone. Women lived in crowded and overpriced boarding-houses. Specially installed housing in the Zone was not an improvement and food costs were higher than in other areas. Expenses for food and board took up most of the income of the workers.[116]

Sexual harassment and job security, then, went hand in hand in the Zone; women were told to 'lie down or get laid-off'; raises and promotions were exchanged for sexual favours, and some women who were laid-off went into prostitution.[117] And inadequate as their wages were, working women were also vulnerable to unemployed men who were after their incomes.

Export-directed industrialization and women as preferred labour

Export-directed industrialization has had very uneven effects on the economy and on gender relations. It may have created foreign exchange for a brief time, but it is now increasingly seen as having dubious advantages to the economy as a whole because much of what is exported carries a high percentage of imported raw materials.[118] Export industries which build foreign reserves also spawn import-dependency so that in the long run, export promotion has increased trade deficits. Export-directed industrialization has also been accompanied by the establishment of export zones which have the effect of detaching selected areas of the country from the rest of the national economy. A global assembly-line has resulted in a restructured global landscape which interconnects 'economically and technologically valuable elements of each country at the world level' and in the process 'disconnecting social groups, regions, and cities that do not belong to the techno–economic system.'[119]

The effect of export-led industrialization on women has been a very complex one. Export-directed industrialization has meant the availability of waged work for young, single women and this led to changes in their social and personal lives. Yet the very nature of export-directed industries simultaneously made women more expendable and sharpened sexual divisions. Export-oriented industries often recreated many of the conditions generally associated with the informal sector; workers' rights to organize and collective action were suppressed, employment was insecure, the minimum wage was often waived, labour was casualized through the practice of apprenticeships, and productivity quotas were used replicating the intensities of piece-work.[120] While employment in export factories may have expanded the range of women's productive work, it is work that has led to their subordination to a global market and a male-dominated hierarchy of management which has single-mindedly reaffirmed sexual stereotypes and commoditized sexuality as a labour-control strategy.

The employment of young women in export-directed sectors derives from a configuration of factors: an ideology of gender and a sexual division of labour which gives men the prerogative in work, the stage of global capitalist accumulation and expansion, in particular, the new forms of the international division of labour, and the subordinate position of the Philippines in the global

economy. There is then a direct connection between the recruitment of women in labour-intensive manufacturing and service industries and the deepening of the integration of the Philippines as a labour-surplus economy into the global market. Recent industrialization in the Philippines has been as much export-led as it has been 'female-led'.[121] Women's low-paid labour has become the basis of the country's growing international competitiveness.

Export-led industrialization has led to the rapid formation of a new female industrial proletariat of a specific age group and to changes in the sexual division of labour. The preference for young single women in the face of a large labour surplus means that capital does not absorb the existing reserve labour of men and other women workers: instead it recruits young women who are new entrants to the labour pool. In contrast some factories in Mexico and in the Caribbean, where there is no sizeable group of young unmarried women available for work, recruit either men or older women with grown children.[122]

Furthermore, employment is being given primarily to young single women who presumably, because of their relatively higher levels of education, come from middle-level peasant families or urban working-class families. Strategies of employment such as these mean that work is not given to those sectors which most require an income, that is women heads of households and women and men among the surplus population. Thus, the rate of unemployment of males, traditional primary earners, is not significantly reduced.[123] Young, single women have increasingly become the primary-income earners. Many of these women are now the main or sole support of their families.

The new forms of capitalist expansion then makes proletarians (or semi-proletarians) of some men and women and leaves many women out of the wage economy, while simultaneously restructuring the sexual division of labour by recruiting specific groups of women into waged work. The combined effects of a large labour surplus and the employment of young women has enabled capital to pay reduced wages. The instability of the world market, frequent fluctuations in prices, and cycles of capitalist recessions, lead to the continuous release and absorption of labour. Low wages and the instability of the market articulate with gender stereotypes and women's perceived role as supplementary earners to make women the buffers – as their labour is released, it is hardly noticed because women then withdraw to the household sphere.

The shift of the burden of primary-income earner to young women has long-term implications and consequences on gender relations and on the sexual and social division of labour. First, with the preference for certain groups of women, a specific type of segregation of tasks results, that is, a female labour-market is created. While this market ensures women some jobs, it also protects the male labour-market with its higher wages and forecloses options for women to upgrade their skills with economic and technological changes. Secondly, transnational capital's strategy of exporting labour-intensive processes encourages a situation of abundant labour; the reserve pool of labour continues to expand, putting emphasis on the need for larger families, and therefore on women's childbearing role and household work. Third, the relatively high educational requirement characteristic of many

multinational hiring operations in industry and agri-business means that increases in the levels of education have, in turn, led to an increase in the requirements for hiring. As a result, the same proportion of relatively less-qualified women, even if their educational levels are higher in absolute terms, will continue to fill lower-level jobs. Fourth, as industry requires a certain age-group of women it demands a constant renewal of the work-force.[124] Women leave the labour-intensive operations at an early age, requiring a continuous and fresh supply of young girls to replace them. This type of paid work also provides no prospects for alternative employment when the allowed age of productivity is past, and so women are pushed back into the traditional hope of home and marriage. And as industry requires specific groups of women because of their submissiveness, docility, and other perceived gender traits, male-dominant and authoritarian structures are reinforced. Finally, on a personal level, young women's experience of factory life structured along gender lines has been that of a job-created gender hierarchy. Young women are confronted with specific definitions of what masculinity and femininity are within the workplace, and which sex is superior in skill and competence, and which sex has authority and the power to discipline. These definitions then shape women's attitudes and expectations and institutionalize gender differences.

How much longer the electronics industry will be able to absorb young, relatively better-educated women remains to be seen. Already the drive towards automated equipment by American multinationals has de-skilled women's labour and made it redundant.[125] Automation has dramatically reduced the number of operations needed to assemble a given volume of chips, that is, there is less reliance on the 'manual dexterity' of women. The skill levels of assemblers – mainly women – have been downgraded, while the demand has increased for skilled technical engineers, mainly men. Although there is a move to retain women workers, the shift is heavily in the direction of hiring skilled male workers.[126] Women workers may still be absorbed by the international expansion of the industry, but this will be limited to specific areas in the Third World, because of the recent move among multinationals to consolidate operations within a smaller number of more politically stable and more technologically advanced Third World countries.[127]

The direction in garment manufacturing has been towards the increasing automation of labour-intensive operations and the farming-out abroad of still unautomated portions to countries close to home, in order to reduce transport costs.

Recent trends in the international economy indicate that export-led industrialization is coming to a dead-end.[128] Low labour costs, the basis of export-led industrialization, will no longer give the 'competitive edge' to Third World countries like the Philippines. Already the industrial countries have gone through a phase of 'flexible automation' which has reduced labour costs to 10–15 per cent of total production costs. Multinational corporations no longer see any advantage in moving their operations to the Third World; instead they have turned their attention away from cutting labour costs to

cutting costs in other areas such as transportation, and by a more efficient management of time. Processes still resistant to full automation are farmed out to the Third World according to their proximity to the home countries. Hence, a specific geographic integration of countries will result. Although the Philippines is not favourably located for industrial countries in terms of reducing transport costs, the country may yet be a supplier of cheap labour to the 'newly industrialized countries' in the region.

A second trend in the international economy that has affected export production is the increasing protectionism of many industrial countries. Now 57 per cent of American imports are covered by non-tariff barriers or 'voluntary export restrictions'.[129] In textiles and garments the figure is higher: 80 per cent of imports are now restricted by quotas. An estimated 47–75 per cent of Philippine exports today are subject to a variety of restrictions. But protectionism goes beyond trade: it also involves copyright and patent legislation. There is now increased difficulty in the flow of information and skills in critical 'cutting-edge' industries – for example, microelectronics, computers, fibre optics and biotechnology. Unless adjustments are made in the country's economic policy in the near future, all these developments in the international economy will mean reduced employment, especially for women.

Administrative and clerical work

Administrative and clerical work within bureaucratic and large corporate organizations is one form of 'realization labour'. This labour is not productive of surplus value in the same manner as factory work but it facilitates the accumulation and expansion of capital and thus serves to reproduce the capitalist system.[130] This type of work is no less segregated according to sex.

Recruitment and promotion practices in administrative and clerical work incorporate gender stereotypes which perpetuate gender divisions. A survey of business establishments in the 1960s showed the extent to which these stereotypes were institutionalized: these stereotypes are very much alive today.[131] Advertisements for job positions continue to reflect this quite succinctly:

Wanted: Experienced Male Secretary.

Wanted: Experienced Female Secretary, must be single, attractive, with pleasing personality, between 18–25 years old.[132]

Employers and managers in the study expressed a preference for women only if there was a decided advantage in employing them in a particular position: for example, women were considered ideal as receptionists, secretaries, and public-relations personnel: otherwise, employers considered it 'cheaper' to employ males. If a position could be performed equally well by men and women, two out of three employers and managers would hire a man. For

female applicants, it was not enough to have the skills or the experience for a position, they also had to have other qualities: they had to be single (because it was believed single women were not distracted by the responsibilities of family life), young (they had to have 'physical attractiveness') and possess a pleasing personality (read 'female pulchritude' and 'sex appeal'). When these factors were not important, employers would hire men. What these men are clearly asserting is their right to sexual access to women and the translation of this claim over women into power over women's access to work. This is not simply a matter of gender discrimination; it is unambiguously sexual objectification in operation.

In this same study, the work performance and learning speed of female and male workers were the same, so that wages for comparable positions were generally the same. But employers and managers preferred men for positions requiring judgement or decision-making which, not incidentally, were higher-paying positions. Where a vacancy arose for a supervisory position where there was a predominantly female staff, employers did not have sex preferences, but if the staff was predominantly male, employers appointed male supervisors because 'males were considered to have more authority than females'.

In another study, this time in a government agency, women and men doing similar tasks received similar wages but, on the average, women received a much lower rate of pay than men because of their positions in the job hierarchy. Only 32 per cent of the gross differences between the average monthly salaries of women and men could be explained by differences in acquired earnings and related characteristics (such as type of education, job training and employment experience within or outside the agency). But when the level of job – supervisory, technical or clerical – was included, differentials in wages were significantly reduced. The conclusion was that discrimination operated through promotion prospects. Women and men received the same pay for the same job but women had a 'lower probability' of obtaining a high-level position.[133]

Professional, entrepreneurial, managerial and executive work

Women who work as middle- or high-salaried professionals, entrepreneurs, managers or executives do so not for economic survival but for a host of reasons: self-fulfilment, the improvement of standards of living – the difference, for example, between sending children to élite universities instead of ordinary ones; the maintenance of a specific standard of living (in other words, a class position); or keeping the management of an enterprise (or the wealth) within the family. One finds in these categories relatively highly paid professionals such as doctors, managers of family enterprises, independent medium- and large-scale entrepreneurs, and salaried women in management and executive positions. The rapid growth in professional, technical and administrative groups has to do, in part, with the widening base of the middle strata whose growth, apart from demographic factors and expanded educational opportunities, derives from the economic developments of the past three decades. These developments have opened up new sources of wealth

and precipitated the need for a range of specialists and professions.

Women at these levels are, like all other women, subject to the same sexual stereotypes at work; they experience similar forms of discrimination and sexual objectification and their work is assigned a lower worth. They are discriminated against in hiring, training, promotion, the allocation of tasks and in pay. In family enterprises, female members are seen as suitable for certain jobs; they are bookkeepers or treasurers but rarely decision-makers. Only when women are independent entrepreneurs do they become decision-makers and this is because they have greater control of the production process. Women entrepreneurs, however, are in fields which are related to feminine tasks: the food-processing business, restaurant and pastry shops, clothing, and such female-oriented services as modelling schools, song and dance studios, sewing schools, 'personality academies', and crafts shops. High-salaried women in executive and management positions are usually found in service institutions, public relations, personnel management, and such sectors as the arts, media and tourism.

Women in the professions are in work deemed appropriate for them: and in fact they express preference for such professions. Women are paediatricians and gynaecologists but rarely surgeons; few women are architects, some are lawyers, but many are pharmacists. Women are in the lower-paying specializations in many professions. In 1971, the median income of medical practitioners (presumably reflecting only salaries and not professional fees) was P12,400 for surgeons, P7,000 for obstetricians and P6,000 for paediatricians.[134] Furthermore, in the lowest paid of the professions – teaching – sexual harassment is not uncommon. Women who wish to become teachers or to advance in their positions have been known to be subjected to a 'road test' by male supervisors.

Independent and relatively substantial income derived from some professions may increase women's position relative to men in the household but it does not free women from the ideology of women's place. Women at these levels also experience the dichotomy of public and private spheres although it is mitigated by the options that wealth provides. What wealth means is that women have the resources and the option to pay for household work, with low-paid domestic servants. Women's access to professional, administrative, and high-salaried positions allows for the high visibility of women's productive work but it does not necessarily challenge the sexual division of labour.

One must note, too, the distinction between women who are salaried and women who own the means of production as members of family enterprises or as independent entrepreneurs. While incomes may be roughly similar, their relations to productive resources are not. With salaried women, their labour is appropriated; as entrepreneurs or business women, they appropriate the labour of others, often other women, so that women as owners of the means of production participate directly in the economic exploitation of other women.

10. Women's Work: Some contemporary configurations (2)

The informal sector

Subsistence commerce

The trading activities of women have continued, with little change in form, through economic and social processes. But relations to the market and women's position within the distribution system have seen basic alterations. Now profit is no longer captured from the trade itself but from the surplus value derived from the labour incorporated into commodities which enter the circuit of industrial capital. The labour intensity that goes into the processing of food or the long hours of work devoted to the trading activities of women are subsistence activities which are dominated, and at the same time transformed, by capitalist processes for further accumulation and expansion. Subsistence commerce has come to serve capital in the circulation, distribution, and consumption of commodities.

Small-scale trading by women encompasses a range of activities from subsistence vending to running small, home-based *sari-sari* stores – the classic compromise between home and work-place – renting a market stall, and street hawking. A few women are in medium or large-scale trading – those which require much larger capital outlay. But the majority of women traders are in subsistence vending or small-scale trading involving one or a few commodities (from ready-to-wear clothes to vegetables, sweepstake tickets, cigarettes, peanuts, cooked duck-eggs and *leis*). Labour use varies with different degrees of control over the means of livelihood ranging from owner–operators to the commoditized labour exchanges embodied in waged work or in hired dependent selling.[1]

In the countryside, the trade is carried on mainly in town markets, although some takes the form of itinerant peddling. Selling is rarely past subsistence scale: some women may sell produce from their backyard or sea-plants which they have gathered along the shores: while others may sell the small fish caught by their husbands. A few women are medium-scale traders and sell vegetables grown on fairly large plots or gathered from other people's gardens, while others sell items, such as salt and rice, on consignment from the town merchants. But types of vending are clearly demarcated according to sex. Larger fish, meat and bulk cloth – generally higher-priced items – are usually

handled by male traders while vegetables, fruits and small plastics are either sold by women or by both men and women.[2]

Vending is not always regular work in rural areas; many women sell their produce when they need cash for a specific processed or manufactured item for their own consumption. Women who sell regularly are either heads of households or they need to contribute to household income. For irregular traders, prices of products are pegged on the basis of their expenses, with a small margin of profit; but for those who are mainly buyers and sellers, market demands determine prices.[3] Where women have some access to the means of production, they are able to have some control over produce prices: but there is hardly any accumulation on their part because trade is on a limited scale. Accumulation takes place among the large-scale merchants who have control over the marketing of specific commodities, and whose operations usually go far beyond the boundaries of the community.

The trading activities of most women in the urban areas are also on a subsistence level. Most of the money earned from the sale of items is used at the end of the day to purchase the commodities that will then be sold the following day. It is a cycle which goes on from day to day. Hardly any profit is made from these sales because trading is on a very small scale.[4]

A study of hawking and vending during the 1970s in Manila shows that trading is basically female subsistence based.[5] Approximately two out of three hawkers in Manila were women. For most of these women, peddling was full-time work. In this study, women vendors, mostly wives and mothers, were relatively older than men and tended to specialize in specific items such as food commodities, which on the average generated less earnings. Hawkers put in about ten and a half hours of work each day but barely made enough to constitute a minimum daily wage. About one-third of the women had been hawkers for ten or more years. Four out of five hawkers had either had no previous employment or had worked as a domestic servant. Most had little education.

Hawkers and peddlers usually live in slums and squatter areas where such types of employment are common. In fact there is a direct connection between low-productivity work in trading and residence in slum areas in the city: in the biggest of these areas, Tondo, close to 40 per cent of women, most of them married, are vendors of one type or another.[6]

Women more than men will continue to trade at this level for as long as capitalist development incorporates a specific sexual division of labour. As capital expands and establishes wage-labour relations, it recruits men more than women. Women are then left to engage in productive work outside the wage economy: this work is usually trading. But trading is also directly dependent on money capital which can be obtained only through wages or the sale of marketable goods. This capital is generally not available to women. In turn, the wages of men barely meet subsistence needs. Furthermore women's trade is also determined by the household as a unit of consumption: whatever profit is made goes directly towards the day-to-day consumption needs of the members. Thus, women's trading activity remains at subsistence levels because

of a configuration of lack of capital, lack of contacts to the broader market, structural constraints arising from the operations of the capitalist economy, the inadequacy of male wages to support the family household, and the sexual division of labour which puts women traditionally outside (or at best peripheral to) the wage economy. However, trading as productive women's work does enable them to engage in a variety of social exchanges which are valuable in themselves for the opportunities they provide and which do not occur in many other sectors of work available to working-class women.[7]

Domestic service

Domestic service as employment has the most direct connection to women's reproductive work. Yet until about the second decade of the century, domestic service was not a particularly female occupation. As work became available in the industrial sector, it drew men in first and so women were left to small-scale trading and domestic services. (However, men still do such types of work if it is paid well: room cleaners in five-star hotels or cooks in up-market restaurants are usually males.)[8]

Domestic work is waged work for women although it bears little resemblance to any other such work. It has no set working hours, that is, there is unlimited appropriation of women's labour: domestics are on call for most of the day and into the night.[9] Work is not covered by the minimum wage, provides no labour benefits, hardly has any job requirements, and is not subject to any contract. It is basically reproductive work but paid a wage.

It is, not surprisingly, at the lowest level of waged work and indeed of any type of work. Domestic-service workers have the lowest educational levels and they come from the most depressed areas of the countryside. The largest proportion of female migrants go into domestic service and the majority of women in domestic service are recent migrants.[10]

The emergence of domestic service as productive women's work (as differentiated from reproductive work or the responsibility of all women) is directly related to the emergence of social classes which are able to pay for one, two or a retinue of household help. Domestic service then is work that should be seen not only in terms of gender relations and the sexual division of labour but also in terms of class divisions among women and between women and men. With domestic servants, women and men of the middle classes participate immediately in subordinating women of the working and peasant classes in employing servants to help minimize conflicts they face between their career and family roles, and to further their own class interests. The nature of the work has also made domestic servants vulnerable to physical and mental abuse by female employers and to sexual harassment and abuse by male employers.

Domestic service is waged work which is seen as transitional, more so than other informal-sector work. Women who constitute the pool from which domestic helpers are drawn are expected, with industrialization, to be absorbed into the industrial economy. But this transition has yet to occur in any significant way in the Philippines. By 1975 the proportion of women workers who were domestics had increased, and although the 1980s seem to

indicate a levelling off, the numbers remained high.[11] The constantly high proportion of women who are maids in towns suggests that this particular pool of cheap labour has not diminished but instead is constantly fed by rural-to-urban migration. Its expansion has served to mitigate the effects of capital's continuing inability to offer employment to women and, as well, its magnitude functions to offset pressures on the production of surplus value.

There is, too, little evidence to support the proposition that domestic work is a stepping-stone to other productive work: most of the domestic servants move from one household to another and many return to the rural areas. Very few move on to other types of work in the towns and cities.[12]

Post-war trends in women's work, therefore, have resulted on the one hand in economic projects which have recruited specific groups of women for export work, while on the other they have created a pool of labour which enters into low-productivity, low-paying work in domestic service and subsistence commerce.

Gender and the informal sector

The bulk of women's productive work, small-scale, unregulated and poor in resources, belongs to the informal sector. The informal sector of subsistence trading, low-skilled services and outwork has been far from a residual category of work for women: it is in fact an expanding category and appears to support export-led industrialization by providing complementary services to factory-based industrial enterprises, and low-cost services and goods to the labouring classes and low-paid middle class. These informal sector activities reveal undercurrents which connect the unwaged, low-productivity sector with the relatively higher-paid industrialized sectors.

The informal sector is not a separate category, divorced from the formal sector; rather it is linked to the formal sector in a dependent and exploitative way. In underdeveloped economies, formal wage employment opportunities are limited and levels of income are generally low. There is a large surplus of labour which, in order to survive, must seek its own subsistence outside of the wage economy. This surplus worker becomes the unskilled domestic servant, the outworker, the subsistence petty-commodity producer or trader in the informal sector. These workers provide the formal sector with low-cost goods and services which enable it to reproduce its own labour-power at reduced cost. Thus the informal sector captures the surplus labour of women: it is labour that is unaccounted for and remains at subsistence levels primarily because it keeps the costs of other labour down or enables other labour to be productive.

Some informal-sector work of women, however, is integrated into industrial organizations by means of work that stretches vertically from salaried and waged employees to casual labourers, subcontractors, piece-workers and scavengers. The recycling industry, which includes such workers as bottle-washers, scavengers, plastics- and paper-recyclers, is integrated into industrial processes[13] while small-scale domestic outworkers in labour-intensive operations, especially in garments, are a growing part of the

international division of labour.

The extent to which female labour is relegated to the low-capital, low-productivity sector of the economy is seen in the gap in labour productivity and wages between the formal sector (more men than women) and the informal sector (more women than men). Output in formal-sector commerce is about six times as high as in the informal sector. The wage difference between a general grocery store employee and a *sari-sari* store one is about 4:1, and between these and petty selling, even more.[14]

The considerable number of women in the informal sector, outside officially recognized industry and agriculture, is added evidence that women's participation in the labour market is shaped by factors different from those which shape men's participation. The merging of gender, reproductive and productive relations has resulted in women's productive work becoming casual. The concentration of women in the low-productivity informal sector lays bare a development process that is exacerbating inequalities between classes and between the sexes.

In economies such as the Philippines, the informal sector has been an important source of survival for the poor and the labouring classes, particularly in times of economic crises and government cutbacks. When neither the economy nor the state are able to provide for basic needs, the casual or self-employed work of women from poor and low-income households is vital not only for their own and their household's survival but also for those formal-sector workers who are inadequately paid.

The sex trade

Sexual practice has seen a few significant changes in the last 40 years but basic frameworks have remained. Male control of female sexuality embodied in the notions of purity, domesticity and familialism continued to dominate women's sexual behaviour. But there have been some redefinitions in the area of sexual relations and, in the last two decades, a more direct connection between political economy and sexuality.

The emergence of wage-labour relations enhanced men's dominance in the family and in the wider society, as women became dependent on men's wages and were relegated to the home in the process. On the other hand, new social and demographic situations arising from the organization of the economy – expanded education, women recruited into wage labour, women working away from home, migration to towns and cities, emigration to foreign countries – did have the effect of weakening some of the requirements for female purity and challenging some of the elements of Filipino machismo.

There have also been changes in sexual norms; sexual openness, experimentation and recreational sex appear to be increasing among adolescents and young adults, notably among the very rich and the poor peasant and working classes,[15] and popular media's treatment of sexuality has begun to reflect a relaxation of sexual mores. Nonetheless, surveys still show

strongly differentiated standards between women and men. Premarital sex is still acceptable behaviour only for single men and this is borne out by the behaviour of these men.[16] Female sexuality is still firmly within the orbit of love and marriage. The double standard also found support in the legal system: until laws were revised in 1987, the state made grounds for marital separation a husband's concubinage under scandalous circumstances on the one hand, and a wife's simple adultery on the other.

The *querida* continues to be very much a part of many Filipino men's lives. In the 1970s it was estimated that between 30–70 per cent of married men kept mistresses,[17] indicating a widespread practice that cuts across social classes. However, women are increasingly less willing to tolerate the double standard: in the Domestic Relations Court in the 1970s, the largest numbers of cases filed by women for marital separation gave male infidelity as the cause. There have also been increases in claims for child-support provoked by men's extramarital relationships.[18]

But while the contemporary sexual situation is a complex maze of sexual relaxation, restriction and a double standard it is unrelenting in its commoditization of female sexuality. The trade in female sexuality has increased unprecedentedly in the past decades.

There are no reliable estimates of the numbers of prostitutes before the 1970s, but there must have been tens of thousands who were engaged in some form of sexual trade (as massage attendants, club waitresses, bar dancers, and so on) based on the large numbers of establishments and enterprises connected with the trade. Many women were out of work or were unable to find adequately paid work; a number of waitresses and nurses, for example, were prostitutes on the side. Others made prostitution their only means of livelihood.

One example of sexual servicing of this type was that carried out in cabarets. Cabarets have since gone down-market and are now places frequented by working-class men. In the mid-seventies, in a cabaret on the outskirts of Manila which resembled a cock-fighting arena converted into a dance-floor, dancers got P0.25 (about $0.02) out of the P0.50 ticket for each dance. Sex was extra and happened in a dark cubicle taking up no more than two square metres of an adjacent room. The 'extra' ranged from P10 to P100. Cabaret dancers worked for about eight hours a night and earned around P400.00 a month. They were usually handled by managers (or pimps) who provided them with food and lodging for 50 per cent of their earnings. Most of these girls had come to the city from the country (because 'there is no hope there').

Since the 1970s there has been a significant increase in the numbers of prostitutes and this increase is directly connected to accelerated structural changes in the economy. No doubt, prostitution will continue to exist so long as the ideology of male sexual needs persists, but widespread prostitution is better explained in terms of women's options for adequately paid productive work. When economic options for women are not present, or even if options exist but are extremely low paying, and sexual behaviour is directed towards the satisfaction of male sexual needs then women will continue to be drafted

into or go into prostitution.

Prostitutes of today are for the most part not volunteers to the work; rather they are more often seen as being drafted into prostitution.[19] Still, there are indications, especially in areas around the American military bases, that second-generation prostitutes or children living around the area are now directed into or volunteered for this kind of work because it is higher paying than any other. There are also women who are forced into prostitution as 'innocents betrayed' or through white slavery.

Prostitution as waged work is relatively higher paying than most types of women's work. But because it is an illegal activity, prostitution entails expenses such as 'protection' and steering to which other types of work are not subject. Because sexual servicing is about money (and illicit money, as well) a large number of men and male-dominated institutions have appeared who derive profit from it. These men range from owners of clubs, bars, beerhouses and discos, to policemen (protection money), pimps, medical doctors and government officals, and all of them profit more from prostitution than the prostitute herself. Thus, prostitution may be higher paying to women than other occupations but it often yields more to the men who make a living off it. Many bars, hotels, clubs, and health clinics are institutions which are supported in large part by prostitution. The magnitude of this network has turned prostitution into an industry (entertainment, hospitality, rest and recreation, among some euphemisms) and its growth is traceable to the country's continuing subordination to international economic and political forces and to state and ruling-class projects.

Two of these projects have a direct link to the growth of prostitution as an industry. One is the presence of a number of American military bases in the Philippines which, apart from its more routinely political objective, is a dollar-earning project for the country: income is derived both from rentals on the bases and the attendant service industry surrounding military installations. The other is the drive to increase the foreign currency reserves of the country through the promotion of tourism and the export of labour-power. In short, prostitution is a dollar-earning activity.

What has emerged in the past 20 or so years is the direct connection of prostitution to an accelerated programme of outward-facing economic development on the one hand, and the rapid pace of social and economic deterioration on the other.

Servicing the servicemen: Prostitution and the American bases

During the American period, the Americans constructed the largest naval base outside the USA in Subic, a former Spanish port about 120 kilometres from Manila. Before World War Two, the area surrounding the base, Olongapo, had a night-life of about five cabarets made up of thatched huts.[20] Less than a dozen girls, it is said, were available as partners.

Activity at the base immediately after the war was not considerable and it served largely as an assertion of American military presence in the area. By 1964, however, with the escalation of the Vietnam War and the realignment of

geo-political forces, Subic Naval Base became, among other things, a rest and recreation (R and R) area for the American military. Olongapo was transformed from a small fishing community to a centre of services for them. At the base of this servicing population were the female prostitutes.

From 1964 until 1973, the year of the Vietnam ceasefire, a daily average of 9,000 military personnel were going out to Olongapo on 'liberty' and millions of dollars were spent on R and R business.[21] Day- and night-clubs, bars, hotels, sauna baths, massage clinics, and the like were set up to service these personnel. Since the Vietnam ceasefire, the R and R industry has declined. Despite this decline, however, in 1979 there was still a network of more than 500 clubs and other entertainment centres.[22] In that year, Olongapo had 9,056 registered hostesses and entertainers and about 8,000 streetwalkers. Another 7,000 women worked as prostitutes in Angeles City, the area surrounding the Clark Air Base.[23]

Prostitutes in Olongapo are rarely from the vicinity: the majority are from what are considered the 'most economically depressed areas', the Eastern Visayas and Bicol regions. They come from tenant-farming, small-fishing and seasonal-labour households. Pimps frequent villages looking for young attractive girls (12—14 years of age), promise their parents that they will educate their daughters and for a small payment to the parents (P50 or about $4 in the late 1970s), take these girls with them. The pimps then teach these girls to sing and dance and eventually set them up as prostitutes.

Apart from the sexual transaction itself, prostitutes earn money in other ways: as hostesses through tips and commission for their drinks, shares from bar fines (fines paid to clubs to take women out) and wages from massage. Some women earn wages as stage dancers and strippers, but the bulk of their earnings comes from sexual servicing. Earnings depend on the presence of ships, but on the average, in 1979, registered hostesses made a minimum of P500 (about $40) a month.[24]

The beneficiaries of these servicing activities, in addition to the American military, are the R and R establishments and the state apparatus. In fact in the 1970s the state and establishment owners were sometimes indistinguishable: one-third of the city-council members in 1979 were directly involved or had interests in the industry. The consequence of this link is the control exercised over prostitutes. Officials try to control the circulation of money in the industry through an ordinance which prohibits soliciting outside clubs. Income is assured for operators by means of shares in club commissions and bar fines. They do not get a share from the sexual transactions themselves, except through hotel receipts. Thus, the city requires that all women who go out with customers have a night-off pass from the club operator in order to differentiate them from streetwalkers who solicit illegally and from whom establishments do not get any revenues.

The new labour code has made prostitution, in the guise of one or other euphemism, formal waged work. As waged workers, prostitutes are required to obtain licenses, pay taxes and make contributions. However, they are entitled to worker benefits as well. But contributions are routinely not made to

the state by operators, so that often claims on these (such as social security benefits and maternity and sick pay and leave) cannot be made. Prostitution is also regulated by the largely American-sponsored Office of Social Hygiene which exists to certify prostitutes as free from any type of sexually-transmitted disease before they are allowed to solicit.

Thus, by means of an array of licenses, certificates, taxes, ordinances, health services and the explicit support of the R and R industry, the state legitimizes and at the same time regulates prostitution. The bulk of the surplus generated from the sexual services Filipino women provide for the American military is captured by the state apparatus and local businesses.

Sex tourism

In tourist areas, Manila especially, it is not the American military but foreign men who are serviced by Filipino women. The increase in the number of prostitutes in Manila and other tourist areas in the country is directly related to the growth of the tourist industry. With the priority given to it by the state, tourism grew from a negligible dollar-earner in the 1960s to the country's largest source of foreign exchange in the late 1970s. In 1977, tourism brought in $300,000,000, which is $262,000,000 more than in 1972.[26] The content of these tours often had little to do with Philippine landscape and culture and more with the provision of sexual services for male tourists. In the late 1070s, at the height of sex tourism, there were an estimated 350,000 women employed in the hospitality industry.[27]

Prostitution was not only allied with tourism but it did in fact support the industry in the 1970s. Prostitution accounted for a good part of hotel receipts, especially since hotels had low occupancy rates. In one hotel, for example, management charged a 'joiner's fee' of $10 to tourists for the right to take women into their rooms.[28] These hotels are part of international hotel chains; most are institutions government-financed from loans provided by the World Bank (one is owned by a government corporation). All five-star hotels acquiesce to the traffic in women because it is a major source of revenue.

Prostitutes in Manila range from high-priced call girls all the way down the scale to streetwalkers. Prices in the late 1970s ranged from about $7 to $200 a night for 'independent prostitutes' (call girls and streetwalkers).[29] The prostitutes in Manila seem to be recruited from a slightly different socioeconomic group to prostitutes at American bases: some do come from relatively poor rural families, but many have urban origins and, as a group, have a higher level of educational attainment than the female population as a whole.[30] In a survey of massage attendants in 1973, for example, many of the women were former teachers and nurses, further evidence of how low paying these jobs are. Half of these women were heads of households.[31]

Prostitutes in Manila reported averge earnings of $7 to $10 a day in 1979 which was higher than the minimum wage and considerably more than the earnings of a factory operative or sales clerk, who made $1.60 a day.[32] Labour benefits covered licensed hostesses but, as in the American bases, the women were often unable to make any claims.

Clients of prostitutes in the late 1970s were largely Japanese, Australians, Americans and Europeans. Close to 29 per cent of the tourists coming to Manila were Japanese men. Prostitution is illegal in Japan and enforcement is stronger there; thus, easy access to women has long been offered as a tourist inducement to men. Japanese men who join sex-tour groups usually choose women from brochures, very much as one chooses merchandise from a catalogue. A look at some of these sex-tour operations reveals the extent to which women, the indispensable commodity that is exchanged, are also the least valued: in one transaction which cost $50 for one night with a woman, $10 went to the Japanese operator, $10 to the local guide, $15 to the tour operator, $15 to the club owner, of which the prostitute received between $4.25 and $5.75. Often even this much is not received by the woman because fines for improper dress, tardiness, smoking, drinking, and so on, were subtracted.[33]

Opposition by women's groups to these tours[34] has diminished their explicitness and also perhaps the numbers of prostitutes involved, because the tourist industry has suffered a slight and temporary decline. But prostitution has resurfaced in new forms; women now go to Japan and other countries as entertainers and artists to service the men there. In Okinawa, the ratio of Filipino to Japanese prostitutes in one city is already six to four.[35] By 1989, an estimated 93 per cent of Filipino women working in Japan were in the 'sex industry'.[36]

American, European and Australian men, who are less likely to move in groups, find prostitutes in streets, bars and clubs. And since there are far more women than potential customers it has not been unusual to see, as one study describes it, an 'often desperate scene of elaborately costumed women shouting and grabbing foreigners along the streets of the tourist district to invite them inside for a drink'.[37]

The interconnections between the state and foreign and local business classes in the promotion of sex-tours has been quite clear. Hotels and clubs financed by the state are locales for these sexual transactions. The Ministry (now Department) of Tourism uses women as come-ons in its brochures and posters. This has become more subtle in recent years but the 'beauty of the Philippines shining through' is still its women. In the 1970s, tourism officials repeatedly denied any structural links between tourism and prostitution while implicitly condoning prostitution. At the same time, these officials tried to regulate prostitution by co-sponsoring seminars on venereal disease prevention. Thus, it exhibited very similar concerns to the American government in its support for the Hygiene Clinic: anxiety about the effects prostitution could have on men and the tourist industry, rather than attacking the root causes of disease in the first place.

But while one agency condones prostitution another shows a rather ambivalent concern for the prostitutes. In 1979 the Bureau of Women and Minors at the Ministry of Labour conducted a campaign to educate prostitutes: the education consisted of teaching prostitutes how to be co-operative and to be genial to clients. The Bureau had a collaborative policy: in its 'Self-Development Guide for Women Workers in the Entertainment

Industry', the Bureau started with 'Be loyal to your employer' and ended with 'Your work, more than any kind of work is full of hazards and temptation. Always look up to the Almighty for help and guidance.' The Bureau also saw 'the need for drastic measures to improve the status of women in the hospitality industry to enable them to contribute effectively to the socioeconomic development of the country.' This attitude on the part of the Bureau did little to help the situation of prostitutes. Since 1987, the Bureau has modified its view of prostitutes as moral vagrants-cum-disadvantaged workers but it has still to effectively address the trade in women.

Yet another agency of the state has different purposes. Law enforcement sees prostitutes as illegal streetwalkers and male clients as merely expressing a natural urge. Raids reminiscent of the early part of this century are periodically carried out in the tourist district: but these hardly make a dent on the trade.

In summary, there has been little ambiguity in the connection between the rise of prostitution and state economic and political projects. These same projects that have intersected with an ideology of gender in recruiting a few women to specific slots in the industrial sector have simultaneously pushed the majority of them to the stagnant sectors, unpaid family labour or low-paid services. When women are defined as suppliers of sex and are unable to find other economic options, prostitution, with its higher pay, becomes an alternative and where the structural mechanisms – the tourist industry, the military bases – are present ('but the men were already there'), then prostitution becomes a very viable alternative.

The magnitude of prostitution in the Philippines, perhaps more than any other economic activity by women, is indicative of the lack of options they have for productive work. It is also the only work they do whose rise is accompanied by moral indignation. No other women's work provokes such a response; it is, as it were, a labour situation that is liable to moral intervention; campaigns against it are couched in terms of the morality of women. This concern is always phrased in terms of the overt, socially recognized problem; the sexual cravings of men. Men need sex and need it enough to pay for it, while women are viewed as not needing sex enough to demand it in the market. Since it is women who supply sex as a commodity, it is they who are to be regulated, morally and legally. The problem, in other words, lies with women. This view takes the double standard of sexuality as a given, and the task is then merely to regulate prostitution – a matter of morality and prophylactics – thus leaving the connections between the 'undifferentiated lust' of men and the 'purity' of women untouched.

Prostitution must also be seen as having implications beyond the issue of work. Prostitution, in Manila and on the American bases especially, has a 'raw quality' to it. The level of violence and drug abuse is high in these areas. It is also not unusual to hear of women engaging in degrading, often painful sexual acts. And after women lose their sexual desirablity, they are reduced to performing obscene shows in clubs. Sexual transactions have also resulted in many Amerasian children (in the late 1970s about 30 were officially registered each month; many more went unregistered).[38] Their increasing numbers have

opened up a large market for these *mestizo* babies, who are desired because they are considered more attractive than native children. Many girls who are not sold grow up to become prostitutes themselves.

The bride trade
Moral indignation against prostitution has spawned more subtle forms of sexual trade. Now women as entertainers and as brides are the subject of international commerce. In 1981, an estimated 3,000 Filipino women went to Australia and West Germany and another 4,000 to other European countries and the USA. Another 25,000 Filipino women were on file in an Australian singles bulletin. All of these women intend to be (or are) mail-order brides. The trade has increased enormously since that time: in Australia there has been a reported 270 per cent increase in mail-order brides; in England, mail-order brides have doubled in number; and in 1987 one agency alone arranged 12,000 marriages for American nationals.[39] Philippine statistics record a 100 per cent increase in mail-order brides every year.[40] Many of these women come from Metro Manila, a tourist area, and Zambales and Pampanga, sites of the American military bases. Many are also college graduates and only a few are reported to come from the lowest economic classes – but then so are the Manila prostitutes. Some in fact end up as prostitutes: a number of marriage bureaux are actually fronts for prostitution.[41]

Motives given by the parties involved are not alike: foreign men choose Filipinos (and other Asian women for that matter) because of sexual stereotypes of female submissiveness. Foreign men unable to satisfy themselves sexually among women in their own country now seek gratification elsewhere – primarily among women of colour in the Third World. Filipino women on the other hand actively seek foreign partners for a variety of reasons – social, psychological and economic. That there is an economic reason for women seeking foreign partners, however much it may be left unsaid, can be seen in the example of Malaysia where the bride trade has declined considerably with increased prosperity among the population.[42]

But whatever the motivation for women who offer themselves as the brides or sexual partners of foreign men, it is they who are the bases of the traffic. The existence of the pool of women who do sexual servicing in one form or another has its roots in the social, economic and demographic processes occurring in the countryside and in the cities.

Women who leave: Work and Migration

Until about the 1960s inter-regional and rural to urban migration was clearly male dominated. Since then migration has been female dominated. This shift in the migration system can be traced to social processes that are in part the consequences of capitalist penetration into the countryside.

The contradictory processes of land concentration and land fragmentation have directly affected women's options for work in agriculture. Faced with the

further fragmentation of agricultural land and dwindling economic resources, household strategy has been increasingly to concentrate marginal landholdings in the hands of sons while daughters are urged to get an education.[43] In some areas in the Ilocos region, as a result of a diminishing land base, only women who work in the fields can inherit land while women who do not work, or are not allowed to work, do not inherit,[44] a practice contrary to Philippine custom and to laws of equal inheritance.

One major consequence of these emergent forms of preferential inheritance has been to place the burden of agricultural production on men. Women's access to the means of production is no longer assured because a viable unit has to be maintained. Preferential inheritance is part of a broader process of women's decreasing access to productive resources, including land, which results in their movement in considerably larger proportion – especially the young and single among them – to cities.

Capitalist processes have also increased the numbers of landless agricultural workers, but the labour hired has been preferentially male so that women are eased out as farm workers. Moreover expanded mechanization has been displacing more female than male workers. At the same time, women, especially the young and single, have little alternative for work in rural areas; while work in the household is not paid and outwork is low paying and irregular. Thus social conditions are created for the migration of these women. Migration becomes an option specifically open to this group, an option which is not open to mothers and wives.

What women's migration indicates is that the relation between the creation of a redundant population and population redistribution is not merely a matter of a growing social division of labour but also of a differentiation according to specific categories of people. In short, young, single women are 'selected out' for migration. Female migrants tend to be young – between 15 and 25 years old and single. Manila has been the single most important destination. Sex ratios in Manila in this age group in the past decades have shown female predominance.[45] The estimated net emigration in thousands in 1970 for the country was 42.6 for men and 58.6 for women, with the greatest differentials between the 20–34 age group.[46]

A few migrant women have ended up in export-directed factories; these are usually the women who have either finished, or have gone beyond, a secondary level of education. The majority end up in services, mainly as domestic servants or in commerce, as subsistence traders. Thus, female-dominated work-migration responds to a service-dominated economy, very much like the contemporary pattern in many Latin American cities.[47] The contrast is with male migrants who do even better in getting prestige jobs and highly-skilled, higher-paying work than do average non-migrant males.[48]

Age and sex-specific migration also emphasizes the relative options of women and men. Men are free to move and seek out alternatives, but women, once married, are tied to their families: they are tied by time and space – by domestic work, by pregnancy and by child-care.

This type of sex and age-specific migration has several implications for

women and for gender relations. First, young single women are leaving the family-household system at younger ages than ever before. This indicates structural conditions are present for a delay in marriage and a corresponding shortening of the years of fecundity. This also means women become independent at younger ages, although economic ties are not completely severed because of the need for two-way subsidies. However, the achievement of some autonomy and the decline in reproductive activities as a result of fewer children is not without its contradictions. The work outside the family which women do brings them into contact with new forms of male dominance in a capitalist hierarchy of productive work. Second, this type of migration means that young women are drawn away from households where they are doing part of the reproductive work. When young women leave, the burden of household work then rests solely on the mothers who stay behind.

The export of labour-power

The migration of women has not been confined to national boundaries. In the mid-sixties to early seventies, almost as many women as men, especially those in the health services, left the country permanently to work and live abroad, mainly in the USA. Permanent emigration of women and men continued to increase through the years; in 1988 alone, a record year, 58,066 Filipino women and men emigrated.[49] From the mid-seventies to the early eighties, because of the specific demands of recruiting countries, mostly in the Middle East, skilled contract workers, temporary emigrants, were largely male. These contracts have since diminished and by the early eighties, there was an increase in demand for low-paid service work in the Middle East and Europe. This most recent labour emigration has been largely female.

Conditions which generate these types of movements are embedded in economic and political relationships between the Philippines and labour-importing countries. This relationship is one of inequality – the unequal exchange of commodities, capital and labour. In recent years inequalities have deepened with the accelerated expansion of the market economy in the Philippines. Since the economic conditions of unequal exchange continue to be reproduced, the movement of people continues. These conditions have varied over time, according to the specific demands of economic processes in the country and outside of it, and have had varied effects on different classes and groups of people. The nature of the migratory flow depends on these conditions, and not on the individual decisions and actions of migrants themselves, these being a consequence of these conditions.[50]

Contemporary migratory flows are understood at two levels of operations: first at a general level, within the context of the industrialization process (mainly the inability of an economy adequately to absorb released labour), patterns of urbanization, the transformation of the peasantry, state policies directed at social change, and the position of labour-exporting and labour-importing countries in the international economy. But while broad economic and political forces create the conditions for migration, these do not explain the selectivity of migration: that is, the categories of people who leave. This second

question is answered mainly not by psychological or personal reasons for migration, which tend to be similar, but by such factors as sex, age, position in the household and the person or household's position in the economy. Characteristics of migrants become significant only within a given social structure and process.[51]

In the post-war years and into the early 1960s, emigration of both women and men was not substantial. One of the reasons then was that the USA, a primary destination, had imposed quotas on the entry of foreign nationals. When, in 1965, this quota was removed, the influx of Filipino immigrants to the USA began. Because of the need in America for certain types of workers, many of these immigrants were professionals, mostly in the medical sciences. By the mid–seventies, an average of one out of six workers who left to work abroad was a professional or technical worker. Proportions of professionals have continued to increase: between 1981 and 1988, 25 per cent of the Filipinos who resettled abroad were professionals and technical workers.[52] This is a particularly large proportion since the national average of professional and technical workers is roughly one out of every 20 in the work-force.[53] Many of these professionals were nurses because there was a great demand for them and American hospitals were actively recruiting in the Philippines. Of the average of 7,500 professionals who left yearly, about four out of ten were nurses.

Thus the increasing enrolment in nursing courses and nursing schools is explained not by the student's expected income returns from the profession – nurses are among the lowest paid professionals in the Philippines – but by the prospects of overseas employment. Indeed, in a survey of labour power in the profession in the 1970s, 37 per cent of nurses reported they were definitely planning to go abroad.[54] With an average labour-power stock of 45,700 in the mid–seventies, one out of every seven nurses was no longer actively engaged in the profession and two-thirds were working abroad.[55] By 1988, Filipino overseas nurses outnumbered those working in the Philippines. An estimated 127,000 out of 160,000 licensed Filipino nurses had left to work abroad.[56]

Nurses continue to comprise one of the major categories of women employed abroad – the market is still increasing – and precisely because of this option, some men are now taking up nursing. Men's entry into nursing suggests that if some advantage can be had from a certain occupation – in this case, an American visa – men will enter it, cultural representations of gender notwithstanding.

Women who go abroad also work as teachers, midwives, secretaries and clerks. Some recruitment of factory operatives occurred in the late 1960s for Canadian industries. Through the years workers from one area were recruited to work in Winnipeg's declining garment industry.[57] By 1974, 35 per cent of the workers in the city's garment factories were Filipino women.[58]

In the mid–seventies, with the promotion of projects which generate foreign exchange, the export of labour-power became official government policy and recruitment for overseas work increased considerably. By 1982, there were officially about 250,000 Filipino land-based contract workers abroad and roughly 18 per cent of these were women. Workers in manufacturing, transport

and communication, most of them men, comprised 40 per cent of contract labour.[59] These workers were recruited for temporary work of roughly one to two years and were required to remit a specific portion of their earnings through Philippine banks. The main destinations were the Middle East, Europe, Africa, and other countries in Asia.

Since the mid–eighties, close to half of these overseas workers have been women.[60] Some of these women migrate as artists and entertainers (often euphemisms for prostitutes) and their main destinations are Japan and countries in Southeast Asia, the Middle East and Europe. But the majority of women who sold their labour overseas became domestic and personal-service workers. Service work is a fairly new category of overseas work for women. They work as domestic helpers, chambermaids or servants. These service workers, now numbering tens of thousands, are employed in Europe – England, Italy and Spain, in particular; the Middle East; and East and Southeast Asia, mainly Hong Kong and Singapore. In Italy in the 1970s an estimated 7,000 Filipino women were working as maids; in England 76 per cent of the Filipino immigrants were women, most of whom were working in domestic or personal service; in Singapore by 1989, roughly 30,000 Filipino women were employed as domestics; and in Kuwait approximately two-thirds of the domestic helpers were Filipino women.[61] Filipino women have replaced Turks and other women from the Mediterranean region as domestic servants in Europe. The flow to Europe, however, is not expected to last much longer because as Eastern Europe opens up, women from the region are expected to be absorbed as low-paid labour by the advanced countries.

Most of the women who work as domestics in Europe have an above-average education and many have finished college. Many, in fact, are teachers and nurses.[62] These workers earn close to six times what they would earn in the Philippines if they practised their professions. If rates were based on wages of service workers in the Philippines, these women earn 20 times what a service worker would earn at home.[63]

What have been the effects of this transfer of human resources? The transfer of labour from the Philippines to many of these countries consists largely of professionals and technical workers, mostly physicians, nurses, medical personnel, engineers, scientists and teachers. This situation has been called a 'brain' or 'skill' drain because these are groups in whom a high level of capital has been invested. It indicates the extent to which resources have been misallocated by the state. The labour the country nurtures and later exports has less to do with its development needs and more to do with the demands of foreign countries.

Emigration has deep social consequences because it often results in the disintegration of family-households. What frequently occurs is that a worker, husband or wife, emigrates leaving behind the spouse to take care of children and other dependent individuals. These separations may be temporary but they are often prolonged. In some cases, emigration has resulted in the abandonment of families and households.

But emigration also has deep personal consequences. Emigration in itself

means that women are able to seek a way out of situations they find subordinating or oppressive and to exercise options for themselves. By means of remittances women have also begun to play a central role in the maintenance of their families. And as they take on major income-earning roles, they confront the sexual division of labour. But while work abroad may be higher paying and fulfilling for some women, it has been painful or violent for others. There has been documented evidence of Filipino women who have lived in a world of fear, degradation, insanity and sexual abuse. Rape has been a 'common occurrence' in some areas.[64] And murder has been the fate of a few women.

Cultural differences have also meant painful psychological experiences for many women who leave. This is particularly true where women's behaviour is much more circumscribed, as in the Middle East. For women who are left behind, changes in their life situation may be disruptive for some, releasing for others. Many women are saddled with the responsibilities of running the household and disciplining children on their own because of their husband's absence. But these absences also temporarily release women from personal male domination. They are nonetheless still dependent on men's wages from abroad.

Gender, work and ethnicity: Women in cultural communities

The distinctiveness of minority cultural communities is not only in their religious divergence from the majority of Christian Filipinos, but in the majority group being more advanced economically and technologically and in being more integrated into the national political system. Communities range across hill-tribes, the Muslim national minority, non-Christian tribes, and traditional groups and communities. Approximately 16 per cent of the Filipino population (or about 7.3 million as of the 1980 census) can be considered members of distinct cultural communities.[65] The biggest of these groups are the Muslims (*Moro*) of the southern islands of Mindanao, Sulu and Palawan; they comprise close to one-third of the cultural community population.

The concept of cultural community (or cultural minority) in the Philippines is largely a consequence of the process of colonization; it is a designation attached to people who were not colonized and have not become Christian and who have maintained a traditional culture. Before colonization, there were no distinct cultural communities, only independent or interdependent social groups.

Prior to Spanish conquest, Islam was emerging as a unifying force in the Islands. Islam was then spreading slowly through the efforts of Islamic missionaries and through trade.[66] Spain halted its spread and replaced it with Christianity but as the spread of Christianity was accompanied by a colonizing power, the process had coercive elements. Some Filipino groups did not come into the orbit of this process. Throughout the Spanish period, Muslims in the south fiercely resisted Spanish incursions while the mountain- and hill-peoples

avoided Spanish rule by retreating into the more inaccessible regions. American superior weaponry and advanced technology broke down Muslim resistance and allowed the colonizers into the mountain regions. But American efforts at integration (or assimilation) by means of colonial administration and a mass system of education could not overcome the effects of the centuries of social, political and economic separation between the majority Christian, colonized population and the 'minorities'. Centuries of separation had engendered feelings of ethnic and religious prejudice and animosity, particularly between Muslims and Christians.

Today cultural communities share many of the economic characteristics of impoverished labouring groups among the majority population, but they also have many characteristics unique to them. These communities are also differentiated among themselves. Apart from differences in custom and religion, these communities are also differentially integrated into the national economic and political system. The types of economies of these communities include hunting and gathering, swidden (slash and burn) agriculture, vegetable and fruit farming, subsistence fishing, trading, handicraft production and wage labour. Some of these communities have only recently become part of a cash economy.

The two major economic and political issues that now confront these communities are their accelerated integration into the national and international economic system and their own struggles for autonomy and self-determination within the national political system. Rapid capital penetration and ecological destruction have affected these communities, as well as the increased encroachment of the majority population, many of whom are themselves being displaced by these same processes. Encroachments have taken the form of capitalist ownership of land or of the appropriation of the livelihood of the communities by the Christian majority population, by local and foreign capital and by the state. Capital's activities include logging operations, mining and oil explorations and hydroelectric power projects. As a result of these operations, traditional methods of livelihood, village authority, customs and cultural practices, many of them maintained from the pre-Hispanic period, have disappeared. The loss of forests, for example, has not only meant soil erosion, it has also meant that women are no longer able to gather forest products for fuel and food. Communities that have been relocated because of the use of their land for hydroelectric plants have suffered marked declines in levels of living.[67] The lands of these communities represent the last frontier of resource-exploitation. As some of these communities have resisted, they have faced the guns of the military.

The critical and central resource in these communities is land. For these groups, as was no doubt for the majority population during the colonial conquest, the loss and destruction of land is not only a loss of livelihood but culture and identity as well. Land is the material foundation of culture. It is on the land that the Filipinos interacted with their gods, it provided them with symbols and the raw material of their culture. This cultural process is not only done on the land, it is nurtured by it.[68] Physical and economic dislocation, as it

has done in the past, contributes to the disintegration of an identity and culture.

Land then is an economic, political and cultural issue. In a few of these communities, land is still communally owned, as is the water around it. For the Muslims, land is closely tied to a religious ideology and identity that is also separate – not Filipino, but Islamic.

In two of these groups, the Cordillera group and the Muslims, economic dislocation is compounded by political strife. These areas have waged armed struggles for self-determination and autonomy. They have also witnessed, as with other communities among the majority population, the armed conflict between the state and the communists. As a result of these struggles, some of these communities have been subjected to 'hamletting' – the reconcentration of communities into areas guarded by the military. As these communities are separated from their means of livelihood, health and malnutrition levels, already the worst in the country, have deteriorated even more.

This historical, economic and political context is also that of gender differentiation. As there is a wide range of village political economies, so also is there a wide range of gender arrangements. Many of these communities share many of the characteristics of gender divisions of the majority Christian population as a result of interaction and state efforts at integration. But other communities exhibit distinctive gender-based social arrangements. Two communities will be cited here to present contrasts to the majority population; one, as an example perhaps of a surviving pre-Hispanic sexual division of labour, and the other of the influence of Islam on the position of women and men.

Among the Bontoc Igorots in the Cordillera mountains of Northern Luzon, there exists today a sexual division of labour that is distinguished for its reversal of roles. In one of these villages, adult women (wives, mothers, and older daughters) are the primary producers and allocators of the major subsistence crop, rice.[69] Women daily take the long trek to the rice terraces, weed the stone walls, prepare the soil with their hand implements, plant the seedlings, weed the rice fields and harvest the crop. As primary agriculturalists, they have great power within the village, not only in planning family meals but also in determining the agricultural calendar and ritual feasts. They accomplish this role by means of co-operative labour groups based on kin and affective ties. These women are said to derive personal self-esteem and autonomy not only in their individual role as agriculturalists but also as a collective because of the political power of their labour group within the village. Nonetheless women are also primarily responsible for reproductive work (including the arduous task of pounding rice) and the maintenance of hillside gardens. Older women who are no longer able to walk to the terraces spend much of their time in these hillside gardens.

Adult men (husbands, fathers, older boys) contribute minimally to economic production. In recent years, they have in fact been marginalized. The abolition of head-hunting and the absence of a need for village defence, until recently the main roles of men, have deprived them of their role in the community. Men's role in agricultural production is confined to specific operations such as

maintaining irrigation canals, providing water for the fields and reconstructing dams.

Men who no longer have any economic or political role in the village have sought new roles outside it. Some have engaged in seasonal waged work in mining operations in other communities. But men who remain in the village lead a life of 'little motivation' with relatively little responsibility. They spend the greater part of their time travelling, taking naps, smoking, drinking and gambling. Men who help women in their work roles, productive or reproductive, are ridiculed by other men. Older men also have more leisure than older women.

Part of the reason these gender work-roles have so far been maintained, it is argued, is that there has been limited economic pressure on the land. Indeed there is even a labour shortage, as many young women and men now prefer to leave the village for waged work or education in the towns and cities. The workload of women who remain has now increased.

Conflicts have recently emerged between women and men with the start of mining operations in the village. Since the women derived their livelihood from rice subsistence-agriculture, they actively opposed these operations. Men saw an advantage in the wage labour that would have been made available to them from these operations. For the moment, because of women's opposition, mining operations have been discontinued.

But in a neighbouring village which had similar gender-role arrangements but which has had economic pressures on land use and expansion, there has been pressure as well to revise cultural notions of gender work-roles. In these areas, male co-operative labour groups have now become involved in tasks in rice cultivation which were traditionally female, including soil preparation and planting. These recent changes show how sexual divisions and an accompanying ideology of gender intersects with economic forces to restructure women and men's roles.

The other example of gender differentiation within a cultural community is that between women and men in Muslim groups. Although Islamic influence, like that of Christianity, was never monolithic, and compared to Arabian religious strictures was not as rigid, it resulted nonetheless in more circumscribed spheres of activity for women. The notion of woman's place appears to be more binding on Muslim women, particularly since this is enshrined in Islamic beliefs of separate male and female spaces.

As a result of religious restrictions, women have had less access to education; educational attendance and attainment show marked gender disparities among Muslims.[70] In the American period, when a mass-based educational system was established in the Islands, Moro parents objected to sending their daughters to public schools because the girls would then come in contact with male Filipino teachers,[71] and because co-education would have meant that girls would interact socially with boys. Until schools were established which accommodated Islamic notions of spaces separated by sex, women were much restricted in their access to education. Although attitudes have changed a good deal with respect to co-education, some prevail. Restrictions on social interaction also

put limits on women's choices for productive work. It seems, however, that the labouring classes and the upper or educated classes have been less bound by religion. The female labouring population in Muslim communities has to work in order to survive, while women of the owning or educated classes, having been exposed to liberalizing ideas, are no longer willing to be confined to their traditional roles.[72] Many of these Muslim women now see the male practice of polygyny as oppressive.[73]

The struggles of women from cultural communities today are expressed similarly to the majority Christian population in terms of class and gender, but they are also expressed differently in terms of religion and ethnicity.

11. Class, Family, State and Development

The present-day intersection of sex and political economy, a legacy of the ideological and material forces of a historical and recent past, is characterized, on the one hand, by a specific integration of the national political economy to a global system which has exacerbated the subordination of women and, on the other hand, by a maturing and expanding base of opposition to this integration which contains within it women's challenge to their economic subordination.

This section looks at other aspects of this present-day configuration: the intersection of ideological and material forces across social classes, the role of the state in women's subordination, and the effects of systemic crisis on women.

Class, ideology and the family-household

Class and 'woman's place'

Productive work had now become, culturally speaking, properly men's sphere, while reproductive work and consumption, women's sphere. The demands of childbirth and infant-feeding kept married women in the home for some time in their lives; these were activities decidedly not compatible with capitalist production, but it was culture and ideology that extended women's biologically-based procreative function to social responsibility for the care and maintenance of household members.

Ideology was to further merge with a variety of social, demographic, political, economic and technological forces to keep women at home. The reproductive activities of women, both biological and social, actually increased and tended to be borne solely by mothers, as kin networks became strained and were not replaced by other social support services. High fertility rates were not countered by developments which would have reduced work in the home; instead, widespread education took children, traditional mother-helpers, from the home without corresponding technological developments (piped water, electricity) which could have eased the demands of day-to-day activities. Productive forces had not developed to a point where they could adequately replace time-consuming and arduous household work. The state had yet to share genuinely the burden of women's child-caring work. Given these coercive

circumstances, the division of labour took on a configuration of a male primary-income earner and a female houseworker.

But the ideology also encountered contradictions in material life. In many households the wages of working-class men rarely amounted to a family wage; in fact, these wages were not only insufficient to buy off child-care, housework or replacement goods but also barely sufficient to enable workers to reproduce themselves. In the countryside, earnings from the farm also could not sustain family members. Women needed to earn an income as well. Thus, much as women's place was in the home, full-time housewives were shortlived in the majority of households. In households which they headed, women's place was both home and market.

In contrast were the material reinforcements that underpinned the ideology for women of the other classes. Among the wealthy and propertied classes, the intermediate strata, and even among the labour 'aristocracy' of salaried workers, married women stayed home because their husbands adequately or more than adequately provided for the household. The women of these classes were also relegated to the home because of children and they experienced, too, the restrictions of the ideology of woman's place, but they were freed from the physical burden of reproductive work: they had servants to do it for them.

Thus, although the ideology of woman's place transcended class, it found extensive expression among the propertied and middle classes because the material made it more possible. It is the women and men of these classes who have sought to define femininity and feminine roles for all classes of women, through their influence in the state, the church, the educational system and the media.

Sexual politics and the family household

The widening sphere of the ideology was attended by the need for increasing justification. The ideology of woman's place became not merely a definition of women's responsibility for the home but her dominance in it. The separation of spheres, it is asserted, is really a separation of spheres of dominance: women in the household, men outside it.[1] Women are not 'just housewives'; they are the real power in the home – indeed they control the family purse and make the decisions.

This argument is fundamentally an attempt to compensate a gender that has been marginalized from production. Women are generally closely associated with the collective aspects of household consumption and their obligation to meet children's needs is regarded as stronger than men's because of their childbearing role. Men's obligation (although this is also dependent on their goodwill) is limited to providing some of the cash or productive assets required by women to carry out their household-management tasks. Since women are held responsible for the maintenance of the household, it is their task to determine where household resources go.[2] A crucial part of this responsibility is that women must meet their families' needs by stretching their husbands' cash contribution with good housekeeping – producing food and making clothing themselves; if this contribution is inadequate they themselves must

earn an income by engaging in servicing, petty trade or other work. It is women who must cope and devise survival strategies when household incomes fall and prices rise. More than a question of household power then, the so-called 'decision-making power' of women is primarily women's responsibility for the day-to-day maintenance and nurturance of men and children. For the most part, then, the meaning of what many call women's control of domestic resources and power in the household is really men's ability to shed their responsibility for housework and child-care, manifested through handing over a part or much of their earnings. And this view is no more true than the Filipino male's general disregard for household work. Women's responsibility in the household sphere, therefore, does not spring from a gender equality based on separate but equal spheres; rather it springs from a gender inequality based on the male's social, sexual and economic dominance.

Furthermore, the money women manage is really not theirs to dispose of as they please. The real meaning of women's so-called power in the domestic sphere is no clearer than in the extent of this responsibility among women of different classes. Earnings from men's productive work are generally used for household needs. In so far as these earnings leave little room for surplus, women use these resources for household consumption. In poor households, these earnings are always inadequate so that women must seek ways to supplement them. However, in affluent households, women still manage resources for family needs, but not much else: since the wealth derives mainly from men's productive work it is men who control (here the term is more appropriate) this wealth; it is men who make the major decisions and investments on where surplus resources go.[3] Of course, if women also make a contribution to household resources, whether rich or poor, they then come to have a say in the disposal of these resources. But even when women have some control over their earnings this does not automatically empower them in any significant way in altering gender relations. The husband's predominance is maintained precisely because of his privileged access to income, his position as head of household and his claim to female sexuality.

There is also the related issue of where women and men's earnings go. It is commonly held that the earnings of men are directly used for household needs. In fact, this is an uncommon experience. Women's earnings generally go towards meeting household needs, but men's earnings are often ploughed back into farm activities or used to meet sizeable household expenditures. It is also the case that men's earnings go for their own personal expenses, like cigarettes or alcohol, going out with their gang (*barkada*), socializing, gambling, and other women. An extramarital relationship, particularly if this is on a semi-permanent or permanent basis, means that another woman or family household has a claim on the man's earnings on a fairly regular basis.

Thus, the family-household system is far from being a power base for women. It is in fact contradictory for them. It starts with the ideological expectation that women can only achieve the main purpose of their existence through marriage to a man and continues its operations through women's servicing work in the home as wife, mother, housekeeper and emotional supporter.

The family-household system as it is constituted today is fundamentally based on a hierarchy of relations where the man is the head and the women is the subordinate. It is hardly a harmonious unit with a single common interest governed by complementary roles and needs. Gender relations within the household are in fact a complex interweaving of access to work, control of earnings, domestic tasks and the satisfaction of personal and sexual needs. The household's response to economic forces is an interplay of cultural and economic variables, of options for its members which open and close on the basis of age and sex. It is the source of the sexual hierarchy that is reproduced in the economy.

The family-household system, embodying as it does the separate spheres, limits women's options and isolates them from the larger society. It defines how women should see themselves. And it is within the family-household that men unambiguously exercise direct power over women. The subordination of women, therefore, is not only a collective experience but also an intensely personal one. Yet alternatives are not really present. Unemployment, underemployment and inadequate wages are very real material difficulties for women living without men.

The family-household is the primary site of men's control of women's sexuality. In some households this control has been expressed violently. Some men leave women and children to seek their own survival and yet come in and out of women's lives expecting them to satisfy their physical and sexual needs on demand. Often, when women resist, they are beaten and sexually abused.[4] Among export-crop workers in the south, the all too rapid recruitment of women, but not of men, has threatened the Filipino male's machismo. It has not become unusual to hear of jobless men spending most of their waking hours in beer-houses, getting drunk, going home to their overburdened wives, demanding sexual gratification, and if refused, inflicting violence on them.

In some communities in Central Luzon, sexual objectification is intense. All women are vulnerable but among the poor and working class in the area, women are particularly at risk because men who own or control no land or property control and appropriate in the only sphere available to them, the sexual. Thus, in this group, male urges must be satisfied at the risk of economic survival and emotional security: a man refused by his wife will not go to work or will turn to other women.[5] Today's marital bond really does embody the sex-for-money exchange.

Thus, the family-household system may be the site of supportive and rewarding relationships for some but it is, for all women, a central site of their subordination. While it is crucial for resource-pooling and mutual aid, indeed for survival, it has also been the source of women's vulnerability.

Women and the state

The state, as it reflects and re-orders gender relations, has figured prominently in the lives of women and men. This section looks at a specific aspect of this role

of the state, the state as agency of intervention. The discussion focuses on a widely held perspective on the connections between women and the economy and how this perspective is expressed in the Philippine state's behaviour towards women – through policy, programmes and bureaucracy. It then discusses one of the major economic programmes on women by national and international agencies deriving from this perspective.

Women and development intervention

During the United Nations' Development Decades (of the 1960s and 1970s), international agencies were increasingly made aware of the effects of economic development on women and on the linkages between poverty, population growth, basic human needs and women's role in production and reproduction. Development intervention directed at women as an economically disadvantaged group had begun to have mixed consequences for their welfare; many were detrimental to them. These interventions were often based on Western notions of family-household arrangements, employment, productive activity and income. They often ignored asymmetrical relations between women and men within households; they underestimated women's work in the household and outside it and directed development assistance primarily at men.

By 1975, the effect of development on women in the Third World became an official concern of the United Nations, declaring the year as the start of the 'Decade of Women'. The framework for this concern was Women in Development or WID. The WID approach emphasizes the distinctiveness of women as a human resource: there must be an efficient use of women as a resource if economic development is to take place. To do this, women must be integrated into the development process. Integration is to be accomplished through education and training and by directing women into decision-making positions and providing them with sufficient opportunities in order to move into the market economy.

The WID approach had three major strains. The welfare approach aimed at upgrading women's traditional skills which would enable them to have access to some income without necessarily taking them away from their mothering and household responsibilities. The anti-poverty approach emphasized the need for mobilizing women to take up income-generating projects so that they could acquire a hold on the market economy and thus help raise household incomes. The equity approach sought to enhance women's existing productive activities and to make more opportunities available for them to participate in all spheres of national life. Most WID projects were admixtures of these approaches, but in the main, the welfare and anti-poverty approaches predominated, and continue to do so, both in the rhetoric and the practice of development agencies and political institutions.

Gender in the bureaucracy

In response to the UN call for the integration of women in development, the Philippine government in 1975 created the National Commission on the Role of Filipino Women.[6] The language of integration is one of partnership and

participation: at making women 'full and equal partners of men', to have 'further equality', and for the 'increased contribution of women to development'.[7] The language of integration takes the substance and direction of economic development as given. It is this language that informs the state's view of women.

Between 1975 and 1985, the NCRFW was engaged in integration projects with a primary interest in the education of rural women and had several areas of concern: child-care, 'conservation of values' and resources, consumer protection and justice. Some of its activities included studies of legislation to ensure equality between women and men under the law, instructional modules to eliminate sex-stereotyping in the school curriculum, and income-generating projects.[8] Its programmes generally reflected the traditional role of women.

The commission was reconstituted in 1986 and since that time its focus has been on raising the awareness of the state bureaucracy for the purpose of promoting a 'gender-responsive development'.[9] The commission's centrepiece is the Philippine Development Plan for Women which is basically a statement of expectations and long-term goals. The commission aims to promote women's 'self-esteem', advocate 'shared responsibility' in family and work roles, eliminate 'social, cultural and legal discrimination', and 'influence and change the economic system' to ensure the equal access of women and men to productive opportunities. These goals are to be carried out within the framework of the state's Medium-term Philippine Development Plan 1987–92 to which the women's plan is a companion piece. It is therefore up to the state to implement these goals; its terms of reference are the terms of reference of the state. To this end the commission's plan is primarily a corrective measure of state strategy; it leaves unquestioned the state as embodiment of gender hierarchy. It also leaves largely unexamined the economic policies of a state of which it is part, policies which contribute to the deteriorating material condition and the social position of women.

A women's desk within the bureaucracy, therefore, may place gender on the agenda of the state, but it does not automatically challenge gender inequality. It must be realized that gender exists within a social context; if the society is characterized by marked social and economic inequality, then gender will reflect those inequalities.

Furthermore, a women's commission, as is the presence of women in political positions, while indicative of women's participation in political affairs, does not automatically work towards the interest of the majority of women. Indeed, Filipino women of the propertied and even middle classes who are in positions of political power have tended to behave in the interest of their class rather than in the interest of their sex.[10] Women who have held political power have largely been unwilling to pose fundamental challenges to accepted definitions of gender. There is a big difference between more women holding social power and women using social power to improve both the condition and position of the majority of women.

It also needs to be understood that a state's commitment to gender equality is contingent largely on the strength of organized women within the bureaucracy

who are committed to gender equality, and on the ability of the women's movement in the community at large to make the state take account of gender.

Policies and programmes

State policies and programmes are framed in terms of a specific gender-based organization of daily life. The state sees women and men in terms of their roles, that is, as individuals who perform certain functions within the collective. For adult women, this role is primarily their responsibility within the household: women are first and foremost (or are destined to be) homemakers; they are only secondarily productive workers. And the statistical basis is there – censuses in the postwar period show that the majority of adult women are primarily doing housework. It is this view that underpins state behaviour toward women.

The policy implication of large proportions of women classified as housekeepers is that the majority of women are considered economically inactive. But this inactivity is not a result of being unabsorbed labour, instead it arises from some sort of voluntary idleness. The housewife's situation then is hardly subject to policy intervention – except in the more obvious manner of making them more efficient (or more 'enlightened') housekeepers.

Thus, when women figure in development programmes it is their household role which is prominent. When women do become direct clients on their own, they are subject to the same separation of spheres and sexual stereotypes that operate in the market. A sampling of state activities is indicative of behaviour of regimes past and present.

The Department of Agriculture looks at a farm family as a corporate unit; it recognizes that farm work is the work of men, and only secondarily that of women. Thus, the transfer of technology that comes with 'raising agricultural productivity' is regularly channelled to the man. Women are usually brought into such activities as home-management skills training, food processing and preservation and a whole array of supplementary livelihood activities within women's traditional occupations.

At the Bureau of Forest Development within the Department of Energy and Natural Resources, an emergent practice has effectively diminished women's access to resources. The social forestry programme, which has the stated goal of involving members of the forest community in forest renewal and conservation, now awards the stewardship contract to the man even if both husband and wife work the land and regardless of who had first access to it.[11] Stewardship contracts, as is also the case with land titles, have implications beyond legal rights. People who hold these contracts or titles have official status and thus it is they who have primary access to training, productive resources and services.

A similar marginalization of women is taking place with management of irrigation systems. The community-managed irrigation systems initiated by the National Irrigation Administration recognize the active involvement of women because first, it is household resources that are committed; second, irrigation concerns not only the efficient irrigation of land but also the provision of water for household purposes; and third, the maintenance of the systems are carried

out by both women and men. Yet memberships in irrigation associations, a key to access to productive resources and services and to participation in decision-making in community resources, are open only to men as household heads. Women are allowed to participate in meetings but only as representatives of their husbands and rarely in their own right. One community has acknowledged women's rights to membership and has asked that joint membership be practised instead. But the licensing agency, the Securities and Exchange Commission, has found this unacceptable.[12]

At the Department of Education, Culture and Sports, gender-based occupational channelling continues. Officials of the department claim that non-formal education is provided to people regardless of sex. However, women are offered teacher-training, apprenticeships in microelectronics and skills training in home-based crafts. Equivalent projects for men are training in mechanics and middle-level training in agriculture and industry. While the rationale is given that the concentration of one sex in a programme is more a matter of self-selection, there is only a limited attempt to rechannel women's training towards more employable, competitive and non-traditional skills.

However, at the same time that women are secondary beneficiaries in development programmes, the state's population bureau pursues strategies directed primarily at them. Although incentives to control fertility since the mid-seventies have veered away from the simplistic connection between poverty reduction and limiting population, strategies have not changed their basic thrust with respect to gender responsibility. Programmes have recently taken the broader perspective of improving women's health and education, providing women with productive work, and preventing environmental decline. The link to women's autonomy assumed in this reorientation of population programmes, while generally beneficial to women, has once more brought women squarely into the centre of the population issue. The centring on women has placed the burden of responsibility on their shoulders, leaving men out of the picture.[13] Since 1986, this burden has been more acutely felt as women's access to contraceptive devices has been circumscribed by pressures from religious forces and by an ambivalent state population programme.

State policies and programmes have been far from gender-neutral.

The economic content of women's programmes

By far the bulk of government and non-government development programmes directed at women (or WID programmes) is that which comes under the category of income-generating projects (or IGPs). By far also the largest assistance to women given by bilateral and multilateral agencies focuses on this area.

The fundamental assumption of IGPs and other such programmes of integration is that within the development process, women have not experienced (or have not been subjected to) the same process as that of men. Hence the strategy is to integrate women into this process.

IGPs are anti-poverty schemes directed at helping poor families improve their standard of living. The focus therefore is the household, but one

constituted by a specific set of social relations and informed by the basic separation of spheres: that women are primarily (and even solely) responsible for domestic activity and men for productive work. Women's principal task is to see to their household's basic needs – nutrition, health and education. Since women's immediate needs and interests stem from their primary role as mothers, wives, and housekeepers, what is required, it is argued, are sets of activities which will not replace this role but which are compatible with it. Moreover, since women's household-based activities are not economically productive, the time and effort expended on these activities are free to be diverted towards alternative or additional activities without incurring major economic costs. These additional activities are the IGPs. Hence the supplementary nature of IGPs: they are in large measure part-time, irregular employment and very small scale 'so that household tasks would not be neglected'.[14] These projects range from weaving and sewing to food processing, swine fattening, backyard gardening, poultry raising, brick, charcoal and soap making, the recycling of cloth and cloth remnants, handicrafts and so on.

While IGPs and similar programmes of integration have helped in supplementing the day-to-day needs of poor households they have failed to benefit women in the long run for several important reasons. First, IGPs ignore the fact that women are already productive workers. They are land cultivators, hired labour on farms, independent producers of handicrafts, outworkers and subsistence traders. IGPs overlook the multiplicity of women's productive and reproductive services to household and community and thus fail to maximize the overall potential and effectiveness of women's *existing* work in rural areas. Because basic economic projects were (and are) given to men as household heads, residual income-generating projects were (and are) given to women. As a result, basic existing inequalities between women and men – the unequal access to productive resources, credit, technical assistance, training programmes, and income-earning opportunities – and the unequal burdens of reproductive and productive work remain intact, and are most probably exacerbated.

Second, the emphasis of IGPs and other programmes of integration on 'increasing productivity' without consideration for women's reproductive work, obscures the contradictory relationship between the two spheres of women's activities. IGPs, by simultaneously placing emphasis on women's traditional roles, especially those of mothering and child-rearing, most likely have the effect of undermining women's entry into productive activity because involvement in one is at the expense of the other. There is a limit to how much women can lengthen their working-day, and child-minding is work that cannot be done more quickly by a more efficient use of time. Yet little or no consideration is paid to easing women's reproductive work, for example, by promoting shared conjugal responsibility for household and child-rearing roles, or by instituting state-run child-care centres. When women try to combine child-rearing and productive work, and often they do, they experience considerable stress and the consequences are usually seen in their physical effort and the adaptations they make with respect to food and nutrition to save

on labour time.

Third, IGPs, because they are low-paying, low-productivity activities, serve to deepen the subordination of women in the development process. As women take on these activities, they come to subsidize part of the reproduction of the primary worker. The primary worker's low wages are both the cause and result of the worker's reproduction being obtained from other means – the productive work of women. Thus, the surplus that is captured by capital is increased because of the combination of the male worker's low wages and the productive work of women, at the same time that this work is partly dependent on inputs from international capital. IGPs do not really 'increase economic productivity' as they claim to do: rather they increase the rate of self-exploitation, and thus the surplus which capital is able to capture, because these activities are necessarily low paying.

In so doing, increased productivity reinforces class inequality: women are encouraged to be more productive by intensifying their labour in order to earn more, while the concentration of ownership and control of wealth and resources remain undisturbed. IGPs, because they are essentially welfare programmes, tend to co-opt low-income and structurally disadvantaged groups and thus serve to maintain power and gender structures. Indeed, some of these programmes have been initiated primarily to forestall urban and rural unrest.

In brief, these activities tend to exacerbate already unequal income distribution and gender relations. These projects further polarize the classes into doing low-productivity work at one end and of increasing surplus at the other: they do not generally benefit women because they were never meant to empower them in the first place. Women may reap immediate gains without ever realizing or going against the unequal gender structures that make such projects necessary. Given this context, it is very difficult for women to become, in the words of many projects, 'self-reliant'.

In summary, programmes for women such as IGPs try to increase women's integration into the development process by providing them with access to skills and productive resources, although not similarly to men. This objective is based on the premise that the benefits of development can be redistributed through participation in the market. Since it was perceived that the bulk of women's labour was already committed to unpaid reproductive work, attention was focused on the supplementary component of women's activities: productive work. Support for women was then given within their prescribed roles, subordinate to the activities and functions performed by men. The relationship between the two spheres of women's contribution therefore is seen in terms of a sexual division of labour, but a division which is a partnership and a relation of complementarity rather than one of dependence and subordination – women's dependency on men's work and women's subordination with respect to rights and duties within marriage.

Thus, although the state is pledged officially to helping women achieve equality with men, economic and political considerations make its position ambivalent. The programmes of intervention do provide women with productive work, however meagre the returns, but without which household

levels of living would deteriorate even more. But such programmes also serve to facilitate inequality-generating processes, and in so doing, reinforce gender hierarchies and the sexual division of labour; they serve to isolate further women from the mainstream of economic activities and lock women into a subordinate position.

The failure of development: Gender and systemic crises

The development decades through the 1980s led to the increased deterioration of the cultural and material lives of most of the Philippine population, but especially women and children. The economic system may have shown vigour and dynamism at times, but people's basic needs remained unmet.

We are now in the midst of many crises.[15]

The crisis of reproduction

We have a crisis of reproduction because the basic needs of the majority of the population are not being met. This crisis affects women directly because women are responsible for the reproduction of people on a daily basis and from generation to generation.

Philippine political regimes have pursued economic-growth policies, expecting growth to 'trickle down'. But economic growth has not improved the conditions of human reproduction. The Philippine state has now taken over some of this responsibility, but state commitment is always contingent on the exigencies of state expenditures.

The reproduction of human beings depends primarily on state policies toward the productive sectors, particularly agriculture, toward employment and toward direct expenditure on the fulfilment of basic needs and the alleviation of poverty. Without these policies economic growth will meet basic needs only if it increases employment and the real incomes of the majority of the population.

The crisis of reproduction was brought about primarily by the excessive emphasis in the world system on aggregate food production and the grain trade to the detriment of land and resource availability for regional and local food self-sufficiency.[16] In the Philippines, the Green Revolution increased total national food production for several years but did not address inequities of distribution among poor regions, classes or income groups. Large estates and *haciendas* co-exist with small tenancies which have increasingly given way to capitalist and corporate farming with wage labour. The increase in the numbers of dispossessed small farmers has led to large-scale shifts to urban slums and rural impoverishment, while the landless have grown dependent on seasonal migratory work, contract farm labour, and overseas work.

In the past few years there has been a failure of agriculture in the country. Crop production has had negative growth for the past four years;[17] farmers have suffered a 16 per cent reduction in nominal income and a 32 per cent reduction in real income.[18] Stagnation in food production and

supply and the fast growing demand among urban workers for food has meant increased prices of food in the cities. The failure of agriculture has also led to the deterioration of living in urban areas and increased unrest among female and male urban workers.

The debt crisis

A crisis exists in the balance of payments and in debt repayment. The Philippines' balance of payments deficit and huge debt burden are but symptoms of a larger crisis in the global financial and monetary system and in related mechanisms of international trade and capital flows.

In the early 1970s, petro-dollars were being recycled by commercial banks through lending to the Third World. The Philippines borrowed heavily from private banks and multilateral institutions, primarily the World Bank and the IMF. Loans were allocated according to priorities negotiated between governments, private lenders and private borrowers, guaranteed by government. But loans were not used for basic needs; instead they were spent for militarization, for infrastructure projects with long periods of gestation, for Western-style goods and services to meet the demands of certain domestic consumers and a few social services.[19] Some of these funds made their way to private bank accounts.

As global trade slowed down, the adjustment process bore down heavily on countries with large debts, such as the Philippines and many countries in Latin America.[20] The burgeoning of the debt burden followed the world-wide recession which prompted a decline in Philippine and Third World exports and was worsened by the protectionist measures of industrial countries and varying international interest rates. These events made the international monetary and financial system unstable; it became more difficult to service debts in the short-run and made long-term planning almost impossible. This configuration of events is the context of the structural adjustment packages negotiated 'in tandem' by the IMF and the World Bank.[21]

Structural adjustment packages have always meant difficult times for the masses. The poor and labouring classes, particularly the women among them, bear the brunt of these economic adjustment programmes as conditions for the reproduction and maintenance of human resources deteriorate further because of cutbacks in the imports of consumer goods, in domestic subsidies for items like food and fuel, and in expenditures on health and education.

The basic needs of the majority of the population are among the lowest priorities of government and multilateral lending agencies. From the years 1986–9, an average of 42 per cent of the national budget went on debt servicing, and little went on health, nutrition, education and other social services. The budget squeeze is also felt directly in public sector employment. Further opening of the economy to foreign goods and expanded capital movement cut into activities of small- and medium-sized firms. At the same time, however, structural adjustment packages are accompanied by policies which favour relatively well-off sectors of the population.

Women as a group are particularly vulnerable in times of economic

contraction. The population in the informal sector, made up largely of women, continues to expand either as a result of increased commodities or as a result of a deterioration of wage and income levels when prices rise. The public sector, the largest employer of women, puts a freeze on hiring and in wage increases. Women's work becomes casual labour as a result of the privatization of many public-sector corporations.

Cutbacks in social services mean women pick up the slack left by the state. Women have to make trade-offs among different basic needs in the use of resources such as their labour time, cash income, and land or other resources over which they have some control. But often, women's labour time becomes the only resource over which they have any control. This means that in order to cope with crisis, women intensify their labour and extend their working day; their work burdens increase. Coping leads to shifts to cheaper or less nutritious food for the household members and for women and children, it also means smaller amounts of less nutritious food. Evidence has accumulated on the adverse effects of economic crises on the health of the population, especially that of women and children. The numbers of severely malnourished children has increased to one out of five children;[22] roughly 37 per cent of the population suffer from anaemia and a disproportionate number of infants and pregnant and lactating women are among this group.[23] Throughout the 1980s there has been a continuing decline in female nutrition and health: there has been a decline in female life expectancy, daily calorie intake and an increase in maternal mortality rates and the proportion of low birth-weight babies.[24]

The crisis of violence

Armed political struggles for national, ethnic or religious liberation have justified increasing state expenditure for militarization. But military expenses in the name of 'national defence' and 'national security' are not merely economic expenditures: militarization is accompanied by indiscriminate repression and violence. Women and children have been among the many civilian casualties and among the many 'internal refugees' of armed conflict. From January 1988 to June 1989, more than 450,000 women, men and children fled their homes due to political strife.[25] Relocation of whole communities means families lose access to land, food supplies and other sources of livelihood. Relocation has led to the further deterioration of nutrition levels of men, women and children and to the death of many children. The sexual abuse and rape of women detainees have become routine military, paramilitary and police procedure.

The military also becomes an instrument of repression as it tries to uphold the very processes and strategies which create domestic unrest, inequality, poverty and exploitation. Development strategies biased against the poor and the working classes create the conditions that spawn opposition, which in turn breeds violence and repressive actions by those in power. The military and its creation, the paramilitary forces, step in and in the process, increase their share of the national budget and external aid. This cuts into social expenditures and increases further discontent. As well, powerful international forces such as

multinationals support domestic repression in the name of industrial peace.

Factionalism within the military has been expressed through violence, while encounters between the state and civil society have led to the suppression of civil rights and death to dissidents.

The crisis in culture

Systemic crisis has been accompanied by a revival of male and religious chauvinism. The economic instability of the country, combined with an amorphous quality of politics, promotes stress and readjustment in social relationships and brings to the fore movements for religious and conservative revitalization. As well, however, the increased activities of Christian and Islamic fundamentalists in the West and other parts of the world have spilled over to the Philippines and in fact support many revivalist (Catholic, Protestant and Islamic) efforts. Christian fundamentalist groups have increased rapidly in recent years. From 1980 to 1986 a total of 145 Christian fundamentalist groups were registered; between 1987 and 1988, in one year, this figure was 290.[26]

Most fundamentalist movements advocate the return to traditional family structures and conservative cultural ideologies in the face of women's increasing entry into productive work. The drive to get women back to their 'proper place' to perform their 'proper roles' is contradictory to the reality of women's need for employment in order to survive and to maintain households. Women are being blamed for the breakdown in culture; yet women themselves are the very victims of the crisis that has bred violence, war and inequality that has caused this breakdown.

The 1980s has seen first a crisis in political legitimacy and recently a political sphere in disarray and incapable of governing. Combined with economic instability, the result has been a society in turmoil.

There is a crisis in national identity as the country is deeply divided on the real meaning of national interest. Women's interest is closely tied to the issue of national interest: the subordination of national to foreign interest deepens the subordination of Filipino women.

Women's response

In crisis after crisis that continue to diminish their life options, Filipino women have shown internal resilience. They have fought for their right to work, to work the land and to work for a living wage, and to have a decent shelter. They have learned to shed traditional submissiveness, and withstand family and community pressures to improve their and their families life chances. They have collectively resisted violence, imperious regimes, death squads and multinational contractors. And now they have come together as a movement to challenge male privilege, not to replace men but to transform the system to a sense of shared responsibility, nurturance, openness and the rejection of gender and social hierarchies.

Part IV:
Gender and Social Transformation

12. Gender Subordination: historical and contemporary configurations

The colonial legacy

[handwritten margin note: colonial era laid ground for recovery of subordination]

The colonial era which started in 1521 and ended in 1946 had laid the basis for the structural subordination of the Philippines in the global economy. Colonial interests converted the country into a source of raw materials, food, and labour, and a market for the manufactures of colonizing countries.[1] This conversion led not only to the drain of the country's resources and wealth but also to the creation of export enclaves in agriculture and mining, the transformation of self-provisioning communities through commercialization, and the introduction of private property in land. Colonial rule eroded the manufacturing base, principally women's cloth-weaving industry, and destroyed traditional crafts and artisan production through the importation of machine-made products, especially textiles. Colonialist political and economic policies also started a chain of practices which led to environmental degradation, demographic pressure and land and resource misuse.

The structural changes wrought by colonization meant the impoverishment of increasing numbers of the population, the institutionalization of inequalities in access to land, resources and power, the creation and reinforcement of a gender hierarchy, and the emergence of powerful groups whose interests were linked to the maintenance of the flow of foreign capital. Thus the colonial period created or reinforced inequality among nations and between classes, genders and ethnic groups within nations.

[handwritten margin note: brought poverty]

The neo-colonial period

[handwritten margin note: — transformed to neo-colonialism]

Economic programmes involving the articulation between internal and international social structures merged with the colonial legacy and transformed it into neo-colonialism. Import-substitution industrialization, instead of protecting local interests and giving economic growth internal momentum, became an invitation for foreign capital to strengthen its hold on the local economy. Export industrialization promoted under conditions of extreme inequalities of landholding and income and without the necessary links to domestic production meant that existing inequalities were exacerbated.

Growth was accompanied by rapid over-urbanization and serious internal dislocation. It created a burgeoning population of unemployed and underemployed and a low-paid working class that saw no option but to export their labour-power as well. By the 1980s, economic growth, because it was based on the flow of external private capital, had become difficult to sustain as the balance of payments crisis and the pressures of debt repayment weighed down on the economy. Under increasing external pressure to repay its loans, the country opened wide its economy to foreign capital and directed resources primarily for export. Multinational corportions, frequently in joint ventures with local wealthy groups, now dominate the economic life of the country directing most of its resources in the interests of global profits rather than of the internal growth of local industries.

Political regimes have yet to counter the pressures from local and foreign interests which stand to benefit from these economic programmes. Regimes continue to pursue industrial growth at the expense of reduced wages, the increased volume and intensification of women's labour, and at the cost of widening gender, class and regional differences. The transnationalization of Philippine political economy has meant considerable political unrest and economic instability for the country.

What have all these historical, economic and political developments meant for gender relations and the sexual division of labour?

The sexual division of labour and social change

During this historical and contemporary process of social and economic change, men's dominance was transformed from a situation where it was customary to one where it had become systemic, and the sexual division of labour from a situation where it was not sharply drawn to one which clearly meant the subordination of women. In an earlier period, women's work used to encompass both reproductive and productive work, when the household was a unit both for production and consumption. But with economic and political reorganization, arising from the economic forces of growth, commercialization and market expansion, and the consolidation of state power, gender-based social relations were rearranged. Men began to dominate civil society and the state more systematically and men's personal dominance was endorsed by the impersonal forces in the labour market which now operated to control women's lives. Spanish and American colonial policies, and the religious, political, economic and social systems and ideologies that went with them, were formulated and implemented by men. These policies and systems disfavoured women in access to land, resources, employment and technology. But male-dominant ideologies of colonial rule were only partly responsible for the worsening of women's economic and political position; equally important was the inherent inequality and poverty-creating character of economic and political structures. When private property in land was introduced, men were granted land rights, while women became subordinate to men, and their labour

went unpaid or badly paid, in systems of tenancy and debt peonage. When traditional manufactures, which meant primarily women's weaving, diminished, female employment and incomes diminished as well. When men were conscripted into forced labour by the colonialists or had to migrate to frontier regions and to other countries, women were left on their own to care for children and the elderly.

With the intervention of capital, production was radically restructured so that productive and reproductive spheres were increasingly separated. Women became primarily responsible for housework as a consequence of the merging of ideological and material forces: a sex-gender system that gave men the prerogative, women's prior connection to the maintenance of the family-household system and the inability of the economy to absorb the released labour of women. An ideology of women's proper place emerged to tie them to the home and a state apparatus endorsed the separation of spheres by regulating women's social behaviour. The housewife role became historically and culturally central to the identity of Filipino women.

The separation of spheres, however, was premised on the role of a waged worker whose earnings could sustain a family-household. This was not the case for most households so that, in fact, women needed to earn a living as well. But when women entered the labour market their work was conditioned by the demands of biological and social reproduction. Women did not have the same cultural freedom as men to engage in paid work nor was the market blind to their gender. Their responsibility for the home was both a material constraint and ideological justification for their secondary position in the work force. As notions of gender stereotypes and differential worth came to reinforce their position, women were paid reduced wages and channelled into low-paying, low-productivity work.

As capital continued to absorb men's labour far more than it did that of women, many women intensified their activities outside of the wage economy. Of necessity women became part of the industrial reserve army. Nonetheless they remained responsible for the daily maintenance of the workers for capital. Indeed the integration of male workers could neither be obtained nor assured in the absence of the domestic production activities and child-rearing tasks of women. Individual survival was possible only on a family-household basis.

Material and ideological transformations were attended by alterations in sexual practice. As the economy shifted from self-sustenance to wage earning and the market, the meaning of sexuality shifted as well; from a situation where women's sexual behaviour was not a cause of concern, to one where it became tied to a specific male-dominated Christian view of sexuality and was the subject of extensive regulation by the community and by men. A double standard of sexuality emerged in the process; women's sexual behaviour became circumscribed as ideologies of chastity, legitimate paternity and separate spheres came together to define more forcefully a proper place and proper behaviour for women. Concubinage persisted into the *querida* practice and sexual relations between women and men became commercialized. As economic options dwindled and structural conditions appeared, prostitution drew in unprecedented numbers of women.

The dominance of men, the subordination of women

Through various transformations in Philippine economic and social life, the intersection of sex and political economy has privileged the interests of men. The experience of women has been one of loss of autonomy and an unending process of accommodation, negotiation, resistance and rejection.

While wealth may have mitigated some of its effects, the subordination of women to men has defined every sphere of daily life. Men's primary right to work has meant that for the majority of women, the women who are compelled to sell their labour-power, conditions have yet to improve. Their ever-increasing impoverishment is only held off by increased hours of poorly paid, labour-intensive and low-productivity work or by higher-paying but decidedly sexually oppressive work. They are burdened by the double shift of housework and paid work. The majority of women, relative to men and other women, are clearly worse off. Productive work, instead of providing the necessary conditions for women's emancipation, has reinforced existing gender inequalities.

Men's greater personal control over property with economic differentiation has been translated into an increase in power over women. Male dominance has been asserted within the productive process itself as jobs have been redefined and gender identities institutionalized to men's advantage. Male privilege means that men occupy jobs that are higher skilled and better paid; they are also in jobs that have greater promotional prospects and use more sophisticated technologies. When recessions come, men are expelled last. Technology and skills are gendered.

Men have shed their share of household work, leaving the core of household. obligations to their wives. Men much more than women have greater personal use of their wages.

Men have exercised power in the sexual sphere. The ideology of male sexual needs serves no purpose other than the perpetuation of a sexual hierarchy which serves the interest of men well. The ideology sees to it that men have much more opportunity to be sexual and more social support for their sexuality; women remain at a particular disadvantage in terms of their right to have sex, much less enjoy it.

Men in positions of authority have used women as sexual objects: women are singled out for certain jobs if they are young, unattached and attractive; sexual harassment has become part and parcel of women's job security. Men as heads of households can (and often do) decide on whether or not their wives can take paid work. In more than a few cases, men's social and sexual dominance has been brutally manifested in the sexual and physical abuse of their wives.

Men have been able to shed their responsibility for population increases. Women's bodies have become the pawns in the struggles among men, regimes, private corporations and religious groups.

Sex and political economy: an alternative future

What then is to be done?

If the weakness of the position of Filipino women is a mere aberration of culture, then institutional reform may be able to correct the problem of asymmetry in gender relations. But if the subordination of women is an aspect of their position in the economy, the polity and the society at a particular stage of development, then institutional reform can at best have only partial results.

If there is to be equality in the life chances of women and men, and furthermore, if society is to allow the development of the full potential and creativity of every woman and man, then fundamental changes in human praxis and in the orientation of economic and political development is necessary.

The subordination of women and the dominance of men is simultaneously an individual and collective phenomenon: it involves a power relationship that is personally experienced and is also a relationship that is collectively experienced. Women and men as thinking, living and acting subjects make sense of structural changes and act, individually and collectively, to maintain, rearrange or resist these changes. Thus, the task is to structure both personal relations and social, economic and political structures and institutions – the economy, the family, the state, religion, the educational system and the mass media – in a non-dominating way.

Social institutions are the cultural and ideological supports for gender division: a particular family-household organization, the sexual division of labour and differentiated sexualities are cultural and ideological representations of gender. Ideological forces carry considerable weight in the reproduction of women's subordination and must be confronted on their own.

Ideological challenges need to be phrased in terms of redefining gender and sexual identities, going beyond traditional gender and sex roles and seeing both women and men as capable of independence and dependence, tenderness and strength, and giving and receiving. There is a need to change the socially-wrought meaning of biological difference in so far as the social subordination of women rests on that difference. Physiological difference is not at issue here; what is at issue is the socially constructed division based on this difference. This construction defines procreation as the naturally given basis for women's social and sexual behaviour. The emphasis on procreation sees women in terms of an inherent responsibility for children, and the extension of this responsibility to their husbands, the sick and the elderly. This biologistic 'common sense' leads to the elaboration of 'natural' differences which are supposed to underlie women's work at home and in the market.[1] Common sense has foreclosed many options for women.

There is a need to realize that the family is in no way a natural, eternal unit, outside the economy and the polity. The way the conventional family household is organized – in a hierarchy of sex and age – and the way it structures women's experience of self and women's options to work, renders it

a crucial, if not the central, site of women's subordination.

Sexual needs ought not to be taken as givens nor observable needs as determinants of social institutions. The idea that women have fewer needs or even no needs because these needs are not observable underlies female and male belief in their different sexualities. We fail to see the male sexual urge as socially defined. People who do not fit stereotypes are seen as abnormal: women who are interested in sex are promiscuous whereas men who are sexually active are perfectly normal.

But it must be realized that cultural representations – 'roles', 'responsibilities', 'images', 'attributes' – are rooted in historical social relations: they are only possible because of the prior consolidation of women's place and the prior commoditization of women's bodies. Hence, change is not simply a matter of wishing away or substituting roles, responsibilties, images and attributes; it is a matter of structures as well.

Today the notions of women's place and differential sexualities exercise a powerful ideological presence and find widespread justification in everyday life, but they are also encountering challenges in emergent changes in material conditions. These same challenges confront the institutions of marriage and family. Waged work and migration can provide, at least in the short term, alternatives to early marriage for many women. Waged work may turn out to be temporary but the possibility of new life situations for women prior to marriage and therefore outside of marriage, and thus even of leaving an oppressive marriage, has been created. But so long as many women are out of work or inadequately paid this option remains mere possibility, and the dependence on the wages of men still represents the only means of survival. It is this structural coercion that must be changed.

Changes in economic and political structures can be both reformist and transformative and are directed simultaneously at the material condition of women and their position relative to men. An ideology of sex and gender, a family-household system, and the sexual division of labour are systematically embedded in capitalist relations. Thus, one cannot see how these elements can be extracted from the relations of production and the reproduction of capitalism without a profound transformation taking place of these very relations. However, the experience of socialist economies also indicates that the overthrow of capitalist exploitation tends to leave other forms of exploitation in place. Socialist societies, because they have continued to support family forms and cultural practices closely allied to capitalist processes and male dominance, have failed to tackle gender divisions in any fundamental way.

But this is not to say that some improvements are not possible within the existing economic system; already there have been ideological shifts as a result of changes in women's position, in women's access to the political, and in the improvements by degrees, in the condition and position of some women. These reforms are important, for certainly if a new society is to be constructed, it is far better to start from a certain level of equality, within the system's own limits, rather than a situation of unchallenged privilege and oppression.[2]

Specific changes needed in the economic and the political spheres have to do

with the reorientation of economic development towards national self-reliance, especially in basic needs: food, healthcare, water, energy and education. Women's role in agricultural production must be reaffirmed.

Social development needs to be diverted from military intensification, ecological degradation and the interests of political fractions and directed towards the elimination of disease and hunger, the preservation of ecological balance, and the institutionalization of political processes responsive to the interests of the majority of women and men.

Economic strategies have simultaneously to emphasize growth and the distribution of the nation's productive assets. Because growth has not been accompanied by distribution schemes, it has resulted in the concentration and centralization of wealth on the one hand, and the barely subsistence standard of living of the working class and the pauperization of an unprecedented number of people on the other. The economic conditions of the labouring masses mean that the problem is not simply lack of economic opportunities; it is also poor remuneration for the employed, poor working conditions, low productivity and poverty. Simply prescribing increases in aggregate demands for labour as a solution to poverty and unemployment, therefore, precludes any enduring solution to chronic underemployment and the impoverishment of substantial numbers of the population, and fails to confront the sexual division of labour.

Economic development through various political periods in Philippine history has been characterized by the continuing pre-eminence of external forces, the same coalition of a dominant class system and of the same pattern of class domination. There have been the same demands for protection of ruling-class interests and the same requirements for political mechanisms to maintain the power of the dominant classes. Economic development therefore should be directed at changing prevailing class and social structures, because it needs to be understood that a balanced sustainable growth is blocked both by the policies of industrial countries and the strategies of international entities, and the resistance to such growth by those domestic sectors whose economic and political dominance is based upon the perpetuation of such policies.[3]

Multinational corporations continue to play a contradictory role in national development. They are said to spur economic growth, but they have also adversely affected large sectors of the population. Their activities need to be regulated by the state, to ensure that small farmers and small industries are not gobbled up by the size and influence of multinationals in the market, and that an ecological balance is maintained in the face of their high-technology, ecologically-threatening methods. These corporations have also been instrumental in drawing away resources for basic needs from the country. While they may employ some women, this employment has not been uniformly beneficial to them.

Economic reform packages such as structural adjustments are often necessary but these need not be borne solely by already disadvantaged groups. A reorientation of the economy towards a focus on gender issues, a greater selectivity in public expenditure cuts, a restructuring of public-sector activities, and greater emphasis on economic production geared towards local needs will

mean that women do not become worse off than men in comparable social groups.

The state has genuinely to take full account of gender: it needs to reorient itself from within, as embodiment of male dominance, and reorient its behaviour towards the population. The regime and the state have to be made accountable for the direction of development and the marginalization of social groups – women, the poor and minority communities. The state has to share in the responsibility and care of dependent members of the population: children, the elderly and the disabled.

The state needs to free its official data and surveys from bias towards male activities. Otherwise as these data become the basis of state policies and programmes, they will continue to contribute not only to increasing the differences between women and men but also to exacerbating their differential access to resources. Furthermore, as these instruments make the connection between women, the family household and housework, they will continue to have the effect both of making invisible women's productive contribution to economic life and marginalizing women from major economic programmes.

The more effective starting point of state intervention therefore is an understanding of those social, economic and political contradictions which immediately confront women rather than any *a priori* stereotypes of women and men's roles and of the complementarity of these roles. The state must revise its categories of family, household, reproduction and production and take account of the diversity and complexity of activities, decision-making, access and control within and across units of intervention. It needs to see society in detail and not in aggregates; and to look at labour as highly differentiated by gender, age, class and ethnicity and as a function which is responsible for a multitude of life's passages. Thus, if the state is to equalize the life chances of women and men, it must realize that women and men work and respond differently to different conditions of the demand and supply of labour. If women are to be productive in the same manner as men then they should receive the same benefits as men: similar access to training, productive inputs, technology, financial services, and the market and not, as so often happens, only by increasing the volume and intensity of their labour.

The sexual division of labour can be largely eliminated by making women and men equally responsible for both reproductive and productive work and by giving both women and men equal rights to productive work. This means first, the elimination of women's dependence on a male wage; and second, the distribution of labour and responsibility for child-care and housework. Whether reproductive work is privatized or shared collectively, it must be shared between women and men. Women's participation in public life will continue to be shaped by the role the domestic unit plays in the economy. As long as family life takes up most of women's time, women cannot participate in the public sphere in the same way as men.

Within the work-place, there needs to be a greater degree of integration of the work that women and men do: this will diminish, if not eliminate, the boundaries of male and female work and there will be a greater degree of

comparison of work, which is necessary to establish equal value principles. It is difficult to struggle for equal pay when there is no basis of comparison. Women cannot struggle against being paid less than men when ideological considerations and material forces favour the interests of men; men see to it that women are not in a position comparable to them.

If equality is to be pursued, then women must be placed in an economic and political position to restructure gender relations on a more equitable basis. This means eliminating the most overt forms of gender inequality, that is, the sexual division of labour, occupational segregation, job market segmentation, unequal work burdens, income and resource inequality, social and political discrimination, restrictions on the biological reproductive rights of women and of the expression of their sexuality, and legal supports for women's subordinate status. Women should be able to forge roles of their own choosing.

Notes

Chapter 1

1. I first encountered this phrase in Rubin (1975).
2. Chodorow (1978).
3. See the arguments from Oakley (1972) and Brittan and Maynard (1984).
4. See Foucault in Rabinow (1984) for a discussion of the body as historically constituted.
5. The reference here of course is to normative gender identity and normative sexuality or heterosexual genital sexuality, the normative continuity between gender identity and genital sexuality, that is, a male whose erotic–sexual object is female and a female whose erotic–sexual object is male. Since this discussion is on the relations between women and men and the social dominance of men within these relations, the focus is on normative gender identity and normative heterosexual genital sexuality.
6. The process of acquiring a gender identity is not one of passive internalization but of an 'active' negotiation, adjustment, resistance and even of counter-socialization (Brittan and Maynard, 1984). Gender identities are also not fixed or rigid; rather they are fluid and flexible (Rose 1986), hence, 'more or less' corresponding and 'more or less' appropriate.
7. See an extensive review of the evidence by Oakley (1972).
8. Oakley (1972).
9. See among others, Masters and Johnson (1966), Oakley (1972), Rubin (1975) and Caplan (1987).
10. I derive a good part of the discussion on origins from Rapp (1977).
11. Mies (1986).
12. Ibid. One section in this book reviews the theories of women's subordination.
13. Engels (1884). See also Sacks' (1974) discussion of Engels' work.
14. I shall continue to use 'sexual division of labour' because it is the established phrase but what I mean by it is the gender-based division of labour.

Chapter 2

1. A third aspect of reproduction is called 'social reproduction' or the transfer of control or use of resources from one generation to the next, as in the practice of inheritance (Beneria 1979).
2. My sources for the discussion of the historical process of the sexual division of

labour are Tilly and Scott (1978), Hamilton (1978), Barrett (1980) and Mackintosh (1981).

3. The phrase 'family-household' is from McIntosh (1979). Family-household is preferred because it is more inclusive than either of the terms used singly.

4. Hamilton (1978).

5. The discussion of the development of the capitalist mode of production is from Marx (1867), translated in 1977 by Ben Fowkes.

6. Home and workplace need not necessarily be separated in a capitalist relation (hence, 'tended'); for example, there is the putting-out system.

7. Barrett (1980).

8. There has been a major debate in the West on whether reproductive work is work which produces exchange and therefore surplus value. For works on this topic see, among others, Seccombe (1974), Coulson *et al.* (1975), Gardiner (1975), Himmelweit and Mohun (1977), Molyneux (1979), and Barrett (1980).

9. See Mies (1986).

10. Layo (1978) argues, on the basis of regression analysis, that men are the most crucial variable in women's work. She subjected the determinants of female labour participation to regression analysis and came up with the finding that, for married women, husbands' approval made a greater contribution to women's work plans than any other variable, 'sociological or economic'.

11. See Enloe (1980), Cockburn (1983), Phillips and Taylor (1986), Humphrey (1987).

12. Ibid.

13. Oren (1974), United Nations (1976), and from my conversations with researchers undertaking studies on women's health.

14. The concern of this study is with the *latent* industrial reserve army of labour. Marx (1867) considered this group a part of the mass of workers: every labourer is part of it whenever she or he is unemployed or partially employed. (See Marx [1867] for other groups which comprise this reserve army.) In *Capital*, Marx describes how the phenomenon of an industrial reserve army of labour arose as an actual historical development. The concept, therefore, cannot be understood apart from the process of capital accumulation.

15. See Marx (1867) and Cockcroft (1982).

16. Johnson (1983).

17. Ibid.

18. Many experiences of women in the Philippines are strikingly similar to those of women in other countries, particularly those in Latin America and Southeast Asia. See for example Stoler (1977), Chinchilla (1978), Saffioti (1978), Young (1978), Deere (1982), and Heyzer (1986).

Chapter 3

1. Again, the reference here is to normative sexuality. Any thorough analysis of sexuality (not the intent of the present discussion) should include sexual practices of minority groups, for example homosexuals, transvestites, which are often seen as showing discontinuity between gender identity and genital sexuality. For an extended discussion of sexuality, see Gagnon (1977), Mitchell and Rose (1982), Rose (1986) and Caplan (1987).

2. See Oakley (1972) and Gagnon (1977).

3. McIntosh (1979).

4. See Oakley (1972), Masters and Johnson (1966).

5. Thomas (1959).

6. Barrett (1980).

7. Machismo, of course, is not unique to Filipino men. See Stycos (1968) and de Hoyos and de Hoyos (1966) for a roughly similar machismo culture in Latin American countries.

8. Johnson (1979).

9. Barrett (1980).

10. The following discussion draws partly on Barrett (1980).

11. Johnson (1985).

12. MacKinnon (1982).

13. Barrett (1980).

14. See Humphrey (1987) and Grossman (1978).

Chapter 4

1. Constantino (1975). The estimate is based on tribute payers. It does not include upland groups in Luzon and Muslims in the south. But Constantino estimates that the numbers of these two groups were not substantial.

2. The Spaniards called the islands, F(e)ilipinas, after the Spanish king, Felipe, and the people, collectively as F(e)ilipinos. During the American period, the islands became known as the Philippines. Today, the people of the Islands call the country Filipinas, and collectively call themselves, Filipinos; men are called Filipinos and women, Filipinas. To simplify usage for English readers, this book refers to the country as Philippines and to the culture and the people, Filipino.

3. See Infante (1969).

4. Colin (1663).

5. Constantino (1975).

6. Chirino (1604).

7. Cited in Scott (1982).

8. Infante (1969).

9. See Infante (1969) for the Tagalogs and the Visayans, Plasencia (1589) for the Pampangos. Other groups were the Tinggian (Worcester, 1913) and the Ifugao (Lambrecht, 1935).

10. Infante (1969).

11. Plasencia (1589), de Morga (1609).

12. de Loarca (1582).

13. Chirino (1604).

14. Colin (1663).

15. On the influence of the *babaylanes*, see Salazar (1989).

16. If burial practices are revealing of a group's contribution to society then women were really the producers; they were buried with their weaving looms or agricultural tools while men were buried with their weapons.

17. Cited in Rafael (1988).

18. Rafael (1988).

Chapter 5

1. Constantino (1975).
2. By the late 1800s unmarried adult women were also required to pay tribute.
3. For a similar experience of native women in Latin America see Pescatello (1976).
4. Phelan (1959).
5. de la Costa (1965), Constantino (1975), McLennan (1980).
6. Constantino (1975).
7. McLennan (1980).
8. This was also the case in Latin America where the role expectation based on the Virgin Mary has been called 'Marianismo'.
9. Guerrero (1989).
10. Jesuit Missions (1608–9).
11. Mananzan (1989), Dery (1989).
12. de Morga (1609).
13. Cited in Mananzan (1989) with examples of entries of official complaints against friars in the *Ramo Inquisicion*. See also Gleeck (1984), Guerrero (1989).
14. de Loarca (1582).
15. de Mas (1842).
16. MacMicking (1851).
17. On Filipino men see Jagor (1859).
18. San Agustin (1720), Pescatello (1976).
19. Lopez de Legaspi (1559).
20. de Morga (1609), Chirino (1604).
21. de Loarca (1582), Colin (1663).
22. Reforms (1884).
23. de Mas (1842).
24. Ordonez de Cevallos (1614).
25. Colin (1663), de Mas (1842).
26. San Agustin (1720).
27. Terms are from San Agustin (1903): see also Dasmarinas (1591). For example, among the present-day Badjao, a cultural community in southern Philippines, sexual exchange for gifts is an acceptable practice. It does not carry any connotation of prostitution. (Nimmo nd)
28. Rafael (1988).
29. Ibid.
30. See ibid for these exchanges.
31. Ferraris (1987).
32. Ibid.
33. Kroeber (1918).
34. Wickberg (1982).
35. Omohundro (1981).
36. From the early years of the seventeenth century until 1765, trade of the Philippines was limited chiefly to the Manila–Acapulco galleon. In this trade, Chinese goods were brought to Manila for trans-shipment to Acapulco.
37. These can be numerous. In the Augustinian convent 300 domestic servants were required for its triennial meetings (Phelan 1959).
38. Diaz-Trechuelo (1966).
39. de Morga (1609).

40. Deere (1977) discusses a similar situation of labour appropriation during Spanish rule in Peru.

41. MacMicking (1851).

42. Under the Spanish Civil Code, married women had similar rights concerning family and property to minors, lunatics and idiots.

43. See Ileto (1979).

44. Ibid.

45. Ibid.

46. Ibid, Ileto notes these sexual liaisons but sees no politics in the practice.

47. Wilkes (1974).

Chapter 6

1. This account is from the US Bureau of the Census (1905).

2. A smaller number of men was engaged in the making of cigarettes.

3. de Jesus (1980).

4. MacMicking (1851).

5. de Jesus (1980).

6. MacMicking (1851).

7. de Jesus (1980).

8. Von Scherzer (1858).

9. de Jesus (1980).

10. Ibid.

11. Ibid.

12. Ibid.

13. Owen (1976).

14. Ibid.

15. Planting is not a yearly operation in abaca production (Owen 1976).

16. Ibid.

17. Ibid.

18. Ibid.

19. Ibid.

20. Jagor (1859).

21. Owen (1976).

22. Abaca production in the Bicol region declined in the early twentieth century and was eased out by more efficient Japanese-run plantations in Davao in southern Philippines. Coconut production replaced abaca in the Bicol region but it was not until advances in chemistry multiplied the uses to which coconut oil could be put that an export market developed (Owen, 1976).

23. Jagor (1859).

24. MacMicking (1851).

25. McCoy (1977).

26. Loney (1857).

27. McCoy (1977).

28. Ibid.

29. Ibid.

30. Ibid.

31. Ibid.

32. McLennan (1980).

33. Ibid., Constantino (1975).

34. McLennan (1980).

35. Ibid.

36. Ibid.

37. Ibid.

38. Ibid.

39. Owen (1976).

40. Ibid.

41. Dery (1989).

42. Resnick (1970).

43. Marx (1867).

44. Young (1978).

45. Ibid.

46. Ibid.

47. Ibid. Similar processes occurring in two regions in Mexico during the nineteenth century are analysed here.

48. Owen (1976).

49. McCoy (1977).

50. See Tilly and Scott (1978) for an account on the connection between birth rate and labour productivity in Europe.

51. San Agustin (1720), Martinez de Zuniga (1803).

52. As quoted in Owen (1976).

53. Written by de Castro (1938). Modesto de Castro was a Filipino priest.

54. de Castro (1938). See Fee (1919) for a Western woman's view of this behaviour.

55. Maria Clara was a major female character in Jose Rizal's two political novels, *El Filibusterismo* and *Noli Me Tangere*. Jose Rizal was a major figure in the Philippine Revolution and is a national hero. He did not think the woman Maria Clara was an ideal role model for women. See his 'Letter to the Women of Malolos'.

56. Fegan (1982).

57. Constantino (1975).

58. See Ileto (1979).

59. On Filipino abuses see Ileto (1979).

60. Mabini's programme for the Philippine Republic included a section on women's civil and political rights. But it seems this did not make its way into the final version of the constitution. Apolinario Mabini was a major figure in the Philippine Revolution.

61. Constantino (1975). Fast and Richardson (1979).

Chapter 7

1. See chapters 1 and 2 of Schirmer and Shalom (1987).

2. Ibid. See Chapter 2.

3. See Report of the Philippine Commission (1904).

4. Ibid.

5. In 1934, 84 per cent of Philippine exports were directed to the USA. Four exports dominated: sugar, coconut products, tobacco, and hemp, which, in total, constituted 90 per cent of all exports. Sugar was 60 per cent of total exports (Kirk 1936).

6. The stage of monopoly capitalism is characterized chiefly by vast monopolistic

corporations, the development of an international market, the growth of the state, and the extension of an industrial reserve army of labour.

7. Constantino (1975).

8. US Bureau of the Census (1905).

9. Ibid.

10. Mies (1986) calls this process 'housewifization'.

11. US Bureau of the Census (1905).

12. Ibid.

13. Eviota and Smith (1983).

14. Romero (1974).

15. Estimates of imports as percentage of total consumption in the period before World War Two was 88 per cent, a complete reversal of the situation a century earlier (Stifel 1963).

16. Alzona (1934).

17. Resnick (1970).

18. Bureau of the Census (1954).

19. Ibid.

20. US Bureau of the Census (1905).

21. Commission of the Census (1941).

22. Kurihara (1945).

23. Commission of the Census (1941).

24. Kurihara (1945).

25. Alzona (1934).

26. Kurihara (1945).

27. Poverty level was not defined in the text from which this information was taken. But if the level has roughly the same meaning then as it does now, there are two criteria for deriving a poverty line: the consumption of the 'representative poor' and 'least cost consumption basket' necessary to meet specified minimum needs. In each case the major component is food. The poverty line for a household is the cost for a typical five-member family (in the 1980s, six members) (World Bank 1980).

28. Beardsley (1907).

29. Kurihara (1945).

30. Runes (1939).

31. Derived from figures given in Kurihara (1945).

32. Kurihara (1945): see also Smedley (1931).

33. Kurihara (1945).

34. Ibid.

35. Ibid.

36. See del Rosario (1985).

37. Kurihara (1945).

38. See Cockcroft (1982), Bennholdt-Thomsen (1982).

39. From conversations with my mother.

40. See Gleeck (1976) and accounts of vaudeville (Ira 1978) and clothes and carnival queens (Sta. Maria 1978). But an account of dating practices (Ira 1978) shows the persistence of the ideology of sexual purity.

41. Cited in Gleeck (1976).

42. *Graphic* (1930).

43. See Ehrenreich and English (1978) for causes espoused by middle-class American women during this time. See Alzona (1934) and Subido (1955) for some of the activities of Filipino women's associations.

44. See Mullings (1986) and Matthews (1987) for similar behaviour among white, middle-class American women.

45. See Subido (1955) for an account of the suffrage movement. See Maranan-Santos (1984) and Gomez (1986) for arguments on how the suffrage movement was encouraged by American officials to distract the movement for Philippine independence. But some Filipino officials also blocked suffrage because they feared the women's vote might go against the movement.

46. See Ehrenreich and English (1978), Mullings (1986) and Matthews (1987).

47. See for example publications such as the *Kislap Graphic* and the *Manila Times* of this period.

48. In 1936 an educational survey committee recommended that home economics be a requisite course: '40 percent of the work taken in schools by girls should be vocational in character, with special emphasis upon home economics' (Report of the Philippine Commission 1936).

49. Absolute divorce was not permitted under Spanish law in the Philippines. It is also not permitted under present Philippine Law.

50. Gleeck (1976).

51. US Bureau of the Census (1905).

52. *Manila Times* (1918, 1921).

53. Brown (1917).

54. Gleeck (1976).

55. Alzona (1934).

56. Ibid.

57. See Smedley (1931).

Chapter 8

1. Fast and Richardson (1979), Bello *et al.* (1982).

2. On women's roles in the struggle see Taruc (1953), Pomeroy (1963), Logarta (1989).

3. International Labor Office or ILO (1974). The following table from ILO (1974) shows this decrease compared to the change for the top 20 per cent:

Percentage of income accruing to:

| | 1956 | | | 1971 | | |
	Total	Rural	Urban	Total	Rural	Urban
Lowest 20 per cent	4.5	7.0	4.5	3.8	4.4	4.6
Top 20 per cent	55.1	46.1	55.3	53.9	51.0	50.7

4. See Lindsey (1985).

5. Frank (1978).

6. Bello *et al.* (1982).

7. Figures are for 1986–7, National Economic Development Authority, or NEDA (1987).

8. World Bank (1985).

9. Amor (1989) from NEDA statistics.

10. Baguilat (1989). The article is based on data from the Food and Agriculture Organization (FAO).

11. 'Worker's Wages' (1989).

12. ILO (1974).

13. Bureau of the Census and Statistics (1963), National Census and Statistics Office (1978).

14. National Census and Statistics Office (1978).

15. Cortes (1982).

16. Ibid.

17. Castillo (1979).

18. Kabeer (1979).

19. In the history of worker struggles in some Western countries, better-organized male unions succeeded in overriding the interests of women workers, resulting in the relegation of women to the home and the subsequent payment of a 'family wage' to male workers. See Hartmann (1978).

20. Report of the Food and Nutrition Research Council (1974).

21. Dimasupil (1978).

22. *Economic and Political Monthly* (1989).

23. World Bank (1980).

24. NEDA (1987) as cited in Amor (1989).

25. Ibid.

26. Amor (1989) based on NEDA statistics.

27. See Tidalgo (1976) and Castillo (1979) for female unemployment rates.

28. Data from Mangahas and Jayme-Ho (1976) support the 'discouraged' effect thesis. The study finds that women's labour-force participation rates increased inversely with the local level of male unemployment.

29. Cortes (1982).

30. Much of this discussion on work participation rates is based on United Nations Fund for Population Activities, or UNFPA (1977) and Kabeer (1987).

31. Castillo (1979).

32. Mangahas and Jayme-Ho (1976).

33. Folbre (1984).

34. Eviota (1980a).

35. See Castillo (1979) and NEDA (1987).

36. Kabeer (1987).

37. Maravilla (1988).

38. Department of Labor (1969).

39. Pagsanghan (1988).

40. Paglaban (1978).

41. Bureau of Women and Young Workers (1985).

42. Paglaban (1978).

43. From the letter of Mrs Basnillo, assistant secretary of the Philippine Technical, Commercial and Clerical Employers Association (PTCCEA) to Mr Herbert Maier, general secretary, International Federation of Commercial, Clerical and Technical Employees, June 1974 (as cited in Rojas-Aleta 1977). Membership in the PTCCEA is about 30 per cent female, most of whom are teachers.

Chapter 9

1. McLennan (1980).

2. Cited in Takahashi (1977).

3. Ibid.

4. Ibid.

5. Ibid.

6. Espiritu (1978).

7. See Po (1981). The agrarian reform programme of the 1970s covered only staple crop production. In the programme, share-tenancy was abolished and eligible tenants became either amortizing owners or leaseholders, depending on the size of their farms; see also Lynch (1972), Hickey and Wilkinson (1978), Bello *et al.* (1982), Ledesma (1983), Bello (1989). For commentaries on the implication of the Comprehensive Agrarian Reform Program of 1987 see Constantino (1989), Azurin (1989) and 'Thwarting land reform' (1989).

8. Ledesma (1983).

9. Gita Sen (1982) documents a similar pattern occurring among some agricultural groups in India. Deere and Leon de Leal (1982) state that, in the Andes, increases in farm size also meant decreases in labour input by women.

10. See Res (1986), Castillo (1985).

11. Santiago (1980).

12. Bautista (1977).

13. Ibid.

14. Bautista *et al.* (1983).

15. Ibid.

16. Ofreneo (1980).

17. Nagano (1988).

18. Jagan and Cunnington (1987).

19. Ibid.

20. Ibid.

21. Rutten (1982b).

22. Ibid.

23. Nesom (1912).

24. Rutten (1982b).

25. Ibid.

26. Association of Major Religious Superiors in the Philippines or AMRSP (1975).

27. Rutten (1982b).

28. Tejada (1980). Chinchilla (1978) noted a similar system of labour appropriation in Guatemala.

29. Rutten (1982b).

30. AMRSP (1975).

31. Lopez-Gonzaga (1983).

32. Ibid.

33. Rutten (1982b).

34. Jagan and Cunnington (1987).

35. Cited in Jagan and Cunnington (1987).

36. Ibid.

37. Ibid.

38. Lynch (1970), AMRSP (1975).

39. Jagan and Cunnington (1987).

40. World Bank (1980).

41. See Azurin (1989).

42. Bello and Fomby (1989).

43. Feder (1983).

44. Broad and Cavanagh (1989).

45. 'Banana workers' (1979).

46. Women's field work in banana production includes weeding, fertilization, fruit bagging, stem sanitation, and treating seed corms (Castillo, 1979).

47. David *et al.* (1980).

48. Ibid.

49. 'Banana workers' (1979).

50. David *et al.* (1980).

51. This account is from 'Banana workers' (1979).

52. Women cannery workers in multinational pineapple firms work under similar forms of labour appropriation. There is no work and therefore no pay in these firms during slack harvest periods or if a line in the cannery breaks down ('Castle and Cooke' 1981). Women in these firms are also paid reduced wages (Utrecht 1978).

53. See Perpinan (1985), Center for Women's Resources (1985).

54. 'Banana workers' (1979).

55. Ibid.

56. Ibid.

57. Ibid.

58. See King and Evenson (1983). Other studies show that women workers in rice crop production devote from one-third to one half of labour inputs in terms of time and number of tasks performed.

59. 'The embroidery and apparel industry: an interview' (1978).

60. Pagsanghan (1988).

61. Paglaban (1978).

62. 'The embroidery and apparel industry: an interview' (1978).

63. Marx (1867).

64. Ibid.

65. Ibid.

66. Ibid.

67. Paglaban (1978).

68. Ibid.

69. Paglaban (1978), del Rosario (1985), Perpinan (1985).

70. Pineda-Ofreneo (1982).

71. Ibid. I have averaged the range of earnings she has given.

72. Vasquez (1984).

73. del Rosario (1985), Perpinan (1985).

74. del Rosario (1985). *Babae sa Paggawa: Hirap at Hinaharap* (1988).

75. Center for Women's Resources (1985).

76. Enloe (1980).

77. Phillips and Taylor (1986).

78. See also Cockburn (1983), Humphrey (1987), Beneria and Roldan (1987).

79. Barrett (1988).

80. 'The embroidery and apparel industry: an interview' (1978).

81. Sembrano and Veneracion (1979).

82. Joekes (1987).

83. Kabeer (1987).

84. Sembrano and Veneracion (1979).

85. Ibid.

86. 'Garments, from rags to riches' (1981).

87. Miralao (1989).

88. Ibid.

89. Rutten (1982a).

90. This account is from Rutten (1982a).

91. *Ibon* (1981).

92. Elson and Pearson (1981).

93. Grossman (1978).

94. Ibid.

95. Ibid.

96. See for example 'The Miss AMD beauty contest' (1978).

97. Grossman (1978).

98. Ibid.

99. Ibid.

100. This account is from Snow (1977).

101. Ibid. The study conducted by the Center for Women's Resources (1985) came up with roughly similar proportions.

102. Vasquez (1984).

103. Snow (1977).

104. Ibid.

105. Grossman (1978).

106. The Philippine National Institute of Occupational Safety and Health reports that electronics is the third most dangerous industry in terms of exposure to cancer-causing substances (Perpinan 1985). See Center for Women's Resources (1985) with respect to reports of the effects of electronics work on the health of women.

107. Snow (1977).

108. Jonhson (1983).

109. Vasquez (1984).

110. See Enloe (1983) for the experience of women in other countries.

111. Snow (1977).

112. Ibid., Paglaban (1978), Eviota (1980b).

113. Snow (1977).

114. Vasquez (1984).

115. O'Connor (1987).

116. Snow's study (1977) showed these costs: median monthly food expenses, P145, median monthly rent, P20, for a total of P165. Median monthly wage of these workers was P204.

117. See Kyoko (1980) for accounts of prostitution in the zone.

118. See Asian Development Bank (1989).

119. Quoted in Bello and Fomby (1989).

120. Kabeer (1987).

121. Joekes (1987). See also Van Waas (1982).

122. Joekes (1987).

123. Frobel *et al.* (1980), Elson and Pearson (1981).

124. See Arizpe and Aranda (1981) for a similar observation among women workers in the strawberry export agri-business in Mexico.

125. O'Connor (1987).

126. Similar trends are observed among minority women workers in US-based operations as a result of automation (O'Connor 1987).

127. Ibid.

128. Bello and Fomby (1989).
129. Ibid.
130. Johnson (1985).
131. The survey (de Gracia 1965) involved 58 commercial establishments employing 32,146 workers, about 30 per cent of whom were office-based and of which ten per cent were women.
132. Most newspapers and other forms of media with classified advertisements carry these types of messages; see, for example, any issue of the *Manila Bulletin*.
133. Boulier and Pineda (1975).
134. Association of Philippine Medical Colleges, or APMC (1971).

Chapter 10

1. See F. Aguilar (1989) for a discussion of commoditized labour exchanges within the informal sector.
2. Szanton (1972).
3. Ibid.
4. Guerrero (1975). Arizpe (1977) describes similar trading activities among women in Mexico City.
5. This account is from Guerrero (1975); see also Hackenberg *et al.* (1982).
6. See ILO (1974), Lopez and Hollnsteiner (1976). For living and working conditions among the women of poor households in squatter areas see *Gawaing Sosyo-Ekonomiko ng Kababaihan* (1988).
7. Kabeer (1987).
8. See Lee (1981).
9. Costello (1982) estimates that household servants work approximately 14 hours a day.
10. Eviota and Smith (1983).
11. NCSO (1983).
12. See for example the study of Costello and Costello (1979) which found that very few women factory workers and workers in small-scale establishments listed domestic service as a previous occupation.
13. See Pinches (1984) on women as bottle washers: see Abad (1990) on scavengers.
14. ILO (1974).
15. Xenos (1989).
16. Mataragnon (1982).
17. Gilandas (1982).
18. From court cases filed in 1971–2.
19. Gagnon (1977).
20. From conversations with my father.
21. Moselina (1979).
22. It is said that after the Vietnam ceasefire, when there were no ships, it was usual to find some five to seven girls soliciting one male customer.
23. Moselina (1979).
24. Ibid.
25. Ibid.
26. Neumann (1978).
27. Estimate is from Morrell (1979).

28. Neumann (1978).

29. Ibid.

30. See the studies on massage attendants (Evangelista 1974) and on hospitality girls in Manila (Wihtol 1982).

31. Evangelista (1974).

32. Wihtol (1982).

33. Neumann (1978).

34. Japanese sex tours declined only because women's groups in the Philippines, other countries in Southeast Asia and Japan pressured the Japanese government to put a stop to them. There was no initiative from the Philippine Government which stood to lose revenue from the decline in these tours.

35. Suzuyo (1982).

36. 'Pinays in Japan sexually exploited' (1989).

37. Neumann (1978).

38. Ibid.

39. 'Mail-order brides business an insult . . .' (1989).

40. 'Number of mail-order brides increasing' (1989).

41. Ranches and Sinel (1989).

42. *Asiaweek* (1983).

43. Smith and Cheung (1981).

44. Personal communication from F. Zialcita based on his work on irrigation societies in the Ilocos region.

45. Eviota and Smith (1983).

46. ILO (1974).

47. See, for example, Boserup (1970), Schmink (1977), Arizpe (1977).

48. Herrin and Engracia (1982).

49. 'Brain drain revisited' (1989).

50. Sassen-Koob (1978).

51. Ibid.

52. 'Brain drain revisited' (1989).

53. NEDA (1987).

54. APMC (1971).

55. Abella (1979).

56. Borje (1989).

57. Bulduhan (1974).

58. Balai (1981).

59. Estimates are from the Philippine Overseas Employment Administration (POEA).

60. Women are about 47 per cent of the total. See Abrera-Mangahas (1987), POEA Annual Report (1987).

61. Italy (unofficial estimates from *Ichthys* 1979), England ('Mail-order brides an insult . . .' 1989), Singapore (Gob 1989), Kuwait ('RP domestics . . .' 1989). In 1987 the POEA reported these figures for other countries: Hong Kong (30,000), Japan (28,000), Spain (10,000), US (7,000).

62. *Balai* (1981), *Ichthys* (1979).

63. College graduates who left for Singapore in 1980 to become domestics earned about P900 a month which is more than the average monthly salary of P600 of nurses and teachers. In 1989 Singapore salaries ranged from P2,500 to P4,000. Teacher salaries in the Philippines are lower. But Singapore is now also used as a stepping stone to domestic work in Western countries where rates are much higher.

In England, domestic workers already earned close to P4,000 a month in 1981 (Balai 1981). In Canada, today, rates range from P8,000 to P10,000. Of course, some of these women do not necessarily end up in the occupations for which they were recruited; a number end up as prostitutes (see the case in Belgium, *Ichthys* 1979).

64. 'RP domestics . . .' (1989), Ranches and Sinel (1989).
65. Christian Conference of Asia–Urban Rural Missions, or CCA–URM (1983).
66. Gowing and McAmis (1979).
67. CCA–URM (1983).
68. Ibid.
69. This account is from Cherneff (1983).
70. See Lacar (1983).
71. Mayo (1924).
72. Lacar (1983).
73. CCA–URM (1983).

Chapter 11

1. On the dominance of women in the household see, among others, LeRoy (1905), Macaraig *et al.* (1954), Fox (1963), Alvarez and Alvarez (1963). See D. Aguilar (1988) for a critique of these works.
2. This practice is certainly not unique to Philippine households. See the case among the working class in England, for example, in Barrett and McIntosh (1982).
3. Banzon-Bautista (1977) finds that at higher income levels women have less of a share in decision-making.
4. Decaesstecker (1974). Increasing violence against women in the home has been reported by a number of *barangay* officials in Metro Manila in the past few years.
5. Pagaduan (1988).
6. The Philippines is signatory to the United Nations Convention on the Elimination of All Forms of Discrimination Against Women.
7. National Commission on the Role of Filipino Women, or NCRFW (1977). Increased participation of women has been a policy goal of the Philippine state since 1978 (see Development Plans since that year). This policy has been made more concrete by means of targets and strategies since 1983 (see Development Plans since 1983).
8. See NCRFW publications from 1977 through 1981.
9. NCRFW (1989).
10. Green (1970). In his study of 'élite' women in the Philippines, Green finds 'it is unlikely that élites in the near future will share power with persons of lower status. . . . This suggests a continuation of the policies necessary to preserve the position of élites'.
11. See Illo (1989).
12. Ibid.
13. The family-planning prevalence rate in 1986 was 36.4 per cent but the bulk of acceptors were (are) women, in large part a consequence of the family-planning campaign which has been overwhelmingly directed at them. Roughly 93 per cent of sterilization cases, second only to oral contraception in the number of acceptors are women (NEDA, 1987). Abortion is illegal but is not rare, especially among the poor and the working class (see *Marhia*, a publication of the Institute for Social Studies and Action 1988).

14. *Balikatan Newsletter* (1982).

15. See Sen and Grown (1987) for a detailed discussion of systemic crises at international levels. Parts of this section on crises are drawn from this book.

16. See Bello and others (1982), Feder (1983), Sen and Grown (1987), Joekes (1987) and 'Engendering adjustment . . .' (1989).

17. Total farm output grew during these years, but this growth was mainly from commercial livestock and poultry. Crops had a negative growth.

18. 'Failure of agriculture' (1989).

19. Bello *et al.* (1982), Sen and Grown (1987). 'Engendering adjustment . . .' (1989).

20. Bello *et al.* (1982), Sen and Grown (1987). The Philippines' foreign debt of US$29 billion in 1988 was the eighth largest in the world.

21. Sen and Grown (1987). The purpose of the World Bank and the IMF 'in tandem' is to institute economic sanctions to enable countries to recover from crisis and thereby regain a good credit-standing among private lenders. Hence, the structural adjustment resorted to by heavily indebted Third World countries in order simultaneously to be able to service these debts and maintain the flow of credit.

22. Baguilat (1989), from World Health Organization data.

23. Baguilat (1989).

24. Cornia (1987), 'Engendering adjustment . . .' (1989).

25. Figures are from the Ecumenical Movement for Justice and Peace. The increase in the number of internal refugees compared to previous years is blamed on the 'total war' policy of the Aquino regime (Balce, 1989).

26. Paredes-Japa (1989).

Chapter 12

1. See Sen and Grown (1987) for a discussion of gender and development in the Third World in general. The Philippines fits well into the patterns described in this book.

Chapter 13

1. Barrett (1980).
2. Mitchell (1976).
3. Taylor (1979).

Bibliography

Abad, Ricardo G. (1990) 'Being squatters and scavengers: the double burden of Smokey Mountain residents', pamphlet. Manila: Sentrong Pangkultura ng Pilipinas.

Abella, Manolo (1979) 'Export of Filipino manpower'. Manila: Institute of Labor and Manpower Studies, Ministry of Labor.

Abrera-Mangahas, Ma. Alcestis (1987) 'Filipino overseas migration: focus on 1975–1986, SMC Paper 1. Manila: Scalabrini Migration Center.

Aguilar, Delia D. (1988) *The Feminist Challenge*. Manila: Asian Social Institute.

Aguilar, Filomeno, Jr. (1989) 'Curbside capitalism: the social relations of street trading in Metro Manila', *Philippine Sociological Review* 37(3–4).

Alvarez, J. B. C. and Alvarez, Patricia M. (1963) 'The family-owned business: a matriarchal model', *Philippine Studies* 20.

Alzona, Encarnacion (1934) *The Filipino Woman. 1565–1933*. Manila: University of the Philippines Press.

Amor, Patria (1989) 'Rich–poor gap wide as ever in RP', *Daily Globe*, 11 June.

Arizpe, Lourdes (1977) 'Women in the informal labor sector: the case of Mexico City', *Signs* 3(1).

—— and Aranda, Josephine (1981) 'The "comparative advantage" of women's disadvantages. Women workers in the strawberry export agri-business in Mexico', *Signs* 7(2).

Asian Development Bank (1989) 'Asian development outlook'. Manila: ADB.

Asiaweek (1983) 'The Asian bride boom', 15 April.

Association of Major Religious Superiors in the Philippines (AMRSP) (1975) 'A study of sugar workers in the haciendas of Negros'. Bacolod City: AMRSP.

Association of Philippine Medical Colleges (APMC) (1971) 'Physician manpower survey report'. Manila: APMC.

Azurin, Arnold (1989) 'Storm over sugarlandia', *Daily Globe*, 17 September.

—— *Babae sa paggawa, hirap at hinaharap* (1988) Manila: Buhay Foundation, Inc., Masikap Workers' Health Program, SIBAT-Women. Development and Technology Desk.

Baguilat, Teddy Jr. (1989) 'Hunger amidst plenty', *Daily Globe*, 29 October.

Balai (1981) 'Off to distant shores', 2:4 (December).

Balce, Nerissa (1989) 'Total war, living nightmare', *Daily Globe*, 18 June.

Balikatan Newsletter (1982) March–April.

Banana workers of Davao (BW) (1979) ICL Research Team.

Banzon-Bautista, Cynthia (1977) 'Women in marriage', in *Stereotypes, Status and Satisfaction: The Filipina Among Filipinos*. Quezon City: Social Research Laboratory.

Barrett, Michèle (1980) *Women's Oppression Today: Problems in Marxist–Feminist Analysis*. London: Verso.
—— (1988) *Women's Oppression Today: the Marxist–Feminist Encounter* (rev. ed.). London: Verso.
—— and McIntosh, Mary, (1982) *The Anti-social family*. London: Verso.
Bautista, Germelino (1977) 'Socio-economic conditions of the landless rice workers in the Philippines: The landless of barrio Sta. Lucia as a case in point', in S. Hirashima (ed.), *Hired Labor in Asia*. Tokyo: Institute of Developing Economies.
—— *et al.* (1983) 'Farm households on rice and sugar lands: Margen's village economy in transition', in Antonio Ledesma *et al.* (eds), *Second View from the Paddy*. Quezon City: Institute of Philippine Culture.
Beardsley, J. W. (1907) *Labour conditions in the Philippine Islands*. Manila: Bureau of Printing.
Bello, Walden (1989) 'New law fosters grand illusion of land reform', *Malaya*, 7 and 8 July.
—— and Fomby, Paula (1989) 'Have-nots face development "dead end"' *Malaya*, 7 and 8 July.
—— *et al.* (1982) *Development Debacle: The World Bank in the Philippines*. California: Institute for Food and Development Policy.
Beneria, Lourdes (1979) 'Reproduction, production and the sexual division of labour', *Cambridge Journal of Economics* 3.
—— and Roldan, Martha (1987) *The Crossroads of Class and Gender: Industrial Homework, Subcontracting and Household Dynamics in Mexico City*. University of Chicago Press.
Bennholdt-Thomsen, Veronika (1982) 'Subsistence production and extended reproduction: A contribution to the discussion about modes of production', *Journal of Peasant Studies* 9(4).
Blair, Emma H. and Robertson, James, eds (1903) *The Philippine Islands, 1493–1898*, 55 Vols. Cleveland: A. H. Clark.
Borje, David (1989) 'Shortage of nurses bared', *Daily Globe*, 18 August.
Boserup, Ester (1970) *Women's Role in Economic Development*. New York: St. Martin's Press.
Boulier, Brian and Pineda, L. P. (1975) 'Male–female wage differentials in a Philippine government agency', *The Philippine Economic Journal* 14(4).
'Brain drain revisited' (1989) *Manila Times*, 20 June.
Brittan, Arthur and Maynard, Mary (1984) *Sexism, racism and oppression*. Oxford University Press.
Broad, Robin and Cavanagh, J. (1989) 'Environmentalism Philippine-style', *Daily Globe*, 19 November.
Brown, Elwood (1917) Letter of Elwood Brown, Athletic director of the YMCA to Mrs Saleeby, President of the Manila Women's Club, *Manila Times*, 24 July.
Bulduhan, Cleto (1974) 'Profiles of Filipinos in Canada', in *Proceedings of the Conference on International Migration from the Philippines June 10–14*. East-West Population Institute, Honolulu.
Bureau of the Census (BOC) (1954) *1948 Census of the population and agriculture. Summary and general report*, vol. 3. Manila: BOC.
Bureau of the Census and Statistics (BCS) (1963) *Census of the Philippines 1960. Population and housing*. Manila: BCS.
Bureau of Women and Young Workers (1985) *Annual report*. Manila: Ministry of Labor and Employment.

Caplan, Patricia. ed. (1987) *The cultural construction of sexuality*. London: Tavistock Publications.

Castillo, Gelia T. (1979) *Beyond Manila: Philippine Rural Problems in Perspective*. Canada: International Development Research Centre.

—— (1985) 'Women in rice farming systems: Some empirical evidence'. Paper prepared for the meeting of the National Academy of Science and Technology, Manila.

'Castle and Cooke in the Philippines' (1981) typescript.

de Castro, Modesto (1938) *Urbana at Felisa*. Manila: Aklatang J. Martinez.

Center for Women's Resources (1985) *Buhay at Pakikibaka ng Kababaihang Manggagawa*. Quezon City: Center for Women's Resources.

Cherneff, Jill B. R. (1983) *Gender roles, economic relations and culture change among the Bontoc Igorot of Northern Luzon, Philippines*. PhD dissertation. New School for Social Research.

Chinchilla, Norma S. (1978) 'Modes of production and reproduction: A framework for the analysis of the historical and contemporary roles of women in Guatemala'. Paper presented to the Conference on Underdevelopment and Subsistence Reproduction, University of Bielefeld, West Germany.

Chirino, Pedro (1604) 'The Philippines in 1600', in E. Blair and J. Robertson (eds.), *The Philippine Islands, 1493–1898*, Vols 12–13. Cleveland: A. H. Clark.

Chodorow, Nancy (1979) 'Mothering, male dominance and capitalism', in Zillah R. Eisenstein (ed.) *Capitalist patriarchy and the case for socialist feminism*. New York: Monthly Review Press.

Christian Conference of Asia–Urban Rural Missions (CCA–URM) *Minoritized and Dehumanized. Reflections on the Conditions of Tribal and Moro Peoples in the Philippines*. Manila: United Council of Churches of the Philippines.

Cockburn, Cynthia (1983) *Brothers: Male dominance and technological change*. London: Pluto Press.

Cockcroft, James D. (1982) 'Immiseration, not marginalization', *Latin American Perspectives*.

Colin, Francisco (1663) 'Native races and their customs', in E. Blair and J. Robertson (eds), *The Philippine Islands, 1493–1898*, vol. 40. Cleveland: A. H. Clark, 1903.

Commission of the Census (1941) *Census of the Philippines 1939*, vol. 2. Manila: COC.

Constantino, Renato (1975) *The Philippines: A past revisited*. Manila: By the author.

—— (1989) 'Aquino's hacienda', *Daily Globe*, September.

—— and Constantino, Letizia R. (1978) *The Philippines: The continuing past*. Quezon City: Foundation for Nationalist Studies.

Cornia, Giovanni Andrea (1987) *Adjustment with a Human Face*. UNICEF, Vol. 1. Oxford: Clarendon Press.

Cortes, Irene R. (1982) *Discrimination against women and employment policies*, Research Monograph 1, 1982 Series, National Commission on the Role of Filipino Women.

de la Costa, Horacio (1965) *Readings in Philippine History*. Manila: Bookmark.

Costello, Marilou Palabrica (1982) 'Female domestic servants in Cagayan de Oro, Philippines: Social and economic implications of employment in a "pre-modern" occupational role'. Paper presented at the Conference on Women in the Urban and Industrial Work-force: Southeast and East Asia, Manila.

—— and Costello, Michael (1979) 'Low-skilled working women in Cagayan de Oro: a comparative study of domestic, "small-scale" and industrial employment'.

Xavier University: Research Institute for Mindanao Culture.

Coulson, Margaret *et al.* (1975) 'The housewife and her labour under capitalism: A critique', *New Left Review* 89.

Daems, Wim (1981) 'Two million submissive doll-like women for sale', *Ichthys* 14 (February).

Dasmarinas, G. P. *et al.* (1591) 'Ordinance forbidding the Indians to wear Chinese stuffs', in E. Blair and J. Robertson (eds), *The Philippines*. 1493—1898, Vol. 3. Cleveland: A. H. Clark, 1903.

David, Randolph *et al.* (1980) *Transnational corporations and the Philippine banana-export industry*, Third World Papers, Commodity Series no. 2. University of the Philippines: Third World Center.

Decaesstecker, D. Denise (1974) *Impoverished urban Filipino families*. PhD Dissertation. Manila: University of Santo Tomas.

Deere, Carmen Diana (1977) 'Changing social relations of production and Peruvian peasant women's work', *Latin American Perspectives* 4 (1–2).

—— and Leon de Leal, Magdalena (1982) 'Peasant production, proletarianization, and the sexual division of labor in the Andes', in L. Beneria, (ed.) *Women and development: The sexual division of labor in rural societies*. New York: Praeger Publications.

Department of Labor (1969) *Labor Services Statistics*. Manila: DOL.

Dery, Luis C. (1989) 'Kung bakit lumaganap and mga kalapating mab aba ang lipad dito sa Pilipinas nung panahon ng Kastila', in *Women's role in Philippine history*, *Papers and Proceedings of the Conference*. Quezon City, University of the Philippines.

Diaz-Trechuelo, Maria Lourdes (1966) 'Eighteenth-century Philippine economy: Agriculture', *Philippine Studies* 14(1).

Dimasupil, Leon (1978) 'Neo-colonialism and the Filipino industrial workers'. *AMPO* 10.

Economic and Political Monthly (1989) Quezon City: Third World Studies Center, University of the Philippines.

Ehrenreich, Barbara and English, Deirdre (1978) *For her own good: 150 years of the experts' advice to women*. New York: Anchor Press.

Eisenstein, Zillah, ed. (1978) *Capitalist patriarchy and the case for socialist feminism*. New York: Monthly Review Press.

Elson, Diane and Pearson, Ruth (1981a) 'The subordination of women and the internationalisation of factory production', in Kate Young *et al.* (eds), *Of marriage and the market*. London: CSE Books.

—— (1981b) 'The embroidery and apparel industry: an interview', *Philippine Development*, 30 May.

Engels, Frederick (1884) *The Origin of the Family, Private Property and the State*. New York. Pathfinder, 1972.

'Engendering adjustment for the 1990s' (1989). Report of a Commonwealth Expert Group on Women and Structural Adjustment. London: Commonwealth Secretariat.

Enloe, Cynthia (1980) 'Sex and Levis: The international sexual division of labour'. Pamphlet, London.

—— (1983) 'Women textile workers in the militarization of Southeast Asia', in June Nash and M. P. Fernandez-Kelly (eds), *Women, Men and the International Division of Labor*. Albany: State University of New York Press.

Espiritu, Rafael (1978) 'Access and participation of landless rural workers in government programs', in *Proceedings: Workshop on landless rural workers*. Los

Banos, Laguna: Philippine Council for Agriculture and Resources Research.

Evangelista, Susan P. (1974) *Massage attendants in the Philippines: A case study on the role of women in economic development*. MA thesis. University of the Philippines.

Eviota, Elizabeth U. (1980a) 'Time-use and the sexual division of labor: The Philippine context', Paper prepared for the Symposium on The Sexual Division of Labour and Women's Status, Wenner Gren Foundation for Anthropological Research, Burg Wartenstein, Austria.

—— (1980b) 'Women workers in the electronics industry: Case studies from the Philippines'. Paper prepared for the Project on the Effects of Transnational Corporations on Women Workers, East–West Culture Learning Institute, Honolulu, Hawaii.

—— and Smith, Peter C. (1983) 'The migration of women in the Philippines', in James T. Fawcett *et al*. (eds), *Women in the Cities of Asia: Migration and Urban Adaptation*. Colorado: Westview Press.

'Failure of agriculture' (1989) *Daily Globe*, 6 October.

Fast, Jonathan and Richardson, Jim (1979) *Roots of Dependency: Political and Economic Revolution in Nineteenth-century Philippines*. Quezon City: Foundation for Nationalist Studies.

Feder, Ernst (1983) *Perverse Development*. Quezon City: Foundation for Nationalist Studies.

Fee, Mary H. (1919) *A woman's impression of the Philippines*. Chicago: McClurg.

Fegan, Brian (1982) 'The social history of a Central Luzon barrio', in A. McCoy and E. de Jesus (eds), *Philippine Social History*. Quezon City: Ateneo de Manila University Press.

Ferraris, M. Rita C. (1987) *The vocation of native women in colonial Philippines*. PhD dissertation. Manila.

Folbre, Nancy (1984) 'Household production in the Philippines: a Non-neo-classical approach', *Economic Development and Cultural Change* 32 (2).

Food and Nutrition Research Council (1974) *Report of the Food and Nutrition Research Council*. Manila.

—— (1989) '450,000 have fled homes due to military operations', *Daily Globe*, 19 October.

Fox, Robert (1963) 'Men and women in the Philippines', in Barbara Ward, (ed.) *Women in the New Asia*. Netherlands: UNESCO.

Frank, Andre Gunder (1978) 'Super-exploitation in Third World countries', *Two Thirds: A Journal of Development Studies* 1(2).

Frobel, Folker *et al*. (1980) *The New International Division of Labour*. Cambridge University Press.

Gagnon. J. P. (1977) *Human Sexualities*. Illinois: Scott, Foresman and Company.

Gardiner, Jean (1975) 'Women's domestic labour', *New Left Review* 89.

'Garments, from rags to riches' (1978) *Philippine Development*, 31 July.

Gawaing sosyo-ekonomiko ng kababaihan (1988) Manila, SIBAT-Women. Development and Technology Desk.

Gilandas, Alex (1982) *Sex and the Single Filipina*, Manila: Philippine Education Co.

Gleek, Lewis E. Jr. (1976) *American institutions in the Philippines (1898–1941)*. Manila: Historical Conservation Society.

—— (1984) *The American half-century 1898–1946*. Manila: Historical Conservation Society.

Gob, Fely (1989) '8,000 Filipino domestics in Singapore are illegals', *Daily Globe*, 6 August.

Gomez, Maita (1986) 'Development of women's organizations in the Philippines', *Isis* 6.

Gowing, Peter G. and McAmis, Robert D. (eds) (1974) *The Muslim Filipino*. Manila: Solidaridad Publishing House.

de Gracia, Pablo P. Jr (1965) 'The problem of employment among women office workers', *Philippine Journal of Public Administration*. 11(2).

Green, Justin J. (1970) *Women leaders of the Philippines: Social backgrounds and political attitudes*. Ph.D dissertation, Syracuse University.

Grossman, Rachel (1978) 'Women's place in the integrated circuit', *Southeast Asia Chronicle* 66 and *Pacific Research* 9(5-6), joint issue.

Guerrero, Milagros C. (1989) 'Ang kababaihan sa ika-labimpitong siglo', in *Women's Role in Philippine History: Papers and Proceedings*. Quezon City: University of the Philippines.

Guerrero, Sylvia H. (1975) 'Hawkers and vendors in Manila and Bagoio', monograph. Quezon City. University of the Philippines. Institute of Social Work and Community Development.

Hackenberg, Beverly *et al.* (1982) 'Growth of the bazaar economy and its significance for women's employment: Trends of the 1970s in Davao City, Philippines'. Paper presented at the Conference on Women in the Urban and Industrial Workforce: Southeast and East Asia, Manila.

Hamilton, Roberta (1978) *The Liberation of Women*. London: Allen and Unwin.

Hartmann, Heidi (1978) 'Capitalism, patriarchy and job segregation by sex', in Z. Eisenstein (ed.) *Capitalist patriarchy and socialist feminism*. New York: Monthly Review Press.

Herrin, Alejandro and Engracia, Luisa (1982) 'Trends in female migration to the cities and the changing structure of female employment in the Philippines'. Paper presented at the Conference on Women in the Urban and Industrial Workforce: Southeast and East Asia, Manila.

Heyzer, Noeleen (1986) *Working Women in South-East Asia*. Milton Keynes: Open University Press.

Hickey, Gerald C. and Wilkinson, J. L. (1978) 'Agrarian reform in the Philippines'. Report of a Seminar of the Rand Corporation, Washington DC: Rand Corporation, 1977. In D. B. Schirmer and S. R. Shalom (eds), *The Philippines Reader*. Boston: South End Press, 1987.

Himmelweit, S. and Mohun S. (1977) 'Domestic labour and capital'. *Cambridge Journal of Economics* 1.

Hirashima, S., ed. (1977) *Hired labor in rural Asia*. Tokyo: Institute of Developing Economies.

de Hoyos, Arturo and de Hoyos, Genevieve (1966) 'The amigo system and alienation of the wife in the conjugal Mexican family', in B. Farber (ed.) *Kinship and Family Organization*. New York: Wiley.

Humphrey, John (1987) *Gender and Work in the Third World: Sexual Divisions in Brazilian Industry*. London: Tavistock Publications.

Ibon (1981) 'Women workers'. No. 15.

Ichthys (1981) May.

Ichthys (1979) December.

Ileto, Reynaldo (1979) *Pasyon and Revolution: Popular Movements in the Philippines, 1840-1910*. Quezon City: Ateneo de Manila University Press.

Illo, Jeanne F. ed. (1989) *Gender issues in rural development*. Quezon City: Institute of Philippine Culture. Ateneo de Manila University.

Infante, Teresita R. (1969) *The Women in Early Philippines and Among the Cultural Minorities*. Manila: University of Santo Tomas.

International Labour Office (ILO) (1974) *Sharing in development. A programme of employment, equity and growth for the Philippines*. Manila: National Economic and Development Authority.

Ira, Luningning B. (1978) 'The dating game', 10. in *Filipino Heritage*, Lahing Pilipino Publishing.

——— 'Two tickets to vod-a-vil' 9. in *Filipino Heritage*, Lahing Pilipino Publishing.

Jagan L. and Cunnington, J. (1987) 'Social volcano: sugar workers in the Philippines', pamphlet. London: War on want.

Jagor, Feodor (1859) *Travels in the Philippines* Manila: Filipiniana Book Guild, 1965.

de Jesus. Ed. C. (1980) *The Tobacco Monopoly in the Philippines: Bureaucratic Enterprise and Social Change, 1766–1880*. Quezon City: Ateneo de Manila University Press.

Jesuit Missions (1600–1609) in E. Blair and J. Robertson (eds), *The Philippines 1493–1898*, vol. 17. Cleveland: A. H. Clark, 1903.

Joekes, Susan P. (1987) *Women in the world economy* An INSTRAW study. New York: Oxford University Press.

Johnson, Dale L. (1983) 'Class analysis and dependency', in Ronald H. Chilcote and Dale L. Johnson (eds), *Theories of Development: Mode of Production or Dependency?* California: Sage Publications.

———(1985) *Middle Classes in Dependent Countries*. California: Sage Publications.

Johnson, Richard (1979) 'Histories of culture/theories of ideology: Notes on an impasse', in Michèle Barrett *et al.* (eds), *Ideology and Cultural Production*. London: Croom Helm.

Jurado, Gonzalo P. and Tidalgo, Rosalinda (1978) 'The informal services sector in the Greater Manila area, 1976', monograph. University of the Philippines, Institute of Economic Development and Research, No. 7805.

Kabeer, Naila (1987) *Women's Employment in Newly Industrializing Countries: A Case Study of India and the Philippines*. Report prepared for IDRC. Brighton: Institute of Development Studies.

King, Elizabeth and Evenson, Robert (1983) 'Time allocation and home production in Philippine rural households', in M. Buvinic *et al.* (eds), *Women and Production in the Rural Household*. Baltimore: Johns Hopkins University Press.

Kirk, Grayson (1936) *Philippine Independence*. New York: Farrar and Rinehart.

Kroeber, A. L. (1918) 'History of Philippine civilization as reflected in religious nomenclature', *Anthropological Papers of the American Institute of Natural History*, XIX. New York.

Kuhn, Annette and Wolpe, Ann Marie (eds) (1978) *Feminism and materialism. Women and modes of production*. London: Routledge & Kegan Paul.

Kurihara, Kenneth K. (1945) *Labor in the Philippine economy*. California: Stanford University Press.

Kyoko, Sasahara (1980) 'Mariveles: Servitude in the free-trade zone', *AMPO* 12(12).

Lacar, Luis (1983) *The Bridge Few Dare to Cross: Muslim–Christian Marriages in the Philippines*. Cagayan de Oro: SPECC Printing Press.

Lambrecht, Francis (1935) 'The Mayawyaw ritual: Marriage and marriage ritual', *Publications of the Catholic Anthropological Conference* 4.

Layo, Leda L. (1978) 'Determinants of the labor force participation of Filipino

women', *Philippine Sociological Review* 26 (3–4).

Ledesma, Antonio J. *et al.* eds (1983) *Second view from the paddy.* Quezon City: Ateneo de Manila University. Institute of Philippine Culture.

Lee, Patricia (1981) 'Hotel and restaurant workers in the Philippines', *Southeast Asia Chronicle* 78.

LeRoy, James A. (1905) *Philippine Life in Town and Country.* Manila: Filipinas Book Guild, 1968.

Lindsey, Charles W. (1985) 'Foreign investment in the Ph;lippines', in D. B. Schirmer and S. K. Shalom (eds), *The Philippines Reader.* Boston: South End Press.

de Loarca, Miguel (1582) 'Relations of the Philippine Islands', in E. Blair and J. Robertson (eds), *The Philippines 1493–1898*, Vol. 5. Cleveland: A. H. Clark.

Logarta, Sofia (1989) 'The participation of women in the HUK Movement', in *Women's role in Philippine History: Papers and Proceedings of the Conference.* Quezon City.

Loney, Nicholas (1857) *Letters from Manila.* Manila, Historical Conservation Society, 1967.

Lopez de Legazpi, Miguel (1559) 'Expedition of Miguel Lopez de Legazpi' in E. adaptations to Manila residence', in R. A. Bulatao (ed), *Philippine Population Resesarch.* Makati: Population Center Foundation.

Lopoez de Legazpi, Miguel (1559) 'Expedition of Miguel Lopez de Legazpi' in E. Blair and J. Robertson (eds), *The Philippines, 1493–1898*, vol. 2. Cleveland: A. H. Clark, 1903.

Lopez-Gonzaga, Violeta (1983) *Mechanization and labor employment: A study of the sugar-cane workers' responses to technological change in sugar farming in Negros.* Bacolod City: Alpha Publishing Corporation.

Lynch, Frank (1970) *A bittersweet taste of sugar: A preliminary report on the sugar industry in Negros Occidental.* Quezon City: Ateneo de Manila University Press.

—— (1972) *View from the Paddy: Empirical Studies of Philippine Farming and Tenancy.* Quezon City: Institute of Philippine Culture, Ateneo de Manila University.

Macaraig, S. *et al.* (1954) 'The development and the problems of the Filipino family', in *Philippine Social Life.* Manila: Macaraig Publishing Co.

McCoy, Alfred (1977) *Ylo-ilo: Factional conflict in a colonial economy. Iloilo Province. Philippines 1837–1855.* Ph.D dissertation. Yale University.

—— and de Jesus, Ed. C. eds. (1982) *Philippine Social History: Global Trade and Local Transformations.* Quezon City: Ateneo de Manila University Press.

McIntosh, Mary (1978) 'Who needs prostitutes? The ideology of male sexual needs', in Carol Smart and Barry Smart (eds), *Women, Sexuality and Social Control.* London: Routledge and Kegan Paul.

—— (1979) 'The welfare state and the needs of the dependent family', in Sandra Burman (ed.), *Fit Work for Women.* London: Croom Helm.

Mackintosh, Maureen (1981) 'Gender and economics: The sexual division of labour and the subordination of women', in *Of Marriage and the Market.* Kate Young *et al.* (eds), London: CSE Books.

MacKinnon, Catharine (1982) 'Feminism, Marxism, method and the state. An agenda for theory', *Signs* 7(3).

McLennan, Marshall (1980) *The Central Luzon Plain.* Quezon City: Alemars-Phoenix Publishing House.

MacMicking, R. (1851) Recollections of Manila and the Philippines during 1848, 1849, and 1850. Manila, Filipiniana Book Guild, 1967.

'Mail-order brides business an insult to RP' (1989) *Malaya*, 14 April.

Mananzan, Mary John, OSB (1989) 'The Filipino woman before the Spanish conquest of the Philippines', in *Women's Role in Philippine History: Papers and Proceedings of the Conference*. Quezon City: University of the Philippines.

—— (1987) 'Sexual exploitation of women in a third world sewtting', in M. J. Mananzan (ed.), *Essays on Women*. Manila: St. Scholastica's College.

Mangahas, Mahar and Jayme-Ho, Teresa (1976) 'Income and labor force participation rates of women in the Philippines'. Discussion paper 76–3. University of the Philippines: Institute of Economic Development and Research.

Manila Times (1918) 15 October.

—— (1921) 14 November.

Maravilla, Cezar (1988) 'Labor advocacy, legal impediments and the workers' situation in the Philippines', *Diliman Review* 36(4).

Maranan-Santos, Aida (1984) 'Do women really hold up half the sky?' *Diliman Review* 32 (3).

MARHIA (1988) Publication of the Institute of Social Studies and Action, June 1(2).

Martinez de Zuniga, Joaquin (1803) 'The peoples of the Philippines', in E. Blair and J. Robertson (eds), *The Philippine Islands 1493–1898*, vol. 4. Cleveland: A. H. Clark, 1903.

Marx, Karl (1867) *Capital*, vol. 1. Ben Fowkes, trans. New York: Vintage Books, 1977.

de Mas. Sinibaldo (1842) 'Internal political condition of the Philippines' in E. Blair and J. Robertson (eds), *The Philippines, 1493–1898*, vol. 52. Cleveland: A. H. Clark, 1903.

Masters, William H. and Johnson, V. E. (1966) *Human sexual response*. New York: Little, Brown.

Mataragnon, Rita (1982) 'Sex and the Filipino adolescent: A review', *Philippine Studies* 30.

Matthews, G. (1987) *Just a housewife. The rise and fall of domesticity in America*. New York: Oxford University Press.

—— (1989) 'The meaning of Luisita', *Daily Globe*, 21 October.

Mayo, Katherine (1924) *The Isles of Fear*. New York: Harcourt, Brace and Co.

Mies, Maria (1980) 'Capitalist development and subsistence reproduction: Rural women in India', *Bulletin of Concerned Asian Scholars* 12(1).

—— (1986) *Patriarchy and Accumulation on a World Scale. Women in the International Division of Labour*. London: Zed.

Ministry of Labor and Employment (MOLE) (1981) *Tripartite conference on wages, employment and industrial relations*, Conference papers. Manila, Institute of Labor and Manpower Studies.

Miralao, Virginia (1989) 'Labor conditions in Philippine crafts industries', *Philippine Sociological Review*, 37 (3–4).

'The Miss AMD beauty contest' (1978) *The Manila Circuit*, 1:1 (August). Advanced Micro Devices, Philippines.

Mitchell, J. (1976) 'Women and equality', in J. Mitchell and Ann Oakley, (eds) *The Rights and Wrongs of Women*. Harmondsworth: Penguin.

—— and Rose, J. eds (1982) *Feminine sexuality: Jacques Lacan and École Freudienne*. New York: Pantheon Books.

Molyneux, Maxine (1979) 'Beyond the domestic labour debate', *New Left Review* 116.

de Morga, Antonio (1609) 'Sucesos de las Islas Filipinas' in E. Blair and J. Robertson (eds), *The Philippines 1493–1898.* Cleveland: A. H. Clark.

Morrell, J. (1979) 'Aid and the Philippines: who benefits?' in *International Policy Report* 5(2) cited in D. B. Schirmer and S. R. Shalom (eds), *The Philippines Reader.* Boston: South End Press, 1987.

Moselina, Leopoldo M. (1979) 'Olongapo's rest and recreation industry: A sociological analysis of institutionalized prostitution with implications for a grassroots oriented sociology', *Philippine Sociological Review* 27 (3).

Mueller, Martha (1977) 'Women and men, power and powerlessness in Lesotho', *Signs* 3:1.

Mullings, Leith (1986) 'Uneven development: Class, race and gender in the U.S. before 1900', in E. Leacock and H. Safa (eds), *Women's Work: Development and the Division of Labor by Gender.* Massachusetts: Bergin and Garvey Publishers, Inc.

Nagano, Yoshiko (1988) 'The collapse of the sugar industry in Negros Occidental and its social and economic consequences', *Kasarinlan* 3(3).

National Census and Statistics Office (1983) *1980 Census of population and housing.* Manila: NCSO.

—— (1978) *1975 Integrated Census of the Population and its Economic Activities,* vol. 2. Manila: NCSO.

National Commission on the Role of Filipino Women (1989) *Philippine Development Plan for Women. 1989–1992.* Manila: NCRFW.

—— (1977–82) *Annual reports* Manila: NCRFW.

National Economic Development Authority (1987) *1986 Philippine Statistical Yearbook.* Manila: NEDA.

Nesom, G. E. (1912) *Handbook on the Sugar Industry of the Philippine Islands.* Manila: Bureau of Printing.

Neumann, A. Lin (1978) '"Hospitality girls" in the Philippines', *Southeast Asia Chronicle* 66 and *Pacific Research* 9. Joint issue.

Nimmo. H. Arlo, n.d. 'The relativity of sexual deviance: A Sulu example', in M. Zamora (ed.) *Social Change in Modern Philippines.* University of Oklahoma.

'Number of mail-order brides increasing' (1989) *Daily Globe,* 19 August.

Oakley, Ann (1972) *Sex, Gender and Society.* New York: Harper and Row.

O'Connor, David C. (1987) 'Women workers and the changing international division of labor in microelectronics', in Lourdes Beneria and Catharine K. Stimpson (eds), *Women, Households and the Economy.* New Brunswick: Rutgers University Press.

Ofreneo, Rene E. (1980) *Capitalism in Philippine Agriculture.* Quezon City: Foundation for Nationalist Studies.

Omohundro, John T. (1981) *Chinese Merchant Families in Iloilo: Commerce and Kin in a Central Philippine City.* Quezon City: Ateneo de Manila University Press.

Ordonez de Cevallos, Pedro (1614) *Travel Accounts of the Islands.* Manila: Filipiniana Book Guild, 1971.

Oren, Laura (1974) 'The welfare of women in labouring families: England 1860–1950', in M. Hartman and I. W. Banner (eds), *Clio's Consciousness Raised.* New York: Harper and Row.

Owen, Norman G. (1976) *Kabikolan in the Nineteenth Century: Socioeconomic Change in the Provincial Philippines.* Ph.D. Dissertation, University of Michigan.

Pagaduan, Maureen (1988) 'A participatory research among women', in *Empowering Women Through Research Networks.* Quezon City: Center for Women's Resources.

Paglaban, Enrico (1978) 'Philippine workers in the export industry', *Pacific Research* 9 (3–4).

Pagsanghan, Stella (1988) 'Profit and patriarchy: the situation of industrial women workers', *Intersect* (February).

Paredes-Japa, Divina (1989) 'Church survey notes rise in fundamentalism', *Daily Globe*, 7 October.

Perpinan, Mary Soledad, RGS (1985) 'Women and transnational corporations: The Philippine experience', in H. M. Scobie and L. S. Wiseberg (eds), *Access to Justice*, London: Zed Books Ltd.

Pescatello, Ann (1976) *Power and Pawn. The Female in Iberian Families, Society, and Culture*. Connecticut: Greenwood Press.

Phelan, John Leddy (1959) *The Hispanization of the Philippines: Spanish aims and Filipino responses, 1565–1700*. Madison: University of Wisconsin Press.

Philippine Council for Agriculture and Resources Research (1980) Proceedings: Workshop on landless rural workers, Los Banos, Laguna.

Philippine Overseas Employment Administration (POEA) (1987) *Annual Report*, Manila: POEA.

Phillips, Anne and Taylor, Barbara (1986) 'Sex and skill', in *Waged work: A Reader. Feminist Review Collective* (eds), London: Virago Press.

'Pinays in Japan sexually exploited' (1989) *Philippine Daily Inquirer*. 6 August.

Pinches, Michael (1984) *Anak-Pawis: Children of Sweat. Class and Community in a Manila Shanty Town*. Ph.D. Dissertation, Department of Anthropology and Sociology, Monash University.

Pineda-Ofreneo, Rosalinda (1982) 'Philippine domestic outwork: Subcontracting for export-oriented industries', *Journal of Contemporary Asia* 12(3).

de Plasencia, Juan (1589) 'Customs of the Tagalogs' in E. Blair and J. Robertson (eds), *The Philippine Islands 1493–1898*, vol. 16. Cleveland: A. H. Clark, 1903.

—— 'Instructions regarding the customs which the natives of Pampanga formerly observed in their lawsuits', in E. H. Blair and James A. Robertson (eds), *The Philippine Islands, 1493–1898*, vol. 16. Cleveland: A. H. Clark, 1903.

Po, Blondie (1981) *Policies and Implementation of Land Reform in the Philippines*. Quezon City: Institute of Philippine Culture, Ateneo de Manila University.

Pomeroy, William (1963) *The Forest*. New York: International Publishers.

Rabinow, Paul, ed. (1984) *Foucault Reader*. New York: Pantheon Books.

Rafael, Vicente L. (1988) *Contracting Colonialism*. Quezon City: Ateneo de Manila University Press.

Ranches, Nards and Sinel, C. (1989) 'RP women expose white-slavery ring in Malaysia', *Daily Globe*, 30 August.

Rapp, Rayna (1977) 'The search for origins: Unravelling the threads of gender hierarchy', *Critique of Anthropology* 3 (9–10).

'Reforms in the Philippine Islands' (1884) in E. Blair and J. Robertson (eds), *The Philippine Islands, 1493–1898*, Cleveland: A. H. Clark, 1903.

Reiter, Ragna R(app), ed. (1975) *Towards an Anthropology of Women*. New York: Monthly Review Press.

Report of the Philippine Commission (1904) Washington: Government Printing Office.

—— (1936) Washington: Government Printing Office.

Res, Lyda (1986) *Households, Women, Labor and Change. A Study of a Philippine Rainfed Rice Village*. Publication Series. Agricultural University, Wageningen, The Netherlands.

Resnick, Stephen (1970) 'The decline of rural industry under export expansion: A

comparison among Burma, Philippines and Thailand. 1870–1938', *Journal of Economic History* 30.

Rizal, Jose P. (1891) *El Filibusterismo*. Manila: Jose Rizal National Centennial Commission, 1957.

—— (1889) 'Letter to the Young Women of Malolos', London; Manila: National Library, 1932.

—— (1887) *Noli Me Tangere*. Manila: Capitol Publishing House, 1956.

Rojas-Aleta, Isabel *et al.* (1977) *A Profile of Filipino Women*. Makati: Philippine Business for Social Progress.

Romero, Ma. Fe Hernaez (1974) *Negros Occidental: Between two Foreign Powers 1888–1909*. Negros Occidental Historical Commission.

del Rosario, Rosario (1985) *Life on the Assembly Line*. Manila: Philippine Women's Research Collective.

Rose, Jacqueline (1986) *Sexuality in the Field of Vision*. London.

'RP domestics bring more tales of woe' (1989) *Daily Globe*, August.

Rubin, Gayle (1975) 'The traffic in women: Notes on the "political economy" of sex', in Rayna R. Reiter (ed.) *Toward an Anthropology of Women*. New York: Monthly Review Press.

Runes, I. T. (1939) *General Standards of Living and Wages of Workers in the Philippine Sugar Industry*. Philippines: Philippine Institute of Pacific Relations.

Rutten, Rosanne (1982a) 'Cottage industry and the easing of rural poverty in the Philippines: A comparison of an entrepreneurial and a cooperative approach', *Philippine Quarterly of Culture and Society* 10.

—— (1982b) *Women Workers of Hacienda Milagros. Wage Labor and Household Subsistence on a Philippine Sugarcane Plantation*. Amsterdam: Publikateiserie Zuid-en Duidoost-Azie Anthropologisch-Sociologisch Centrum Universiteir van Amsterdam.

Sacks, Karen (1975) 'Engels revisited: Women, the organization of production and private property', in Rayna R. Reiter (ed.), *Toward an Anthropology of Women*. New York: Monthly Review Press.

Saffioti, Heleieth (1978) *Women in Class Society*. New York: Monthly Review Press.

Salazar, Zeus (1989) Ang babaylan sa kasaysayan ng Pilipino', in *Women's Role in Philippine History. Papers and Proceedings of the Conference*. Quezon City: University of the Philippines.

'San Agustin's letter on the Filipinos' (1720) in E. Blair and J. Robertson (eds), *The Philippine Islands 1493–1898*, vol. 23. Cleveland: A. H. Clark, 1903.

Sta. Maria, Felice P. (1978) 'The 1920s: When Balloon Pants Came to Town' in *Filipino Heritage*, vol. 9. Lahing Pilipino Publishing.

Santiago, Emmanuel S, (1980) *Women in Agriculture: A Social Accounting of Female Workshare*. Quezon City: Institute of Philippine Culture.

Sassen-Koob, Saskia (1978) 'The international circulation of resources and development: The case of migrant labor', *Development and Change* 9.

von Scherzer, Karl (1858) 'Narrative of the circumnavigation of the globe by the Austrian frigate "Novara"' in *Travel Accounts of the Islands (1832–1858)*. Manila: Filipiniana Book Guild, 1974.

Schirmer, Daniel B. and Shalom S. R. (1987) *The Philippines Reader*. Boston: South End Press.

Schmink, Marianne (1977) 'Dependent development and the division of labor by sex: Venezuela', *Latin American Perspectives* 4(1–2).

Scott, William H. (1982) *Cracks in the Parchment Curtain and Other Essays in Philippine history*. Quezon City: New Day Publishers.

Seccombe, W. (1974) 'The housewife and her labour under capitalism', *New Left Review* 83.

Sembrano, Madeleine and Veneracion, Cynthia (1979) *The Textile Industry and its Women Workers: The Philippine Study*. Quezon City: Institute of Philippine Culture.

Sen, Gita (1982) 'Women workers and the Green Revolution', in L. Beneria (ed.) *Women and Development: The Sexual Division of Labor in Rural Societies*. New York: Praeger Publishers.

Sen, Gita and Grown, Caren (1987) *Development, Crises, and Alternative Visions: Third World Women's Perspective*. New York: Monthly Review Press.

Smedley, Agnes, (1931) 'The women in the Philippines', *The Modern Review* XLIX (4), April.

Smith, Peter C. and Cheung, Paul P. L. (1981) 'Social origins and sex differential schooling in the Philippines', *Comparative Education Review* 25:1.

Snow, Robert T. (1977) *Dependent Development and the New Industrial Worker: The Case of the Export Processing Zone in the Philippines*. Ph.D. Dissertation. Harvard University.

Stifel, Laurence David (1963) *The Textile Industry – A Case History of Industrial Development in the Philippines*. Ithaca: Cornell University Press.

Stoler, Ann (1977) 'Class structure and female autonomy in rural Java', *Signs* 3:1.

Stycos, J. Mayone (1968) *Human Fertility in Latin America*. Ithaca: Cornell University Press.

Subido, Tarrosa (1955) *The Feminist Movement in the Philippines 1905–1955*. Manila: National Federation of Women's Clubs.

Suzuyo, Takasato (1982) 'Women on base', *AMPO* 14:4.

Szanton, Maria Cristina Blanc (1972) *A Right to Survive: Subsistence Marketing in a Lowland Philippine Town*. The Pennsylvania University Press.

Takahashi, Akira (1977) 'Rural labor, and agrarian changes in the Philippines', in S. Hirashima (ed.), *Hired Labor in Rural Asia*. Tokyo: Institute of Developing Economies.

Taruc, Luis (1953) *Born of the People*. New York: International Publishers.

Taylor, John G. (1979) *From Modernisation to Modes of Production: A Critique of the Sociologies of Development and Underdevelopment*. London: MacMillan.

Tejada, Ed. (1980) 'Socioeconomic study of landless workers in sugarcane plantations in Negros Occidental', in Proceedings: Workshop on landless rural workers. Philippine Council for Agriculture and Resources Research, Los Banos, Laguna.

Thomas, Keith (1959) 'The Double Standard', *Journal of the History of Ideas* 20 (2).

—— (1989) 'Thwarting land reform'. *Daily Globe*, 20 October.

Tidalgo, Rosalinda (1975) *Wages and the Wage structure in the Philippines 1957–1969*. Ph.D. Dissertation. University of Wisconsin.

Tilly, Louise A. and Scott, Joan W. (1978) *Women, Work, and Family*. New York: Holt, Rinehart and Winston.

United Nations (1976) *Report of the World Conference of International Women's Year*. New York: UN.

United Nations Fund for Population Activities UNFPA (1977) *Labour-Force Projections by Age and Sex for the Philippines. 1970–2000*. UNFPA–NCSO Population Research Project. Manila: NCSO.

United States Bureau of the Census, (1905) *Census of the Philippine Islands*. Taken under the direction of the Philippine Commission in the year 1903. 4 vols. Washington, DC: USBOC.

Utrecht, Ernst (1978) 'Corporate agriculture versus subsistence agriculture in the Southern Philippines'. Paper presented at the Seminar on underdevelopment and Subsistence in Southeast Asia, University of Bielefeld, West Germany.

Vasquez, Noel, S. J. (1984) *The Impact of the New International Division of Labour on ASEAN Labour: The Philippine Case*. D.Phil. Dissertation. Brighton: Institute of Development Studies.

van Waas, Michael (1982) 'Multinational corporations and the politics of labor supply', *Insurgent Sociologist* 11(3).

'Who wants Maria Claras anyway? They belong to the past', (1930) *Graphic*, May.

Wickberg, Edgar B. (1982) *The Chinese in Philippine Life. 1850–1898*. New Haven: Yale University Press.

Wihtol, Robert (1982) '"Hospitality girls" in the Manila tourist belt', *Philippine Journal of Industrial Relations* 4(1–2).

Wilkes, Charles (1858) 'Narrative of the U.S. exploring expedition', in *Travel accounts of the Philippine Islands (1832–1858)*. Manila: Filipiniana Book Guild, 1974.

Worcester, Dean C. (1913) 'The non-Christian peoples of the Philippine Islands', *National Geographic Magazine* 24.

'Workers' wages deteriorating' (1989) *Malaya*, September.

World Bank (1980) 'Aspects of poverty in the Philippines: a review and assessment', 2 Vols. Washington DC: World Bank.

—— (1985) 'The Philippines: recent trends in poverty, employment and wages', Washington DC: World Bank.

Xenos, Peter (1989) 'Youth, sexuality and public policy in Asia: A research perspective', Working Paper no. 59. Honolulu, East–West Population Institute, East–West Center.

Young, Kate (1978) 'Modes of appropriation and the sexual division of labour: A case study from Oaxaca, Mexico', in A. Kuhn and A. Wolpe (eds), *Feminism and materialism*. London: Routledge and Kegan Paul.

—— et al. (1981) *Of Marriage and the Market: Women's Subordination in International Perspective*. London: CSE Books.

Index